CHARACTERS OF HENDON AND THE EAST END

by

Matty Morrison

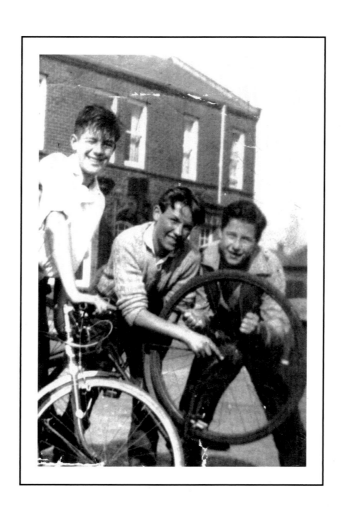

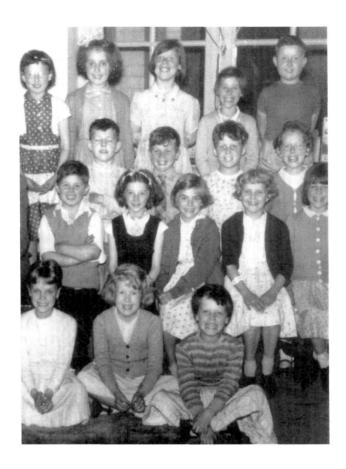

Previous page: Members of Hendon Cycle Club.

Above: Pupils from Hendon Board School 1956-57.

Opposite page: Teaching staff at Hendon Valley Road School 1887.

First published in 2006 by

Black Cat Publications
163 Brandling Street
Sunderland
SR6 0LN

ISBN 1 899560 89 0

Acknowledgements

I would like to thank the following for their help with this publication:

George Alder, Anne Ambrose, Joe & Mary Arnett, Joe Ashton, Mary Bevens, Brian Blyth, Tommy & Cathy Bowens, Anne and Norman Bracy, John Brown, Michael Bute, Bobby Byers, Bobby Carlisle, Marion Cook, Gordon Cowe, Phil Curtis, Harry Dalton, Bob Davison, Jack & Mary Donkin, Bill Emmerson, Mary, Margie & Willy Fergerson, John & Tommy Fletcher, Brian Ganley, Peter Gibson, Jimmy Goodfellow, Phil Hall, John Harrison, Brian Holden, Mandy Hutchinson, Billy & Lindsey Jones, John & Terina Kirkwood, Joan Lawrence, Ronnie & Stella Loughlin, Ted Lynn, Ernie Malt, Fred Maw, Stephen & Joyce Miller, William Miller, George Mole, Cathy Mullin, Jimmy Mullin, Phyllis Podd, Archie Potts, Ellen Pryde, Dot Ratcliffe, Tommy Ratcliffe, Arthur Rich, Billy & Sheila Roberts, Peter Shevlin, Les Simm, Tommy Southern, Bobby & Pauline Steabler, Ray Storey, Jean Stratton, Anne Strong, Ashley Sutherland, Alan Tedder, Albert Thompson, Liz Tinker, Billy Tipling, George Tyson, Davy Wake, Jack Webster, Billy Welsh, Trevor Williamson, John Wood and especially my wife Gwen for putting up with my tantrums.

Hendon Valley Road Schools
Sunderland Echo
Sunderland City Library (Local Studies)

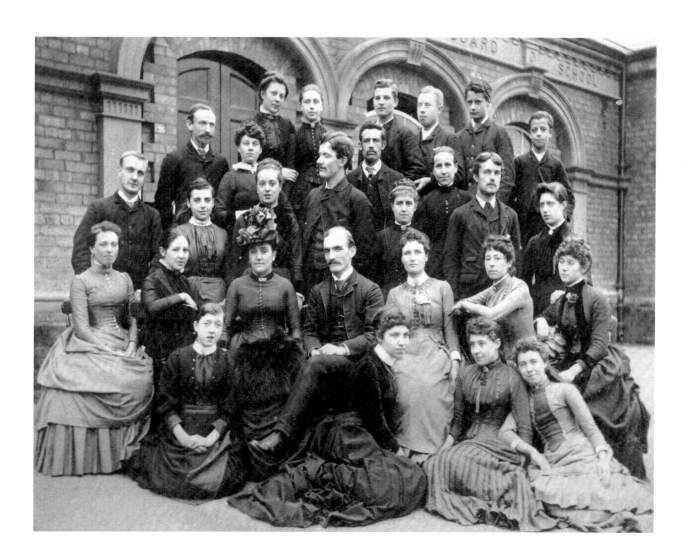

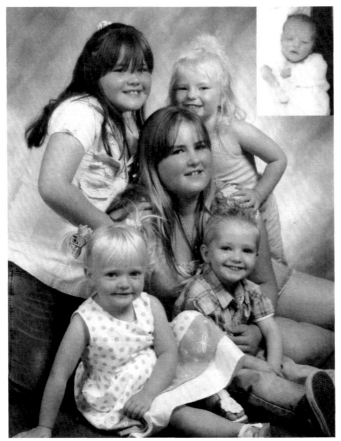

Brogan, Cody, Alisha Morrison, Kirsty James and Sean Morse.
Inset: Melissa Morrison Morse.

For Alisha, Brogan, Cody, Melissa, Sean and Kirsty
So they will know what it was like in the black and white days.

Introduction

The following story is of the people who lived and died in the best place on earth – Hendon and the East End of Sunderland. Two different areas, two different cultures but joined together by their determination to succeed and their openness and friendliness. Whatever adversity would come their way they would face and come through it and throw a smile at it to show that as long as the community was there they would come to no harm. Here are many stories of such happenings, not all deeds are mentioned for fear of libel action and of course my memory loss. Some famous people will be mentioned, and some will not, some not so famous people will be entered and some will not. I apologise now to all who have been omitted and say that it is simply not possible to remember all and that I have no wish to offend anyone.

The basis of this book will centre on HENDON BOARD SCHOOL and its pupils, the lower part of HENDON and its families. It will take in some of the other schools, the East End, families, sportsmen, sportswomen, military personnel, entertainers and those who have done well for themselves.

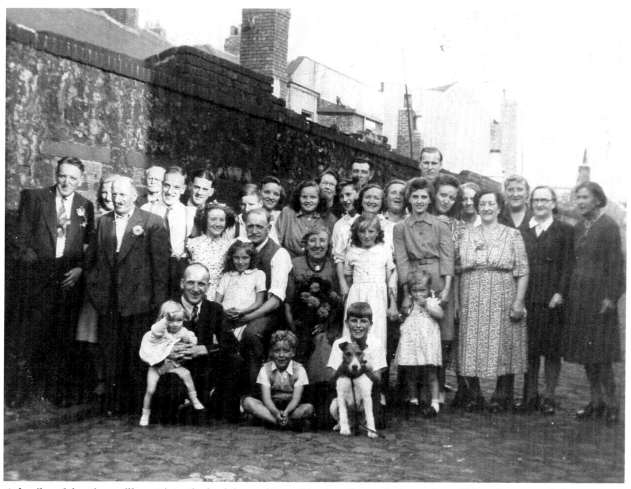

A family celebration spills out into the back lane of Page Street so that a photograph could be taken to mark the event. The occasion was the Golden Wedding of Peter and Mary Hawkins attended by their children Peter, George, John, Frank, Jim, Alice, Mary, Dolly and Nellie and all their grandchildren.

The Cobblestone Kids

I'm not sure whether it was the first time I had heard the saying or if I had heard or read it somewhere else before but I do know that I did overhear one of the schoolteachers in Hendon Board School yard say, "They are the cobblestone kids." I didn't know at the time what he meant but can only surmise that he was referring to the area where certain kids were living at the time. Well he may have been right about some of us living in Cumberland Terrace, Cliff Terrace, Henry Street East, Addison Street East, Burlington Road and the streets around such as Clementina Street, Christopher Street and Thompson Street, and even at one time there was a part of Bramwell Street that was cobbled.

Let me tell you the story. It was the norm for kids to run around either in their bare feet or, if you were well off but not posh, to wear sandshoes. Winter or summer it was all the same, you wore sandshoes. As there was a total of ten kids in my family, my mam, bless her, had to mend and make do anyway she could, especially when my dad was not working. Like many other mothers at the time she went to the Salvation Army which used to give out either vouchers or clothes. Well mam was given a brand new pair of blank leather boots which unfortunately fitted me. My grandfather took the boots and put them on his cobbler's last and began to put big iron tacks in the soles and a heel and toe bar. When he got to 20 tacks in each sole he gave them to

Doreen Fletcher and her Bramwell Street brood including the cat.

me to try on. Well apart from the weight of each boot because of the newness of the leather it was torture to wear them but wear them I did. But every cloud has a silver lining. When I had to go to school on the mornings, as I was running over the cobbles, the tacks used to make an awful racket and used to wake everybody up who lived at the top end of Bramwell Street so I did get some fun out of wearing what I called the tackety boots. The sandshoes were another source of fun, not at the time of course, but when I look back at wearing them it does sound and probably looked funny. As I said sandshoes were worn by most kids, and all the year round, simply because they were reasonably cheap to buy at Berstein's shop in Hendon Road. The problems started when they began to wear out. It was weird how the first hole used to be just under the big toe and how quickly your sock use to poke out just a little bit at first. If the weather was dry your sock would stay small but if it was

Matty Morrison aged 18 months at 92 Ward Street.

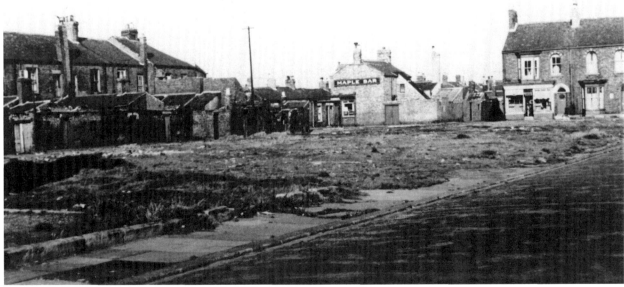

Demolition of Bramwell Street around 1964 with the Maple Bar in the background.

raining it was funny how your sock used to get longer and longer, and the faster you ran the longer it got. Worse was to come, the sock used to hit the pavement and then splash back and the dirty water off the ground used to hit you in the face and put black and white stripes down your face. So it didn't make any difference when you took off your sandshoe and curled the sock up and tucked it under your big toe to keep it from creeping out the hole again, everybody knew you had a hole in your sandshoe by the marks on your face. There were other tell tale marks on your body that would tell people what kind of footwear

Off to make a Bogie.

you had just had on and that was the welly ring. That was another black mark around your calf muscle that told that you had been wearing your Wellington boots all the week, and yes we would wear them as we wore the other footwear, all the year round. After a while you would turn the tops of the wellies over to stop the marks arriving, so there is always a way. When I went into Hendon Board Senior School I was able to get rid of my tackety boots. I found a benefactor in a teacher, Mr Jack Washington. When ever a class would go for PE each individual would go to a cage and pick out a pair of sandshoes that was nearest to their size, and after the lesson they would take them back to the cage – well sometimes. Whenever my own shoes, which were sandshoes anyway, were worn out, Mr Washington would let me put my own shoes in the cage and I would keep the new pair. God only knows what the next pupil in the next class thought about the smell. Only one other strange footwear to describe and that is everyday football boots. These were boots that were converted by taking out the studs from both the heel and the sole and nailing pieces

The Blondies of Ward Street including Ann Hall and John Lindsey.

The Bramwell Street Shadows, left to right: Ronnie Fletcher (Tony Mehan), Harry Walker (Bruce Welsh), John Fletcher (Hank Marvin), Tommy Fletcher (Jet Harris) and David Fletcher (Cliff Richard).

Miss Podd on her new three-wheeler in Cumberland Terrace.

of leather shaped like bars, two or three across the sole and one or two across the heel. The boots themselves had a toe cover as hard as rocks with a heel the same, almost as good and as hard as the present day safety boots. Therefore they could be worn for anything, from playing football to going for coal! I've heard that even the shipyard workers wore them to work as safety boots. Where there's a will there's a way.

Thinking back to why we went through so many pairs of different footwear brings me to the reason. It is of course because of the different kinds of games we played. Being as there was no television, well not to us kids anyway, we busied ourselves in groups and we probably played with the same group each time. Games like 'kick the tin', 'dilly I go', 'mummy' and 'hide and seek'. These games were played by both sexes and were played sometimes for hours. Games for the boys were football, cricket, fighties and a game which was popular with a name I still don't know where it came from and that was 'alleys', which was really marbles. The game we played in the front garden was progressed by digging three shallow holes about a yard (metre) apart. You had to flick the alley between your thumb and forefinger and aim to get in all three holes one at a time. If you succeeded you were then killer and could then start to hit your opponent's alley into a hole and if you did then they were killed and you could win their alley if you knocked it into a hole again. We also played the game in the roadside gutter on the way to school and back and while we would run messages. Today, alleys or marbles are played on a professional basis all over the world and I

Tommy and John Fletcher with Bimbo the dog in Bramwell Street.

Harris Macca and Lillian Walker outside Brown's shop in Bramwell Street

Young Alex Fraser with his dad Stanley at 9 Hedworth Street.

Michael Freeman aged 1 year in the best pram of the time in Gray Road.

Margaret Freeman aged 10 (back) with Joseph Blenkinsopp aged 6 and his sister Gwen aged 4 in Gray Road, 1954.

John and Tommy Fletcher in Bramwell Street.

believe that there is a World Championship Competition.

The game the girls were playing was hitchie quoit. The girls would draw a pattern of squares on the ground and put numbers in the squares one to ten and hop on one leg to complete certain tasks. I believe if the individual was to step on a line then they were out and the next person would start. Another game the girls would play was two baller, where they would throw two balls at the wall one at a time like a juggler would do, mumbling a rhyme, 'one malara, two malara, three malara, four.' I still don't know to this day what a malara is! Part of this game the lads used to enjoy was when the girls tucked their skirt up the edge of their navy blue woolly knickers so that they could bounce the balls

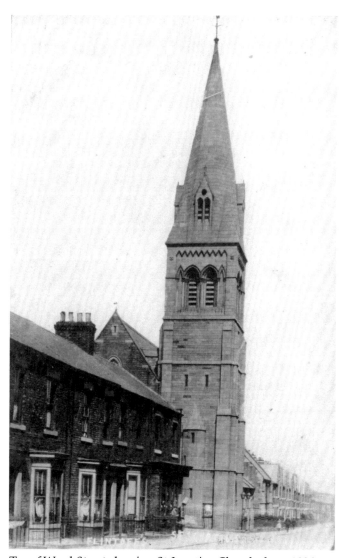

Top of Ward Street showing St Ignatius Church about 1928.

Two views of Tower Street West today.

Doris Knox aged 18 months with dad John and brother John at 92 Ward Street.

Madeline Hopper aged 3 in Norman Street.

Alan Oliver aged 2 in Ward Street.

Bobby Dunn aged 5 in Norman Street.

Margaret Critchlow aged 5 years.

Jacky Hammond aged 5 years in Norman Street.

Ashey Humble aged 8 at 103 Ward Street.

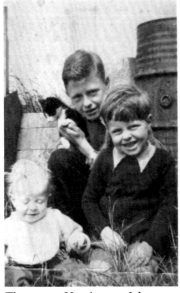

James aged 5 and Lillian Oliver aged 8 in Bramwell Street.

The young Harrisons – John aged 10, William aged 6 and David 1 year, 12 Ward Terrace.

Linda aged 5 and Elsie Bargwell aged 10 in Surtees Street.

Ernie Malt aged 5 in Ward Street.

Gwen Blenkinsopp aged 5 in Gray Road.

Margaret Freeman aged 10 Gray Road.

Jimmy Davison (back) with Brian Temple and Tommy Southern in Tower Street.

Anita Purvis aged 18 months at 23 Salem Street.

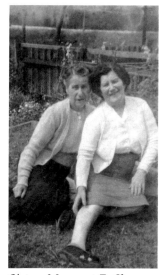

Sisters Margaret E. Sharpe and Isabella Sharpe.

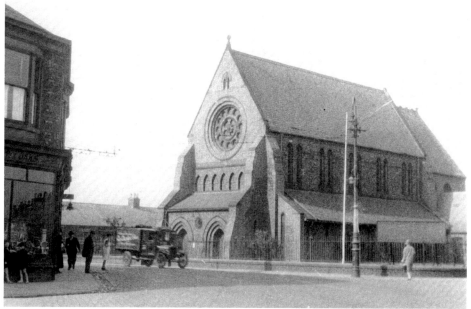

St Barnabas Church around 1920 with Tower Street in the background.

between their legs. In the summer time these and other games would continue well in to the night, sometimes until 10 or 11 o'clock. The story goes that on a Sunday night during school term the mothers would come out, grab the first seven kids, hoy them in the tin bath and sort them out for next morning, no matter whose kids they were. One of many of my memories growing up in Bramwell Street was when a group of us would just sit on the curb and tell jokes and sing to each other as a party trick. Betty Harris when she was about 9 or 10 years old was the champion hula hula girl, she would wear a proper grass skirt and dance to Guy Mitchell's 'She wears red feathers and a hula hula skirt.'

Being entertained by Betty wasn't the only music we were listening to at the time as we had the late song birds from the pubs to listen to and as there were many pubs there were many singers. The best by far was a man called Norman Stubbs, who although he was never really drunk he would sing Al Jolson songs from the top of Bramwell Street to the bottom where he lived. We would walk along with him and try and sing along and sometimes we would get a copper for our troubles.

Ivy Morrison née Oliver.

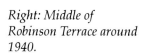

Above: Doris Sanderson of Bramwell Street.

Right: Middle of Robinson Terrace around 1940.

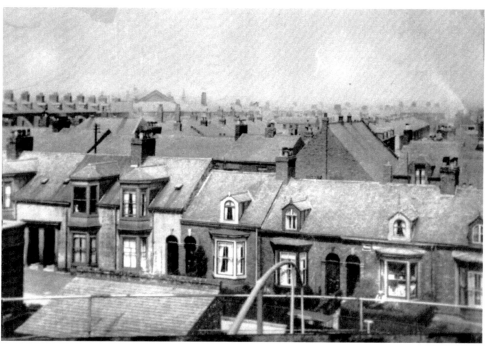

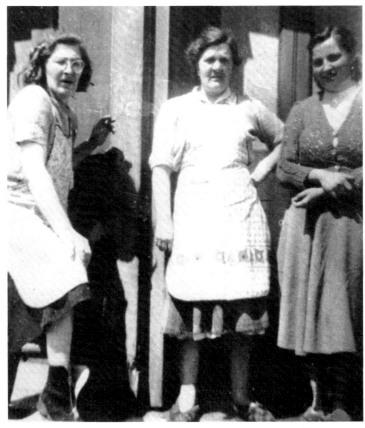

Mrs Malt and young Ronnie Malt in Ward Street.

Fag time, left to right: Mrs Allan, Mrs Edie Ware and Lillian Oliver née Farrell, 8 Bramwell Street.

I suppose it was for that reason we grew up becoming attached to the singers of the day, Kay Starr, Frankie Laine, Frank Sinatra, Rosemary Clooney and even Bing Crosby. The songs I remember from the time were *Jealous Heart*, *If You Loved me Half as Much as You Do*, Josef Locke with his *Goodbye*, and *I'll Take You Home Again Kathleen*. Johnnie Ray's *Cry* and *Little White Cloud* and of course many others. I was lucky enough to listen to all of these on my uncle's wind-up gramophone, but I suffered some because I had to listen to his favourite songs too, like Jerry Colona's *Ebb Tide* and *Velvet Glove* and Spike Jones and his City Slickers' *The Wedding*. Although we still played our games and played our pranks such as knocky-nine-doors, raiding

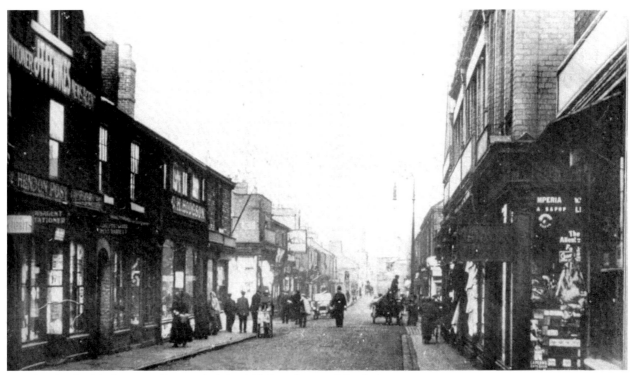

Hendon Road with the post office on the left which later became Worthy's.

someone's orchid, chasing cats and dogs and all the other thing kids would get up to.

Things were changing, the short trousers were getting longer our voices were getting deeper and to the boys the girls started to look different. Everything was going along fine and then BANG – 1955 arrived. I was nearly fourteen years old and boy did things change. Teddy Boys, Bill Haley, Little Richard, Fats Domino, Jerry Lee Lewis and the King – Elvis Presley. Rock and Roll was here and though at the time they said it wouldn't last, it was here to stay and it's still here. For us kids it was the best time ever. We were able, if we could afford it, to go to a dance every night of the week. YMCA one night, YWCA the next, Bailys, Elliott and Fields and others. And not only in Sunderland but Ryhope and Seaham and Washington. There was also the cinemas where we could take a girl, if you had one. What a sight we boys must have looked when we went Edwardian. The dress code was amazing, wide shouldered, knee length brightly coloured jackets, light blue, yellow, lime green. Mine was red, an old riding jacket I managed to buy from Ginny Moore's second-hand shop for a shilling. All the jackets had velvet collars, velvet pocket lapels and velvet cuffs. We had tight powder blue jeans which we used to shrink tighter by sitting in a cold bath which shrank the jeans to your shape, some of us you couldn't bend wire to the shape of our legs. We wore blue suede crepe sole shoes, which when they were wet would slip, even on a smooth surface, and when the ground was dry but the shoes still wet it was like having two suction pads on your feet. The hair was long, collar length and shaped at the back to look like a duck's a—, the style was called a DA. The front was formed into an elephant's trunk, and how did we get this hair style to keep in?

Left to right: Brian Hall, Peter Roony and Willy Fergerson all about 15 years old at 107 Ward Street.

easy – cover your hair with either lard, margarine, butter if you could afford it or any kind of grease. That's where the film *Grease* got its name. The girls enjoyed getting dressed up too, their skirts were flared out by wearing many petticoats underneath, they wore low cut blouses with a cardigan draped round their shoulders and flat shoes and white ankle socks. Their hair was in a pony tail, sometimes tied with a long ribbon. Rumour has it that they used to use gravy salt to give their legs a false tan and then take a dark

The Norfolk Hotel 31st August 1965, left to right: Billy Baxter, Margaret Fergerson née Sanderson, Brian Hall, Arthur Lackenby, Freddy Fergerson, Ritchie Miller, Tommy Lindsey and Willy Fergerson. All of Ward Street.

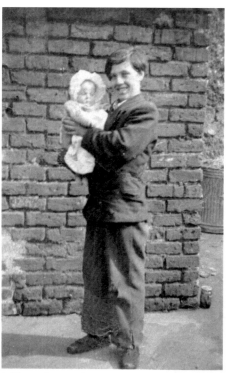

Billy Roberts with cousin Sylvia Powell in 1951.

pencil to draw a straight line down their legs to give the impression of wearing stockings. Later when their hair styles changed to the beehive, they would use sugar and water as a spray to keep the hair in place. These days you can buy it off the shelf. I'll leave it to the reader's imagination as to what both boys and girls looked like after dancing in a hot dance hall all night with the grease from the boys and the gravy salt and sugar and water from the girls, plus if it was raining when we came out what the girls legs were like. The girls also wore lots of mascara and not a so expensive one so when it ran it ran. It wasn't that rare to see a fine bit of leg either when the girls were swinging round and round, suspenders and stocking tops and all, Happy Days. Is that where the title of the television programme came from? There were the British rock stars coming up, like Cliff Richard and the Shadows, Marty Wilde, Terry Dene, Alma Cogan, Ruby Murray, and many more, but the one that gave us our home base, was Tommy Steele. Tommy began his career in a coffee bar called the 2 i's in Soho, where kids would go and play the then new juke box and listen to live shows and become Americanised.

Here in Sunderland a family opened a café on the same lines called The Verona and it certainly attracted us kids. The family was called Nethercot, The Verona was in Mainsforth Terrace West, next to Matty Wilson's and opposite St Barnabas Church. The Nethercot family sold the café on to whom I think was the real person who brought us kids into the real Rock and Roll world, Irma and husband Jack Dennet. The juke box arrived, the hamburgers and Coke arrived and best of all the tick bill. Irma allowed us to tick on and we used to work it off or pay her at the end of the week. By then I was left school and running around working on the fair on the Burn, and with Lukey, Ritchie and Jimmy Wynn, we used to go to The Verona for our meals, play the

Irmagard Charlotte Dennet formally Lamicka née Schicora. Joint owner of The Verona Café – first home of Rock and Roll in Sunderland – Mainsforth Terrace West 1959-1966.

Mainsforth Terrace West, the shop with the shutters is the old Verona Café, now the Rainbow Chop Suey House.

Mainsforth Terrace West from the other end.

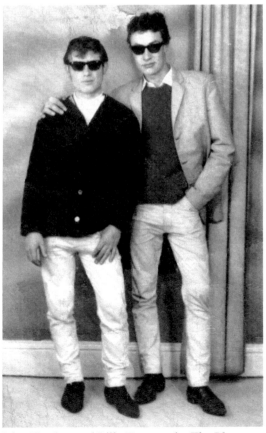

John Fletcher and Billy Daymond – The Blues Brothers in Bramwell Street.

juke box and dance, and sometimes Lukey would give us a turn. Already I could see that times were changing and what was ahead for us. The kids who were older than us by a couple of years were already frequenting the local ale houses. This was their enjoyment and although there was no harm in what they were doing I could see us younger element going the same way. It was now 1960 and time for me to move on so after certain events I left to join the Army and went the way of the older element anyway.

That's how we used to play but how we used to live was completely different. While I was living in Ward Street I grew up with electric lights in the house and canvas on the floor. The toilet was down the back yard and, although it was cold, at least we had running water from the tap in the yard. My mam and me lived in 92 Ward Street, in a room on the top floor along with Mr and Mrs Knox and their children Iris, John and Doris and although things were basic it was comfortable and at night we had lights on the stairs. When I went to stay with my Nana and Granddad Oliver in 103 Ward Street everything was basically

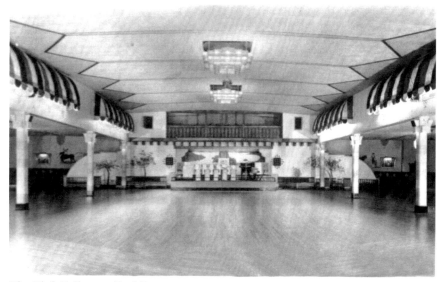

The Rink Ballroom, Park Lane.

Night out at The Rink in Park Lane featuring D. Underwood, Kit Miller, Billy Fox, Des Ellis and in front George Harrison.

the same except for one further luxury, there was a sink and a cold water tap in the kitchen UPSTAIRS. In the kitchen there was a great big iron black leaded oven for cooking. It was heated by pushing the fire from the hearth underneath the oven and my nana would cook all kinds including her home-made stottie cake and tea cakes. Brilliant! The best of all to come out of the oven was the iron shelves. After cooking, the shelves were wrapped in a towel and placed in my bed so the bed was nice and warm and then after I got in I

Freda and Sandra Potts, Ward Street.

Elsie Donkin 27th July 2006 formerly of Bramwell Street.

Ronnie Carter, 13 Bramwell Street 1950s.

pushed the shelf a bit further down and put my feet on for the rest of the night.

Ward Street had a proper wash house in the yard for the use of all tenants but the downstairs tenants were my uncle and auntie Harold and Phyllis Humble and their children. So there was no problem of when to share the wash house. The wash house had its own fire to heat a small boiler to put the dirty washing in. It was the kids, me and my cousins' job to make sure there was plenty of wood to heat the fire. There was one more job that we used to hate and that was possing. What you say? Possing I say. Before the dirty washing was boiled the adult, either my nana or Aunt Phyllis, would fill this large wooden barrel called a poss tub with hot water and put the dirty washing in.

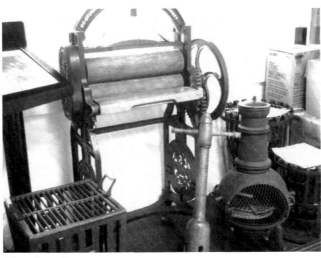

Mangle and posser.

They would then give us kids this great big heavy wooden stick that was split at the bottom in four pieces and we would have to poss the clothes by pushing the stick in and out of the barrel, twisting it at the same time. Hard work. When the clothes had been washed they then went through the mangle, a great big heavy machine with two large rollers that squeezed the water out of the clothes, wringing them dry. Hence the mangle came to be known as a wringer. Most of the houses in Ward Street were rented from private landlords and many of them were owned by Brown and Cummings of Frederick Street. Mr Cummings himself would sometimes come to collect the rent and he seemed very fair and kept most of his properties in a well maintained condition. I say that because what a culture change I was heading for when our family, mam and dad and us kids, moved into Bramwell Street in the early 1950s. Although some of the houses were in very good condition and well maintained by the tenants, quite a few were not. There were already derelict houses, either by bombing or just falling down because of their bad state of repair. I'm not sure, but it wasn't very impressive. All the time I lived there I don't think I ever saw the landlord.

Susan Spoors née Morrison, Ward Street.

Margaret McLin Elgee née Armour, Athol Road.

Anne Ivy Morrison aged 10 in Bramwell Street.

Back, left to right: John Morrison, Tom Morrison, Allan Morrison. Front: Mary Bevans née Morrison, Matty Morrison, Phyllis Maw née Morrison and Anne Ivy Ambrose née Morrison, 15 Bramwell Street.

In the particular house where we lived, 15 Bramwell Street, the only source of lighting was by gas, and that was with one arced stand on the wall beside the fireplace, in two of the three rooms that we rented. The third small room couldn't be used as it had no floor boards. The gas light was supposed to be enhanced by adding a mantle, a small delicate unit that was fitted to the stand to help make the gas brighter. Unfortunately nine

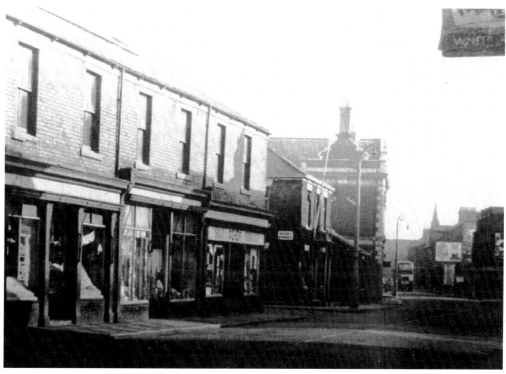

Hendon Road looking south with the old Ivy Leaf Club and the New Shades on the left.

times out of ten my Dad would try and light his fag off the gas and he would break the mantle, which, although the gas was still on, didn't shine enough to light across the room, so we may as well have been in the dark anyway. For a while the only cooking facility we had was by the main fire, that is if we had the fuel for the fire, which we didn't always have. Everything we ate that needed heating was done on that fire. We had two pans, a frying pan and a pan to boil stuff. Eggs, sausage, chips and beans all done in the frying pan with a little dash of soot. All at the same time, pies and pasties were warmed on the shovel and the water for tea and the tins of peas were warmed in the boiling pan. There was no water except for the tap in the back yard and we lived on the top floor, so all the water had to be brought upstairs by us kids in a bucket and every time it was empty we would have to fill it day or night. There was also the other bucket, which I'll explain later, which had to be emptied first thing in the morning, so sometimes we would be struggling with two buckets. I mentioned eggs and sausages, that was if we had any money to buy them, but both work and

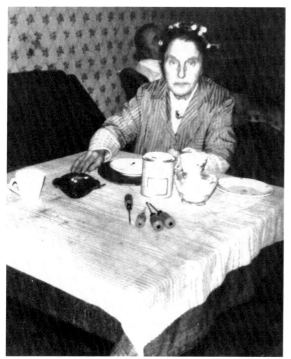

Mrs Malt in curlers, one of our neighbours in Ward Street.

money was scarce at the time for many families, so it was more likely water cakes we would be having or, if Kitty Walker had any chips left at the end of her shift in the fish shop in Hendon Road she would let us have them cheap (for nowt). The water cakes were easily made, just flour and water, made into a dough, and put in the frying pan and cooked. The other delicacies we would endure would be dripping and bread, sugar and bread and, when possible, jam and bread. Sometimes we would take some sugar and bread to school and have it when we got our bottle of milk at breaktime and that would make up for not having a breakfast back home. At night before bed we used to have to go to the toilet, we called it a lavy, once again it was down three flights of stairs, with no lighting at all, in the middle of winter, so we had to roll up a full newspaper and make it as long as we could. We would take a deep breath, stick the paper in the fire and run down the stairs, out of the yard door, hoping first of all that no one was on the lavy and second but most important, that the paper didn't burn out, for two reasons, one for the light, but mainly for a small piece of paper to use when you were finished the business. If we were unlucky, and sometimes we were, then we would have to either wait in the dark, whistling, so the lucky person knew you were there, and to ward of the

creatures of the night, seeing how it was pitch black, or go back upstairs and on to the other bucket. Unfortunately it was alright to use the bucket for a wee during the night but if we used it for anything else we would get a clip round the ear and we would have to empty it for a week as a punishment. To keep warm at night anything and everything was used on the beds as well as blankets, if we had them. People used to make their own clippie mats and they used to put those on the beds. My dad was in the TA and he had a big heavy army coat which we put on the bed. The vicar came for tea one day and my mam put us kids in the bedroom. After a while I shouted to my mam, "Our Phyllis has pulled the coat off the bed." Mam came running in and said "Don't say coat, the vicar's here, say eiderdown" and she went back to the vicar. After a while I shouted, "Mam our Phyllis has pulled the sleeve out of the eiderdown!"

Left to right: Gwen Morrison, Ivy Morrison, Lily Oliver, Elsie Bargwell and Peggy Armour.

Things slowly started to improve as we started to grow up, we began to help our mam in many ways. The older kids would look after the younger ones and when the time came we would go out into the tattie fields and pick tatties and earn hard cash along side my mam. My two brothers, next to me, started very young by having Guy Fawkes Night in September. They would find an old pram and one would get blacked up, if they weren't already, and sit in the pram while the other would push it round the pubs shouting, "Penny for the Guy!" They then brought Christmas forward to about November and went round carol singing. All very lucrative. All the kids round Hendon would go to Hendon Beach for fuel for the fires and they would be well supplied with wood and sea coal, which they would haul back home on old nobblers, bogies, old prams and bikes, and even carry them on their young backs. They would do it because the fuel was needed but mostly because their mothers needed their help.

Sometimes, to pass the hours away the whole family would sit and make clippie or proggy mats, a form of carpet, which was made from old rags, mostly woollens. One of the adults would sew together old onion or potato sacks, and draw a pattern on them and fasten the sacks to a wooden frame, meanwhile us kids would be cutting the old rags into strips about an inch wide and about four to six inches long. The adults would then prod one end of the cut rags through the sacks, pull the other end through again to form an equal length, keeping in shape with the pattern. They would be talking away and smoking and maybe sometimes having tea or a can of beer. When the mat was finished, depending on the quality, it would be either sold for ten bob (50p), or thrown on the floor or, as I have already said, thrown on the bed to keep us warm.

In later years with my dad getting work for Brimms and Monsanto, building the new pier down Hendon Beach, and most of the older kids bringing in a few bob here and there things began to improve. We got a single gas ring which ran off the gas mantle, so that got rid of the taste of soot and then eventually we got a full gas cooker which was just pure heaven; proper cooked food, and plenty of it. We still lived in Bramwell Street and still had no electricity, so when I went to live in Ward Street with my Nana Oliver what joy; electricity and all that went with it, wireless to listen to, *Journey into Space*, Radio Luxembourg, and music all the way, Rock and Roll. And later, when my nana and granda could afford it, television, hired from Rediffusion on a weekly basis (*left*). I couldn't believe it. The Wooden Tops and the Cisco Kid, The Lone Ranger and Tonto, Hopalong Cassidy and Gene Autry. My nana's favourite was the wrestling with Jackie Pallo and Mick McManus, Les Kellet and the Ghoul and she used to like watching the *Saint* with Roger Moore. It was now 1960 and I was off to join the Army and I would be away from Hendon for the next six years.

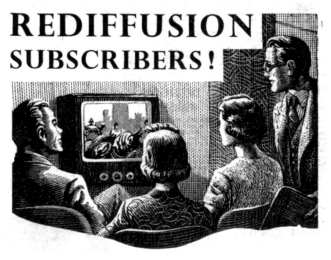

REDIFFUSION SUBSCRIBERS!

Extraordinary Cobblestone Kids

Tanya Louise Lovett was born 21st April 1987 in Sunderland General Hospital, the first child of Darren Lovett and Michelle Lovett née Morrison and the first grandchild for both sets of grandparents, John and Cathy Morrison and Eileen and Bobby Lovet. She was born a healthy normal baby after mum's 29 hours of labour. At first everything went well, until the baby was about nine months old, and then became constantly sick and began to lose a lot of weight and Michelle began to take her to the doctors on a daily basis. Eventually the hospital kept Tanya in overnight for observation – that overnight stay lasted three months. In the end Tanya was diagnosed as having Cystic Fibrosis, which creates a problem with the lungs and digestive system and results in children rarely reaching adult age. Tanya needed constant care from the start

and her parents and grandparents all got stuck in with the task of attending to Tanya's medication and more importantly the hourly massages that were needed to help Tanya to clear her lungs. She is an adult now and like any young person of today I'll leave the last word to Tanya herself. "I am now eighteen years old and I am enjoying life so much. I do everything that a normal person can do. My mam and dad mean everything to me, they have had to live with my illness just as much as I have and both sets of my grandparents have always been there for me. My brother Jamie has also been great over the years. I'm going to live life to the full, as life is too short to waste."

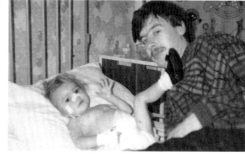

Tanya Louise and father Darren at home.

This story is about Kyra Miller but it is also about the devoted family she has, especially her mam Kelly. Kelly who lives with her fiancé Carl Richards and daughters Kyra aged 6 years and Mia 7 months in Tower Street, Hendon. When Kyra was born she was diagnosed with a rare disease which affects most of her major organs. First of all Kyra needs a major spinal operation in the hope that it will prevent her being paralysed permanently. She will in time also need a kidney transplant; members of her family are presently undergoing tests to see if any of them are compatible. Kyra's dad, Stuart Dodd, will also take part in the tests. Another problem is that Kyra has a neuropathic bladder, which means that it is smaller than normal and doesn't function properly. In the future she will need operations to enlarge her bladder, to operate on the tumour on her spine to try and prevent permanent paralysis, and of course her kidney transplant. Kelly while coping with all of this had the stress of her dad Stephen coming through two heart attacks and having a triple heart by-pass. I was in hospital with Steve having the same operation, and all he was worried about was how little Kyra was doing, and constantly pestering his daughter to bring his granddaughter in to see her. On top of all that, Stephen after a successful by-pass, was informed that he has lung and bowel cancer. In the background while the world falls apart around her, is Joyce Johnston, Stephen's partner, and the family's strength. The Miller family's luck must change and the sooner the better. They deserve it.

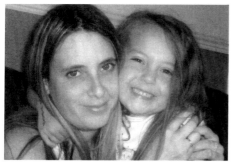

Mam Kelly Miller and Kyra aged 6 years.

Clinton Morrison was born 11th January 1993 to James Morrison and Teresa McGloughlan. Clint's dad had been profoundly deaf since he was involved in a bus accident in 1961. Even at the age of about three years, Clint must have realised that his dad had a problem, when Clint was trying to speak to him from behind. So very quickly, when he wished to say anything to his dad, Clint would make sure he was standing in front of him and he would move his lips very slowly as though he had realised that dad could lip read. Clint had

two other brothers and a sister who were much older than him and they had already left home, so when mam and dad were in different rooms and wished to communicate Clint would be the go-between and keep his parents in touch. Clint's dad, Jimmy, learnt to use sign language, so he could speak to strangers who were also deaf, and most times, Clint would be there with his dad and without Jimmy realising it Clint had picked up enough of the sign language to be able to make himself understood. He was only five years old! He learnt how to answer the door and he would tell dad if any unusual noises were in the house and was generally his dad's ears. He was nominated for an achievement award as an outstanding young person and was presented with his award by the Lord Lieutenant of Durham when he was eight years old. An extraordinary intelligent cobblestone kid.

Clint Morrison and dad Jimmy (left), mum Tess and Uncle Matty, Durham University presentation for outstanding achievement.

Mr Gordon Liddle – a unique teacher in all ways. He trained the football and cricket teams. He taught first year seniors and later became headmaster of Springwell Junior School. Now retired he attends the School reunions when he can.

Newrick Stores – last time I saw him was when the cricket photograph that we are both on was taken. I can only assume that Newrick, being a brain box, passed his 11 plus and went on either to the Bede or to Villiers Street Technical Collage.

Fred Warren – born at 4 Christopher Street, Hendon in 1941. Started as an errand boy at the London and Newcastle Tea stores in Hendon Road. Worked on the railways in the South Docks and later worked as a driver for a number of local firms before becoming the steward at the Railway Club in Holmeside, where he remained for twenty-two years. Now retired.

Sydney Mordey – born in Henry Street East he spent all his school life at Hendon Board. He began work at Hopps fruiterers and later worked as a paint sprayer at JL Thompson's until his health took a turn for the worse. He married in 1963 and produced five daughters and four sons. Let's hope he soon regains his health.

Kenny Vipond – attended Hendon Board until he was 13 and then moved on to Commercial Road School when his parents moved home. Worked as an office boy at Shorts Shipyard and then started an apprenticeship as a shipwright but after only two years left to join the Army. Then worked for oil companies rising to Terminal manager until retiring due to ill-health in 1994.

Matty Morrison – home address was 92 Ward Street, Hendon. Worked as an office boy at Bartrams Shipyard, briefly as apprentice caulker and burner at Bartrams. Worked on fairgrounds before joining the Army in 1960. Later worked as a driver for several local firms before becoming a bus driver in Sunderland for a total of 27 years. A trade unionist, a local author and now retired.

George Mole – left school at Easter 1958 started work for Sykes lemonade company. Left after six weeks to work with the firm that his brothers were working for on the South Docks, George Horsley Timber Company, cutting pit props for the mines. Stayed with them for a few months and left to become a miner but left after a while to enlist in the Army. Later worked at Bartrams and retired in 1988 when head timekeeper.

Jimmy Goodfellow – born 16th September 1943 near Hendon Board School. After passing his 11 plus, Jimmy moved to Villiers Street Technical Schools and then on to Southmoor Technical School. Played for Newcastle United Juniors, Crook Town, Bishop Auckland and pro with Port Vale, Workington, Rotherham United and Stockport County. He later became a trainer with a number of League clubs. Now retired.

Mr Jack Washington – originally from Kitsgrove in Staffordshire, he moved to Sunderland as a toddler when his father came to work here. Joined Hendon Board School's teaching staff in 1947. A much loved teacher, he had the same attitude as Mr Liddle towards us kids and most of us got on really well with him.

Gordon Walker – was another of our well educated pupils who went to Bede School. In about 1965, when he was about 21 years of age, he was working in Barclays Bank at Seaham Harbour, he was either assistant or branch manager at the time.

David Carter – David was a very intelligent and educated boy and, after passing his 11 plus, he left Hendon Board to attend the Bede and went on to university to take up chemistry. He later gained employment with the Guinness Group.

Davy Wake – born in Mowbray Road in 1943 the family later moving to Arnott Street. Started Hendon Board in a wheelchair due to ricketts. Overcame the bone disease and later joined the Merchant Navy and travelled the world. Returned to Sunderland and found work at a number of companies including Ericssons.

Jimmy Davison – born in Tower Street in 1942. Passed his 11 plus and went to the Bede later becoming a pro with Sunderland making over 70 League and Cup appearances for The Lads. He joined Bolton Wanderers in 1963 and later played for Queen of the South, South Shields and Darlington. He worked for Sunderland Council and Brian Mills. Sadly Jimmy passed away in 1987 at the age of only 45 years.

Tommy Southern – born in Noble Street in 1942 and was still living there when he started Hendon Board in 1947. In 1954 Tommy left school for West Park to further his academic career. In 1958 he started as a shipwright draughtsman for JL Thompson and remained there until 1986.

Billy Richardson – started an apprenticeship with a Southwick firm and left as a qualified joiner. Employed as a foreman joiner for many companies in many different countries until returning to Sunderland to work. He was forced to retire due to ill-health.

Bobby Byers – born in Harold Street, Hendon in 1943 and attended Hendon Board School until 1958. While at school Bobby was a keen sportsman and enjoyed both football and cricket, and could have gone on and played for any of the local amateur teams, but for some reason decided not to. When leaving school Bobby took up joinery as a profession and moved with his parents to Farringdon.

Freddy Warren, July 2006.

Sydney Mordey, September 2006.

Kenny Vipond, July 2006.

Matty Morrison

George Mole, July 2006.

Jimmy Goodfellow.

Jack Washington.

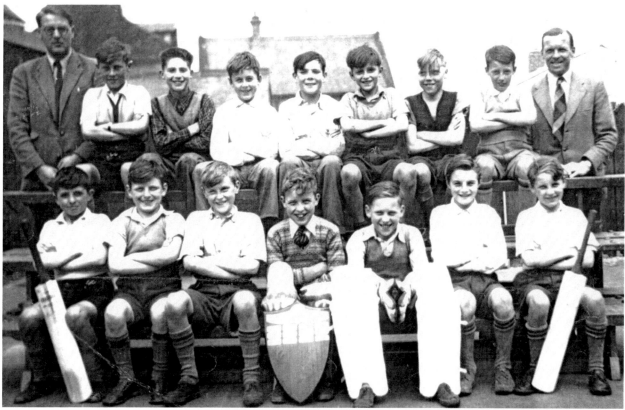

Hendon Board cricket team 1952-53. Back row, left to right: Mr Gordon Liddle, Newrick Stores, Fred Warren, Syd Mordey, Kenny Vipond, Matty Morrison, George Mole, Jimmy Goodfellow, Mr Jack Washington. Front row: Gordon Walker, David Carter, Davy Wake, Jimmy Davison, Tommy Southern, Billy Richardson and Bobby Byers.

Davy Wake, 2006.

Jimmy Davison in the 1960s.

Tommy Southern, 2006.

Billy Richardson, 2006.

Bobby Byers, August, 2006.

* Unfortunately I was unable to obtain recent photographs of Gordon Liddle, Newrick Stores, Gordon Walker and David Carter.

Life in the Garths

Burleigh Garth around 1990. At this time there was also High Garth, Walton Garth, Wear Garth, River Garth, St Patrick's Garth and Covent Garden. Recent years has seen housing in the old East End radically transformed with most of the Garths being demolished to make way for a return to traditional street layouts.

Cubby's daughters Masie and Nancy Hodgson, Burleigh Garth 1960.

Above: Elizabeth Hodgson and Billy Boy her feathered friend in 71 Burleigh Garth. She had lived there since 1937 with her husband Cuthbert 'Cubby' (*left*). Elizabeth came from Deptford but was converted to an East Ender by Cubby as soon as they were married. She liked to visit the Boar's Head snug with her friend Mrs Hunter for their night cap. Cubby, an engine driver, was very well liked in this tight-knit community. He was born in Carter Street and loved being in the place of his birth. He passed away in 1955.

Masie Hodgson, Burleigh Garth 1950.

The Garths were like Little Villages

I was born in Wear Garth in 1940 and first went to St John's School and then later St Patrick's School. I loved living in the Garths when I was a kid and remember well some of my neighbours. Good people like George and Jimmy Dillon, Mrs Horn, Mary and Joe Arnett, Mrs Taylor and Mrs Allan. It may have been rough but it was fun. Each Garth was like a little village of its own and the kids of one Garth were frowned upon if they were to enter another Garth. This was possibly because around Bonfire Night each set of kids would raid the next Garth and pinch the wood for their bonfire – but there was never any real battles. We were reasonably safe playing there because the Garths were enclosed and traffic was very rare.

When I got married I moved away from the East End and longed to return. When I finely managed to do so things had changed and I didn't like it but I'm coming to terms with the idea now.

Ronnie Loughlin

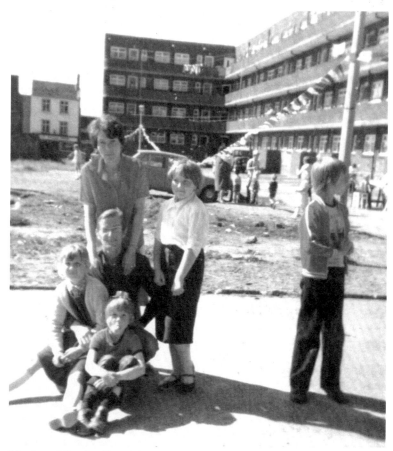
The Loughlin family with Teresa Rennie and Lisa Dunn, Wear Garth, 1982.

Walton Garth next to Lambton Tower in the early 1990s.

Stella Loughlin and Teresa Rennie, Wear Garth, 1982.

23

The Barracks

Allan Bute came to Sunderland in the 1870s with his regiment the 106th Light Infantry. He was stationed at the Barracks in the East End. He was living there in 1875 when he married a Hartlepool girl Hannah Kingston.

Originally from Berwick-upon-Tweed Allan Bute continued to live in the East End after leaving the Army in 1881 completing 21 years service.

Local author Michael Bute and the late Bobby Bute, the well known boxing coach, are two of his ancestors.

The Barracks in the Twentieth Century

The Barracks remained a military installation well into the last century, billeting soldiers and Prisoners of War until shortly after the end of the Second World War in 1945. Pat Conlin can still remember when he was about ten years old a German airman being marched up from the Docks to the Barracks. After the Barracks was demilitarized it was used as housing for retired people. Alex Sloanes can remember the wooden housing still standing in the early 1970s. The houses stood opposite the bus terminus and the Welcome Tavern was at the opposite end of the houses from the Dock entrance.

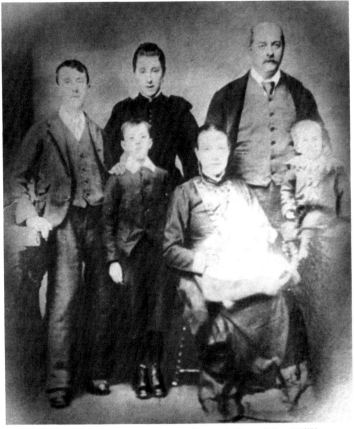

Allan Bute and family in 1888. Back row, left to right: William, Jean, Allan Snr. Front: Allan Jnr, Hannah (with baby Major on her knee) and James.

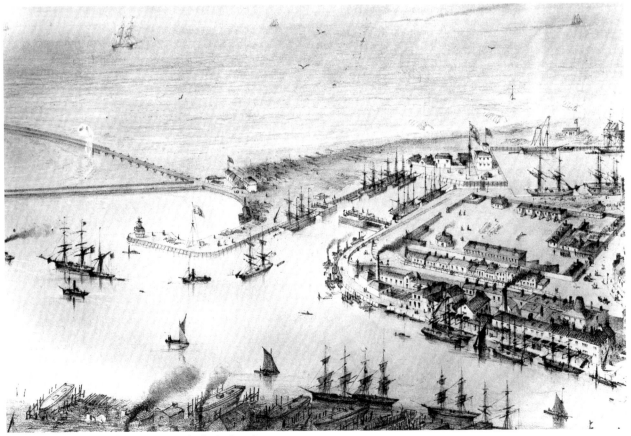

An illustration showing the Barracks in its heyday.

24

Shipbuilding

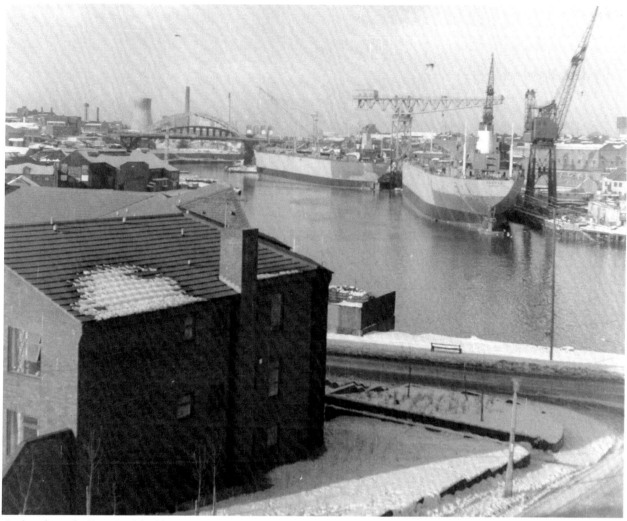

A view from the East End looking up river at two ships being fitted out at JL Thompson's.

La Marea

On the 15th July 1958 an unfortunate accident took place at Bartrams Shipyard on a ship called *La Marea*, a car carrying vessel, that at the time was being fitted-out in the dock. Two shipwrights were killed and another four men injured, when the car deck they were fitting broke loose crushing to death 49 year old Norman Young and 20 year old John Richardson. Of the injured 42 year old Matty Sayers was kept in hospital overnight and James Phillips, Robert Miller and George Hall received treatment and were let home. It's not known for certain what caused the accident, some say it was a lug that came loose. Others say that the men were using the wrong crane grip to lift the deck. Whatever the reason, two good men lost their lives. Rumour has it *La Marea* upon completion, sailed to Buenos Aires on her maiden voyage and, having reached her destination, her crew jumped ship, refusing to sail on her again. It has never been confirmed but they say she never left the port again and just rusted away.

Right: One of the survivors of the La Marea accident Matthew Sayers with his wife Mary Ann née Critchlow of Henry Street East with Mary's mam who lived in Harrison's Buildings.

Streets of Hendon

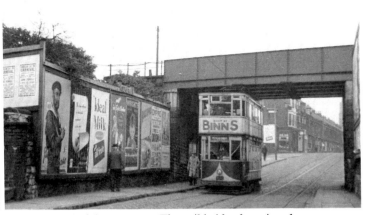

Two views of Tatham Street Bridge around 1950 towards the end of the tram era. The rail bridge has since been demolished and the trackway is now a public walkway.

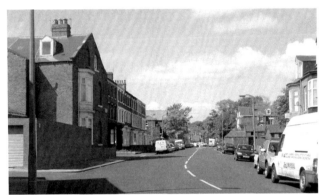

Gray Road looking east.

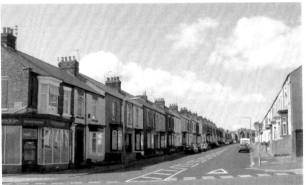

The bottom of Gray Road looking east.

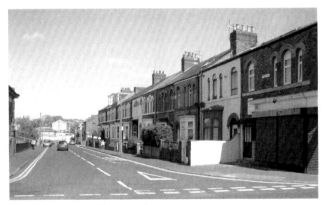

Toward Road looking north.

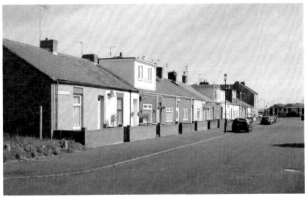

Mainsforth Terrace looking east.

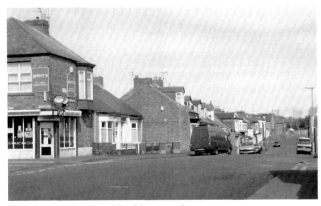

Hendon Valley Road looking north.

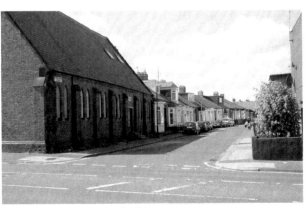

Hendon Burn Avenue looking east.

Decline of the Flicks

THE NEW PICTURE HALL!

THE

"VILLETTE"

Villette Road, Hendon.

This Hall is now the Daintiest and Most Comfortable in the District
and the Programmes shewn are only of the VERY BEST.

THE "VILLETTE" CATERS FOR EVERYONE

WHO WANTS A GOOD ENTERTAINMENT AT A LOW PRICE

BRING THE FAMILY!

Before the First World War a picture house opened in Villette Road called The Villette. It only showed silent films and closed in 1929 when the talkies started.

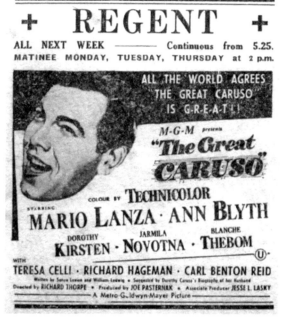

The Regent was the local picture house for people living south of Villette Road (Little Egypt).

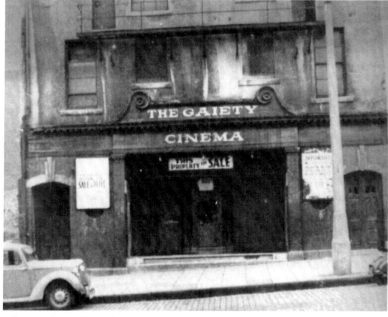

Above: The Gaiety Cinema in High Street. As well as films The Gaiety also held talent competitions. One of the local boys who used to enter was Lukey Ratcliffe. High rise flats now stand on the site of The Gaiety.

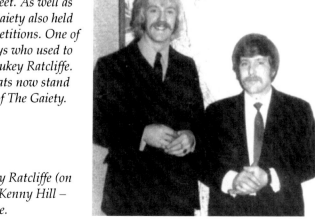

An advert for televisions from Joplings in the 1950s. This was the decade that television took off in this country (helped by the Coronation in 1953). One of the consequences was the decline of picture houses. The Gaiety closed in 1958 as did The Villiers. Others that shut down in Sunderland were the Palace in High Street West (1956), Cora (1959), Savoy (1959) and Millfield (1959). The Regent showed its last film in 1961 and was knocked down to make way for a supermarket.

Right: Lukey Ratcliffe (on right) with Kenny Hill – Blue on Blue.

Lukey Ratcliffe

It must have been the first time that I had stood with my mouth open, here was this stranger walking on his hands across Noble's Bank Road towards our school. Of course I had seen other gymnasts walking on their hands before but this boy was doing it so easily. Still on his hands he walked fully across the school yard and

into the side door and I'm sure if the teacher hadn't stopped him he would have, and could have, walked up the stairs into his classroom. It was the first time I had come across Lukey Ratcliffe but my admiration for him was there immediately.

Although I was amazed at this feat that Lukey performed I was to be more impressed when I found out about his background. When he was very young during the war, like many other children he and his brother and sisters were evacuated, to a place called Story Grange. During this time when he was about a year old an accident occurred when he was being looked after by some children which resulted in Lukey's back being broken. For the

Above and left: Lukey Ratcliffe on his way to school from his home in Noble Street.

next six years Lukey was either encased in plaster or held together in a steel jacket. When eventually he returned home he had to learn to walk. For a further four years he continued to wear the steel jacket and had to travel to a special school for disabled children. Was that the last of Lukey's problems? Oh no, he had to go on and contract scarlet fever, well was that enough for him? No, he had to try TB but thankfully he survived all his illnesses and adversities and because of his positive outlook and his will to succeed he was able to grow in character and do what he always wanted to do – be like other big boys and do what they could do.

Lukey succeeded in most things he was to try. At school he joined the gymnastic team and was very good, he taught himself many musical instruments, accordion, mouth organ, guitar and piano, and he also taught himself to sing, so much so he would enter talent competitions wherever they were, such as the Villiers Cinema and The Gaiety. He also sang on the Ivy Leaf Club in Hendon Road. Lukey's talents

Tommy Ratcliffe, aged 10 years.

continued to grow and develop; he would try anything, even going around Hendon with a home-made wheelbarrow collecting rags and scrap. He continued to entertain even when we worked as young boys for Johnny's Fairground on the

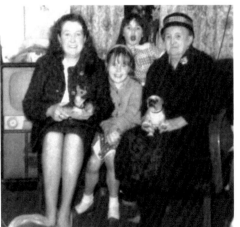

Hendon Burn, Lukey would dance and sing on the platform of the Waltzer.

When we would take our dinner break in The Verona Café, he would entertain us with his guitar playing and singing. It was at this time I was to leave Lukey and join the Army, but Lukey went on to other things such as meeting his wife Dorothy Hort,

Left to right: Ethel Elfreda Ratcliffe née Sproates, Carol Ratcliffe, Isabella Ratcliffe and Mrs Ethel Sproates.

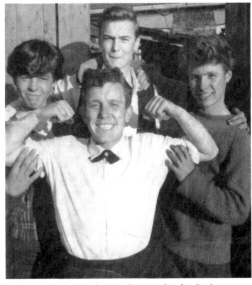

Gibb's toothpowder really works for Lukey. Back, left to right: Ronnie Potts, Alfie Miller, Tommy Ratcliffe and in front Lukey, Noble Street about 1959.

marrying her at John Street Registrar's Office in 1965. Along with his brother, Tommy, they tried different schemes including buying and running a scrapyard which they later sold and while Lukey went on to open various second-hand shops, and eventually, a bicycle shop in Chester Road called Kelly's, which was Lukey's middle name, Tommy had picked up enough to venture out on his own. Tommy tried TV repairs and second-hand shops. He now operates a joint venture of installing bathrooms and running the Regale Tavern in Hendon.

The old Ivy Leaf Club in Hendon Road.

Lukey had at one time met and teamed up with an old schoolfriend, Kenny Hill, and together they formed Blue on Blue and stayed together touring the local clubs for a number of years. When they broke up Lukey took the stage name of Little Teddy Rock and that was probably what he was best known by professionally. Lukey then went on to channel his energies in to helping others, along with other local stars like Bobby Knoxall and Bobby Thompson, they raised lots of money for many different charities,

and he loved every minute. Lukey got a surprise while he was doing a charity bash one night. When he and Dot entered the club, because of Lukey's height the people in the club thought he was a jockey, and when he told them his name was Ratcliffe, they thought he was Ratcliffe the jockey and the drinks came from everywhere and Lukey, not wanting to disappoint, accepted gratefully. I could sit forever and tell you stories about Lukey and not tire of doing so, but the memories bring back the sadness of Monday 17th April 2000, when Lukey passed away, he was only 58 years old but he left behind a multitude of friends and no enemies. His wife Dot, and his four children, Thomas, Julie, Sharon and Ann, and grandchildren Luke, Kelly and Ashleigh Carr miss him greatly. We will all remember you Luke Kelly Ratcliffe.

A special granddaughter Ashleigh Carr and favourite granda Lukey.

Left to right: Tommy Ratcliffe, Carol Ratcliffe, Freda Ratcliffe, Isabella Ratcliffe, Lukey Ratcliffe and Joe Gibbons.

Mrs Dorothy Ratcliffe née Hort and husband Lukey Ratcliffe.

Mammy's little treasure, Coronation Street around 1950.

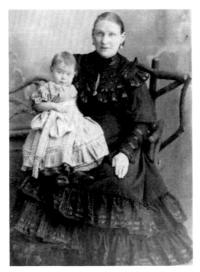

Above: Grandma Donkin and grandchild.

Left: Proud Grandfather Donkin and his 'happy brood' Covent Garden Street.

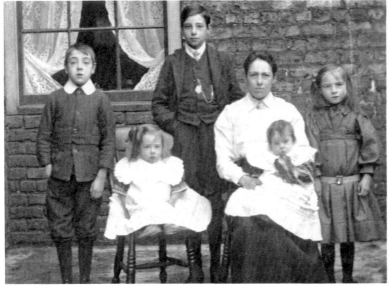

Donkin family ready for church.

The Animal Lover

You have a nice cup of tea with the other mothers, sit on the front step have a nice relaxing fag and calm your nerves mam. All the bairns are out playing and out of your way, the rest of the mothers already have the gossip at full speed, her next door is pregnant again, her down the street was out all night, her man's out of work again. Just a minute, isn't that our John coming downstairs with the gold fish bowl in his hands. PANIC, John's only four years old and the gold fish bowl has water in it but no goldfish. "Where's me goldfish?" screams mam. Calmly John looks up into her fearful eyes and replies, "I eat it". That was the start of my brother's love of animals. His next trick was to try and eat a dog. All the mothers were in their usual position, sitting having their cup of tea, and passing the time of day when an almighty yelp filled the air. All heads turned to face the incident and observed a young puppy galloping for all it's worth into Mrs Walker's house and young John sitting not far away with a smile on his face and blame written all over it.

"What have you done?" said mam.

"I bite it", says John.

"Why?" says mam.

"Because it bit me" says John.

There were lots of cats living in the vicinity of our house, and they were not the cleanest of cats, so loving John decides it's time the cats had a bath, whereupon he collects about four cats and takes them down the yard towards the toilet, picking up the dust bin lid on the way. Reaching the toilet he puts the cats one by one into the toilet and puts the dust bin lid on top. He sits on the dust bin lid and begins to pull the toilet chain, hence washing the cats, but the cats don't want washing and begin to cause an almighty noise, while trying to escape, and drawing lots of attention from concerned people. Someone opened the toilet door and sees John bouncing up and down on the dustbin lid. Not knowing what to expect, they grab John off the lid, the lid goes one way, while the cats go the other, and their unsuspecting saviour goes the other screaming in shock, while John just stands there wondering what all the fuss is about. The cats needed washing didn't they?

Jack Casey

Jack Casey was born in Edward Burdis Street in Southwick, son of John and Elizabeth Casey, out and out East Enders, and shortly after Jack was born they moved back to their roots. He attended Gray's School and although not very academic, he was good at sports and captained the senior football team. He went to work as a newspaper boy.

One day he went to watch a boxing tournament at the Holmeside Stadium. One of the first round bouts was about to be cancelled, one of the contestants hadn't turned up, so Jack volunteered, winning against W. Teasdale. It was 17th July 1926, and the bout was recorded as Jack's first fight in the ring. He continued with the competition and reached the final, earning a draw with Jim Britton, and picking up fifteen shillings for his troubles. When he fought another Sunderland lad, on 31st May 1930, he lost but went one better on 23rd April 1934 when he beat Tommy Farr then British champion, but the contest was not for the title, so although disappointed at not being champion Jack had proved he was good enough to be the best.

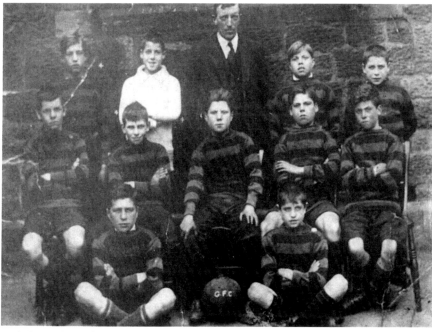

Jack Casey (seated centre) skipper of Gray School football team in 1922.

Jack also fought the great Len Harvey but lost over fifteen rounds. Jack, who was given two nicknames by his fans, the Assassin or Cast Iron Casey, had a total of 224 bouts losing 61 and drawing 15. He was never put on the floor in the ring but was stopped eight time inside the distance, losing his last fight that way to Martin Thornton on 22nd February 1942.

In 1939 Jack joined the King's Own Scottish Borderers and later became a lance corporal in the Garrison's Military Police.

Shirley Ritchie better known as Atta Matta

He also had his own gymnasium based in the Golden Lion Hotel in High Street. Although he was never knocked out in the ring, it is rumoured that he was knocked out by a WOMAN. The story goes he was arguing with the woman in the Argo Frigate public house in Sunderland, and the lady hit him over the head with a bottle and knocked Jack out. The lady was none other than Shirley Ritchie, better known as Atta Matta. Can this be true?

Atta Matta sketch by Ray Storey, 1955.

Pryde's Bakery

A Ha'penny Iron Ore Boat

It's 12 o'clock; I'm out the gates, two farthings in me coat
A lang to Pryde's Bakery for me ha'penny iron ore boat
A na I'll pass Puffy Howard's and past Ernie Robinson's al
float
Gannan strite to Pryde's Bakery for me ha'penny iron ore boat
Al run past Bull's back lane, with its slaughter house of note
Cos nowt's ganna stop me get me ha'penny iron ore boat
Strite past Bramwell Street where al watch the bairns gloat
While a gan to Pryde's Bakery for me ha'penny iron ore boat
Av got Metcalfe's paper shop in sight and the New Shades is
on the right
Is that a clinkin' in me coat, am almost at the bakery for me
ha'penny iron ore boat
Kitty Walker shouts ower, "ya need a haircut, Matty"
Titchy says "forget the cost, al de it for wots in ya coat"
If uses them two farthings for my ha'penny iron ore boat
Ne chance I shout back at Tichy as carried on and ran
This for my iron ore boat and ya na where it's ganna gan
A get to Lightfoot's chemists, the bakery is just next door
A ran strite into a shopper who knocks me farthins on the floor
I'm almost in a tizzy when the baker says dinn't fret
If yav cum for ya ha'penny iron ore boat am sorry we've got
neen left
Ah they not bringin any more, a said with tears in me eyes
Not today said the baker they only fetchin' pies
A might as well gan yam for me dinner a said with a git lump
in me throat
When the woman shopper got off the floor and pulled from
under her coat
Just gi me ya farthings and ya can hev this iron ore boat
It was good, it was great an a could de wat a normally de
Sit outside the Ivy Leaf with me iron ore boat on me knee
Ad eat slow and bit by bit but it wadn't tak uz long
Ad even ad time to listen to the turn as they sang one last song
Then back past Kitty's fish shop "hev ye got any chips left"
Ah always used ta say "well that's your fault for makin so
many"
Ad say it ivery day, it was what Kitty would expect
Cos a always played the fool then away ad gan along the road
Back ta Hendon Board School

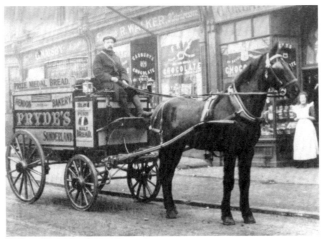

Pryde's delivery at Grangetown about 1920.

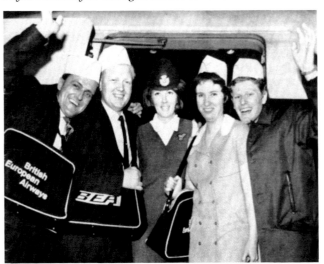

From left: Stanley Fraser 39 years and Keith Brannigan 24 years, both from Pryde's Bakery on their way to Gibraltar Saturday 5th July 1969.

Mary and Jack Donkin, pride of Pryde's employees that was Jack.

An advert for sliced bread from Pryde's Bakery. Otto Rohwedder perfected his sliced bread cutter in 1928 and two years later the first sliced loaf went on sale called 'Wonder Bread'. I'm not sure if Pryde's took a slice out of Otto's product's name for their bread but 'Wonderloaf' by Pryde's was born about the same time.

Who made the iron ore boats? Not the ships but the famous cakes. How were they made? Mrs Ellen Pryde, widow of the late Mr Gordon Pryde let out the secret of how it all started. William Campbell Pryde began baking bread for his neighbours in and around his home in Coronation Street in 1906. He used one room in the back of the house at first and then some shopowners came and asked him to bake for them and so the business began to expand. William had three sons, William who took on the clerical side of the business, Robert the transport and Gordon who was the baker. The business got so big that the bakery was the whole of Zion Street block in Coronation Street, but the one room where it all started was still in the bakery, one

large roofing beam that William Campbell Pryde insisted would remain until the factory was no more.

The transport in the very beginning was just a home-made barrow with a big box on the top which carried the bread to the homes and shops of the customers, and then more barrows and barrow boys, horse and carts and then the motor vans which delivered to the larger shops.

At one time Pryde's Bakery was the largest bakery in the North East, which unfortunately began to attract bakeries from the outside, such as Spillers. By this time William Campbell Pryde's grandson, Gordon

Ellen and Gordon Pryde having lunch with someone else's bread.

Pryde, was chairman of the company having taken over from his father Joseph Holmes Pryde who had retired for health reasons. Gordon was determined not to sell out to Spillers and keep the business in the family. However, sadly Joseph was to pass away due to a brain tumour and Gordon did give in to Spillers. The bakery had already been making bread for other companies and putting it in the related companies packages, so when Spillers came along it was easy to revert to Wonderloaf. Gordon Pryde was given the Managing Director's job but sadly he passed away in tragic circumstances, collapsing in his garage at home, aged fifty. Gordon was the only son, and grandson. His other uncles, William had two girls, Valerie and Patricia, and Robert had four daughters. Gordon and his wife Ellen have a married daughter, so Ellen Pryde is the last surviving Pryde.

Inside Pryde's about 1960, John Fraser baker (centre).

The secret of the iron ore boat. I always assumed that they were made from all of the cakes that were taken back to the bakery that hadn't been sold in the shops that day. I was almost right. Pryde's used to make, what were called sly cakes, and they were made in slabs, to cut the slabs into three inch squares, a machine was used, and when the machine cut the cakes, it left the edges of the slabs. These edges were put back into the mixer and out came the beginnings of the iron ore boat, put a thin cover of sweet baked bread over the top and hey presto, a ha'penny iron ore boat.

A Brief Childhood

Corrie Barber

Michael Dalton left St Patrick's School at the age of 12 to start work at the shopfitters Coutts & Findlater's in Hudson Road (they are still there today).

Growing up, Michael always loved horses and at one time thought he might become a jockey. When he had a wage coming in he decided to buy a horse to race locally. Each week he handed the 'horse money' over to his mam, Anna, for safe keeping. Anna was a real East End character and liked a drink and when cooking at her Coronation Street home she would even put Guinness in the pies. After two years he asked how much he had saved and she replied "Nothing son, its spent." Michael was soon to meet a tragic end. He had not reached his fifteenth birthday when he hurt his leg playing football in St Pat's playground. He had his leg bandaged but complications set in and he died.

Harry Dalton

Henry Dalton and his son Michael at home in Coronation Street around the time of the First World War.

COUTTS & FINDLATER Ltd.

SHOPFITTERS & CABINET MAKERS

15/16, HUDSON ROAD, SUNDERLAND

At the bottom of Coronation Street in the East End, stood, or rather stuck out of the wall on the side of a shop was a red and white striped pole. Over the door was the name of the owner barber John Armbuster. He was definitely a very good barber by reputation as his customers who came from far and wide proved. The thing that made John stand out from other barbers was his nickname – the American Eyebrow Cutter. I don't know where he got the name from but it was certainly unusual.

Grandma Sloanes née Dodds and daughter Mary Curtis née Sloanes in St Leonard Street.

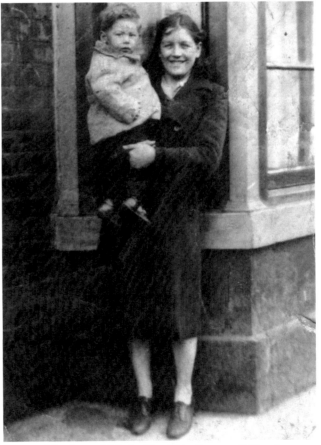

Doreen Fletcher with baby David in Bramwell Street.

Local Shops

Watson's shop, Norman Street.

I'Ansons sweet shop, later McCarthy's off licence,
Burlington Road/Suffolk Street.

Moore's Store

Moore's had a store at the bottom of Ward Street, on the corner of Suffolk Street. It sold all kinds of loose food, such as cheese which they would cut to the size you required with a strand of very strong wire, butter, margarine and corned beef. Everything that needed cutting was cut with this wire. They sold loose tea in ounces, cocoa, tinned powdered eggs, milk, basics of all kinds, and all cheap, sometimes without the coupons when the ration book was still in force. Amos was the manager of the shop and he was a very strict man and he made out that children were not welcome in his shop without being accompanied by an adult. But we kids of Ward Street found out that Amos had a soft centre. The shop used to sell all kinds of biscuits, and plenty of them. Well with all the dipping into the various tins lots of biscuits would get broken and Amos, trying to show people that he was being thrifty, would put the broken biscuits in a separate tin and attempt to sell them off at a cheap price. And where would he put this tin? – right in the front door, so anyone would have access from the outside of the shop, and who had the easiest access? – us kids, and although he would see us do it, he would give us a few seconds, and then shout at us to get away but he would leave the tin where it was and it would be there again the next day ready for us to make our move. As long as I can remember that tin was there and none of us kids were ever caught. I'm sure Amos put the tin there for us. Thanks Amos.

Right: Louis's stores in Hendon Road as seen from Charlton's pub. There was no need to go shopping in the town centre when you had Hendon Road with the likes of Louis's which seemed to sell everything.

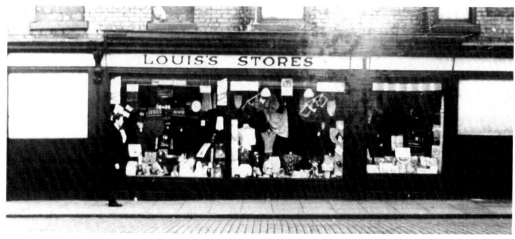

Sweet Shops

Even when times were hard a halfpenny or penny could always be found to spend in local sweet shops like Matty Wilsons, Craggs, I'Ansons and many more. We nicknamed sweets – bullets, sweeties, chummies, bubbers or ket. Among our favourites were: pineapple chunks, sherbet dips, sherbet flying saucers, liquorice roots, gob stoppers, sarsaparilla tablets, black bullets, Palmer violets, Spanish, Trebor chews, jelly babies, taffy cakes, taffy apples, cinder toffee, liquorice allsorts, dolly mixtures, sherbet lemons, Holland toffees, imps, fisherman's friends, victory V's, rainbow drops, liquorice torpedoes, bulls eyes, midget gems, wine gums, candy whistles, mint humbugs, candy cigarettes, chocolate cigarettes, chocolate baccy, aniseed balls, oxo favoured crisps, jubblies, pink bubble gum, PK gum, beechnut gum, jelly dummies, wiggly worms, chocolate mice, liquorice laces, red laces, pear drops, acid drops, butter scotch, love hearts, sugar almonds, mint imperials, Pontefract cakes, walnut whirls, cubes, sour lemons, lemon drops, lemon jiffs, strawberry jiffs, ice cream cornets with monkeys blood, treacle toffee, banana split toffee, jelly tots, jelly beans, chocolate peanuts and zubes.

Charabanc trip to Blackpool 1954, left to right: Peggy Armour née Oliver, her mam Maggie Oliver née Sharpe, her father James Swales Oliver and unknown.

Left to right: Kitty Walker, Tommy Fletcher and Doreen Fletcher.

An advert for this well known grocers from 1948.

Tommy Bowens and wife Cathy née Rock, Henry Street.

Working Life

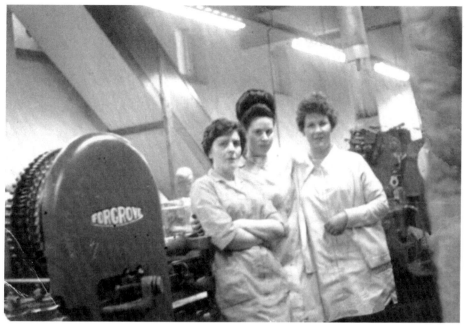

The sweet factory in Hendon Road, left to right: Gina Davison, Irene Mariner and Doreen Adler.

Phyllis Sharpe, telephonist, born 14th May 1904 at 8 Henry Street and died 28th February 1994 in Hull.

Rag and Bones

I remember the old rag and bone yards in Hendon. Even in the 1960s they would still take bones although it was mainly rags that people took in. One of these yards was run by a woman and she would separate the more valuable woollens from the linen. She might pay sixpence or if you were lucky a shilling.

John Kirkwood

Woollen Raid

We lived in Christopher Street in the 1960s and one day a wagon came collecting rags. It was packed and its contents had to be tied down with ropes. When the driver went into one of the houses a load of kids piled on the wagon and started to pull out the woollens. They were climbing all over it like monkeys.

Terina Kirkwood née Chapman

Above: John 'Bull' Rennie at work. At one time tatters were a common sight on the streets of the area.

Left: Bobby Carroll, the rat catcher.

Pasqual 'Peter' Someo

'Highstacreee.' That was the high pitched cry that could be heard around the streets of Hendon every evening during the week, and, during the daytime every Saturday and Sunday during the 1940s and '50s. Every child of the time knew that it was the ice cream man Peter Someo, his little push barrow, brightly painted, red and cream, would be full of wafers and cornets, ready to be filled with his lovely ice cream and sold for a halfpenny.

Pasqual Someo, Peter, was born in Italy, in a place called Capra, which is about 25 kilometres from Naples. Peter's cousin, Pietro, was already in England and had been married. He and his wife Elizabeth had four children, all girls, Mary, Elizabeth, Mariana and Pasqualine. When Pietro's wife died suddenly Pietro asked Peter if he could come to England to help to look after the children and Peter agreed. The times were hard, but, together and along with people coming in to clean and do the washing, Pietro and Peter managed and even started a business. One would look after the children while the other went around the streets of Hendon buying and selling anything that came to hand. The business was small at first selling ice cream and when there was no ice cream to sell they used to sell boot polish and laces but things got better through hard work. Sadly, Pietro passed away and Peter was left to bring up the children on his own and so even though the children knew different, they began to look upon, and call Peter dad. Eventually the children grew up and Pasqualina, in 1943 met and married Jack Gettings. They had five children, one of whom became a classmate of mine, Sheila Gettings, who gave me this information. When Sheila and her other siblings were growing up, because Peter was around so much he was looked upon as the grandfather, and so that's what he was called.

Peter Someo and his daughter Mariana Carr.

Peter opened a shop in Addison Street East, selling all kinds of confectionery, but mainly the ice cream, as at the time sweets were on ration and so people found it easier to buy the ice cream. Every Thursday Peter and granddaughter Sheila would make their way to Pucci's ice cream shop in Coronation Street to make his ice cream and use their freezers. Then on the Sunday they would pick up the ice cream then make their way back via Lawrence Street, Woodbine Street, Pemberton Street, East Street, along past the Town Moor, and under the arch at Hendon Station and into the shop, and for this Sheila got two shillings. When Peter opened a shop near the Parade, opposite the Oddfellows pub, he used to push his barrow from Pucci's around the same route, but then went on to push it up Noble's Bank, leave some ice cream in the shop, and continue along Commercial Road and around Grangetown. On one of his rounds Peter used to come into Bramwell Street but by this time he was getting old. As he got near the Maple Bar I could hear his cry, 'Highstacreee!' and I would be there to meet him at the bottom of the street. I would help him push his barrow up Bramwell Street, over Hendon Road, up Ward Terrace and up both Ward Streets, and I would leave him there because my Nana Oliver lived there. For pushing him I would get a free cornet, which I was happy with, until years later Sheila told me she got two bob! When I got a little older and went to work my brother Jimmy took over

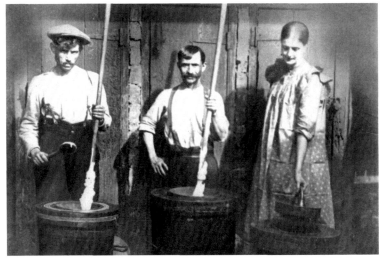

Above: Left to right: Peter Someo, Pietro Someo and his wife Elizabeth making ice cream.

Right: Pietro Someo cousin of Peter Someo.

and he and Peter became great friends. Peter carried on day in day out doing these rounds until he was 75 years of age, not one complaint and not an aching bone in his body. Peter used his leisure time at an allotment in Corporation Road, growing different produce including grapes and special Italian tomatoes along with the normal potatoes and turnips. One of his quirks, which surprised his family, was to bring home snails, and of course cook and eat them. Peter lived off the land and used all the old wives' remedies for ailments. If you had a cold then around your neck went the garlic. Vinegar baths if you had a temperature. Peter loved his pint and spent a lot of time in the Maple Bar, not drinking a lot but, he

Peter at the top of Noble's Bank Road with the famous barrow.

did enjoy a game of dominoes. Unbeknown to Peter his skill in dominoes was to make his name famous. Whenever the game would end and a count of the spots was needed to decide the winner, invariably Peter would be holding double blank. How it happened is not known but he always had it. Forever after that the double blank was known as the Peter Someo, even to this day.

Every year the Sunderland ice cream men, Pucci, Nortrianni and Peter Someo would take a trip back home to Italy. For three reasons as far as Peter was concerned. To see his immediate family and to see his adopted daughter Mary and his two grandchildren.

In October 1971 Peter had a freak accident. He fell as he was trying to sit down on a stool and broke his hip. Being of the age of ninety, as he was lying in hospital, pneumonia set in and Peter passed away. Although he never married, and never had children of his own, he loved all of his adopted family and apart from all his grandchildren and great-grandchildren, he was survived by the hundreds of children of Hendon. They loved him as though he was their own.

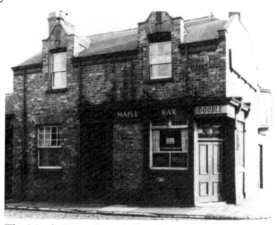

The Maple Bar – Peter's 'local'.

Sheila Gettings with her adopted grandfather Peter Someo.

Jack Gettings' baby Ann Pasqualine Gettings and young Jack Gettings and Sheila Gettings.

Sheila Gettings and Ann Wilson, Henry Street, 1957.

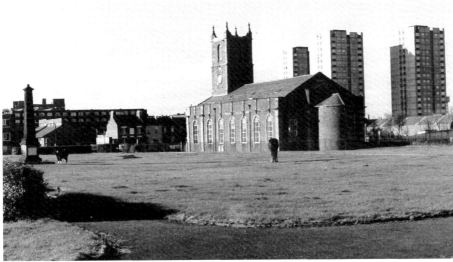

Top left: A view of Holy Trinity Church looking west with the high rise flats on High Street East.

Top right: Gordon and Brian Ganley outside Holy Trinity Church.

Right: Brian Ganley and wife Ann née Jopling with bridesmaid Maureen McCarthy née Carson. The couple were married at Holy Trinity Church on 29th July 1967. This was reputed to be the last wedding to be performed at Holy Trinity. Today the old church is only open on a handful of occasions each year.

Caroline Amelia Smith née Oliver, born 26th March 1902 died 1st December 1987, with her children, left to right: Nora aged 7 years, Winifred aged 1 year and Edward aged 4 in Sans Street.

Margaret Ellen Oliver née Sharpe and her husband James Swales Oliver. Margaret Ellen was born 15th November 1897 and died 16th April 1965. James Swales was born 29th November 1897 and died 14th November 1955. They married on 11th November 1918.

George Henry Farrell and his wife Elizabeth Jane Abernethy and daughter Mary Jane. George and Elizabeth were both born in 1897. They were married 21st September 1918 and Mary Jane was born 25th November 1919.

Wartime

The Lodge Terrace Incident

In the early morning of 24th May 1943, the last, and the worst, air raid of the Second World War took place in Hendon. The area involved was Lodge Terrace. The terrace ran from Railway Street at the top, down to East Hendon Road at the bottom. It was the four houses at the bottom of Lodge Terrace that were to sustain the worst damage, being totally wiped out, as well as a purpose-built air raid shelter. Seventeen people were killed in the raid. These included seven children of 15 years and under. One person died in Cowan Terrace First Aid post. Two died in the Royal Infirmary and twenty-three people were seriously injured including nine children under fifteen years old. Eight people were seriously injured. In the Municipal Hospital one child under fifteen and two people who were attending the out-patients department in the Municipal Hospital died, making a total of fifty-three people either killed or injured in the raid. As throughout the war in Hendon, many heroes had sprang up, and it was no different in this case although it would only be fair to mention them all, there is only room for a few, like Billy Ord, one of the fire watching crew, Mrs Mary Sweeting and Mrs Adelaide Hutchinson, along with the many other heroes they worked tirelessly to free the injured and the dead without any thoughts for their own safety. This extract is from a report written in May 1993 by a William Miller. I urge people to try and obtain a copy and read it.

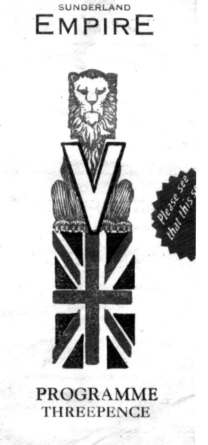

SUNDERLAND
EMPIRE

Please see that this s

PROGRAMME
THREEPENCE

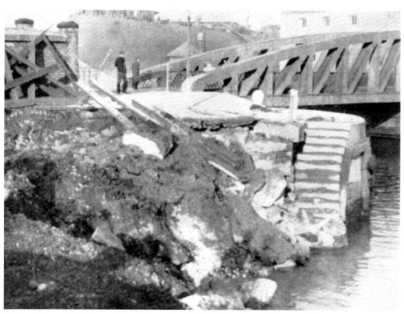

The aftermath of an air raid on the Docks in 1941. The Docks were a prime target for German bombers in the Second World War.

A Sunderland Empire programme from 1944. Entertainment continued throughout the war years. However, there were differences from peacetime – the programme had a warning about what was to be done if there was an air raid during the show (below).

AIR-RAID PRECAUTION
Should an Air-Raid Warning be sounded during a Performance, an announcement will immediately be made from the Stage. Those desiring to leave the Theatre may do so, but the Performance will continue.

Evacuees

It's difficult for me to imagine what the other kids, unlike myself who was left at home, felt like when they were taken away from their home and evacuated to the other side of the country for safety during the war. Some were as young as only three or four years old and often on their own. Some had brothers and sisters with them at first but often they would be separated because the family that were taking them could only manage one child. While some children would settle to their surroundings after a while quite a few were so homesick they became very ill and would eventually be brought home. The children who were not evacuated, for whatever reason, were sometimes lucky, but not all. We just have to look at some of the rolls of the dead scattered around our city to see how many of our children were lost during that terrible time.

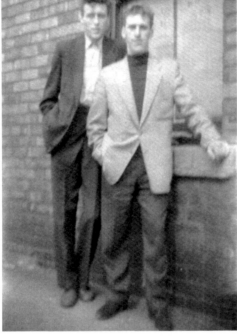

Above: An early picture of Wetherell's dance hall on Bishopwearmouth Green. It was a popular venue well into the 1970s.

Right: Before Teddy Boy suits – John Dobson and Alex Sloanes in Salisbury Street, in the 1950s. Are they off to a dance at Wetherell's?

Ginny Moore (left) one of Hendon's most famous characters. She ran a second-hand shop in Borough Road for many years.

Alan Oliver and Elsie Oliver née Bargwell on their wedding day in 1956.

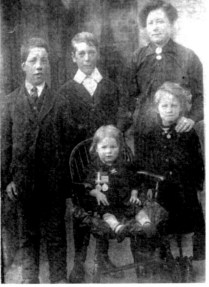

William Hold aged 26 years, born 25th October 1899, Coronation Street.

Left to right: William Hold, born 24th April 1904; William Hold, born 25th October 1899; their mother Elizabeth Ann Cheales Atkinson formally Hold née Olson (in the chair); Whilemina Atkinson, born 8th May 1914 and standing Noreen Atkinson born 23rd February 1910 Coronation Street.

Elizabeth Ann Cheales Atkinson formally Hold née Olson. Born 7th June 1872, died 28th June 1933, Emma Street

Fred Stratton

The Burton House public house in Norman Street was at one time run by the Stratton family – Fred and Mary. On 6th April 1919 Frederick William Stratton Jnr was born there and he was brought up in the pub. In 1939 Fred went off to war with the 11th Regiment DLI. He was taken Prisoner of War and was held in Poland near the Russian border. In 1945 Fred returned to Sunderland and with his payment from the Army he purchased his first vehicle – an ex-MoD coach – in which he transported workers to Consett Iron Works.

The name Redby was derived when Fred and Mary couldn't agree on a name so it was finally decided to name the company after the area where they were living in Sandringham Terrace which was known as Redby. (Redby School stands nearby.) Fred began to do tours at home and abroad with his first tour overseas being to Belgium in 1958.

Fred passed away in 1991 aged 71 years. His daughter Jean now runs the family firm which is based in Hendon.

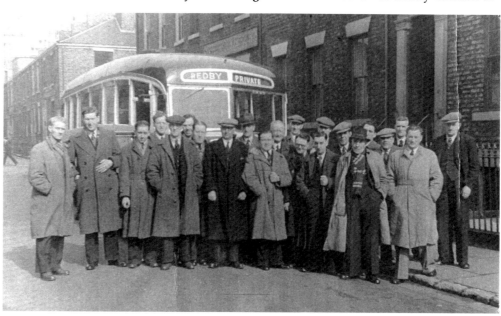

A Stratton charabanc trip to Catterick races from Frederick Street Workingmen's Club.

Above: Redby Bus & Coach Co – still going strong after more than half a century.

Left: Fred Stratton with grandson Neil who is now a company director.

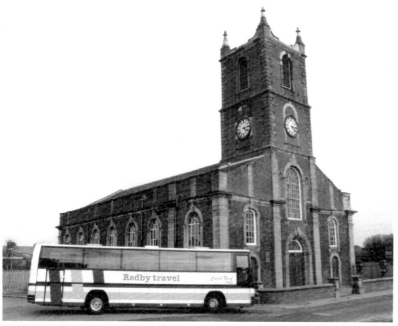

Redby coach outside Holy Trinity Church.

Fred Stratton relaxes with a spot of accordion playing.

George Tyson

I was born in Addison Street, East Hendon and attended Hendon Board School from the age of 5 years until I left at the age of 15 years. I believe I was well educated while I was there and influenced by many of the teachers, but especially by the sports teachers, Jack Washington, Mr Hopkirk and later Mr Liddle. I was impressed by the then headmaster Mr Mountford, a big powerful man but a fair man. Miss Wright was my teacher as well as my older brother Norman, who is 5 years older than me, and she also taught my father. I

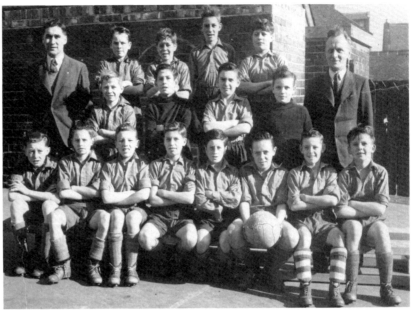

was always interested in most sports, football and cricket being my favourites. I played regularly for the school teams, juniors and seniors, and when I finally left school I had trials with Ebor football team which was a very successful side. I eventually became captain of the team in its most successful season when we won League and the Knock-out Cup. The centre forward at the time was a school friend of mine Bobby Sumner. It was at this stage Sunderland AFC came and invited me for trials. This was in the days of Alan Brown and I was training over at Roker Park, and then had my trials at Hendon Cricket Ground. I got through the trials and was with Sunderland for about six months. The reason I left was that I was playing for South Hetton and they were in the same league as

Hendon Board A Team 1950. Back row, left to right: D. Innes, R. Sumner, J. Reekie, J. Telfer. Middle row: T. Miller, R. Fothergill, R. Gardiner, C. Moore. Front row: J. Wilson. D. Lindsey, R. Lowes, A. Lund, A. Usher, T. Bowens, R. Croft and G. Tyson.

Sunderland 'B' team and at the time a player was not allowed to play for two teams in the same league. At the same time I think I realised that I would not be good enough to make the grade, so I gave up any thoughts of becoming a professional footballer and returned to the local leagues playing for Bishops Old Boys. I notched up my hundred goals because I was a goalscoring inside forward in those days. I was about 25 years old by then and injuries, such as broken legs, strains and pulled muscles were becoming more and more frequent. Many times when we would turn up for a game we would be short of a referee so I thought I would give it a go. On 12th December 1965 I took out my referee's ticket, class three, and went to train in the Wearside Combination League. I took my first game in the December, in the middle of the season, and I

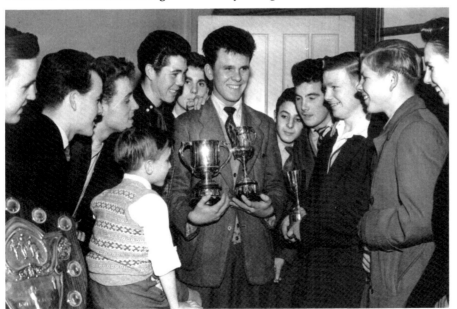

George with two trophies – the John Askew Memorial Cup and the YOC Minor League Cup 1955-56.

hated every minute of it so I went back to playing until the end of the season. At the beginning of the next season I thought I would give refereeing another try. This time I was more at ease and went from class three to class two to class one in successive seasons, progressing through the local leagues first and then on to firstly running the line in the Football League. This was in 1973, and then I stood still for a while, taking the middle in the Northern League and then the line in the Football League. I caught on that it was probably my fitness

that was at fault, so I trained and trained running every weekend and Bank Holidays whenever I was able. Although it was to take another four years, in 1977 I was invited to London and I was elected to the Football League. I also changed my job as I was working for a private company and they weren't too keen about giving time off so I went to work for Sedgefield District Council, as Building Manager. Eventually retiring 10 years ago as Director of Works and Leisure. So I had 20 great years working for Sedgefield who were great at giving me time off for refereeing, especially when the football programmes would say referee George Tyson, Director of Works and Leisure Sedgefield District Council.

George before a match between Everton and Norwich City at Goodison Park. The two skippers are Kevin Ratcliffe (Everton) and Steve Bruce, now manager of Birmingham City.

My first match in the middle was 23rd August 1977, Barnsley and Torquay. It was a beautiful sunny day and I was feeling really fit and up for the game but when I finally got on the pitch my legs went to jelly. I became so nervous but I got through it alright and went on for another 17 seasons refereeing all over the world. I took a number of international games, Scotland and Peru, and I also went out to Korea for three weeks for the pre-Olympic tournament in 1988, being the representative from England. I was lucky enough to have two Wembley Finals. I refereed the Freight Rover Final between Bristol City and Bolton Wanderers in 1986, and to walk out on to that hallowed turf was simply just amazing. In 1988 I was senior linesman in what I would describe as the 'Ragged Arse Rovers against the Best Team in the World', Wimbledon against Liverpool, and it was me who flagged for the incident that led to the cross that Sanchez of Wimbledon headed in the winning goal. I also refereed a Cup Final in Egypt because the Egyptian Final was so volatile, none of the Egyptian referees would take the game, and the Egyptian FA had to invite referees from all over the world to take the fixture, so this time I was invited. I was out there for four days and it was absolutely great. I had become, by now, one of the top four referees in the country and the FA were about to experiment with the retirement age of referees. The retirement age was at the time, as it is now, 48, and the FA were trying to extend it provided the individual was still fit enough. I was lucky enough to get an extra 3 years and I went on until I was 51 years old but FIFA was not too pleased and insisted that referees' retirement age would remain at 48 years. I think it is ludicrous that if you are keen enough, good enough and fit enough, then you should be allowed to continue until you're not able to do the job correctly. Anyway I had to retire and then I became a referee assessor for the Football and Premier Leagues, and continued for sixteen years, and last year I was told that now the assessors have to retire. Now I take retirement seriously and now have a new love – golf.

I was asked the question, 'Can you hear the comments shouted by the crowds during the game?' In fairness, when you're at Crewe or Hartlepool where the crowds are small, yes you can, but at the likes of Liverpool or Manchester United, no. All you can hear there is the noise. I would comment that the discipline in the Football League is much better than in the local Sunday morning leagues. In the local leagues it is becoming a serious concern and it must be taken to task as soon as possible.

In my private life I met and married Christina in 1963 in All Saints Church, Fulwell. We have two children, Helen the elder who has two children, Grace aged 14 years and Cameron aged 11 years, and my son John aged 37 years. So you can see I have been very lucky in life. I have a wonderful family around me and I have had what I would call a successful career. Can you ask for more?

George Tyson, July 2006, referee 1963-2005.

Working Life

TIMBER

This old Hendon timber firm is still going strong today.

The Docks employed many local men in its heyday.

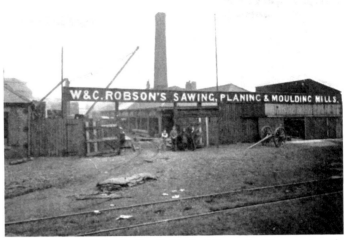

Robson's saw mill in the South Dock at the end of the nineteenth century. At this time they supplied local shipyards, collieries and engineering firms.

The gasholders on Commercial Road dominate the skyline.

A pan manufacturers in the East End.

Local Shops

William Hold, Coronation Street 1890.

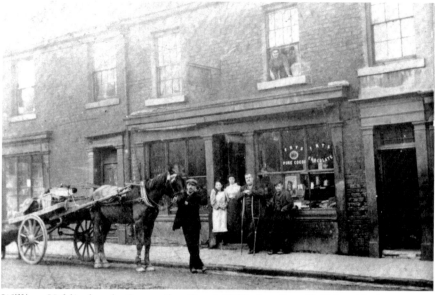

William Hold's shop in Coronation Street, 1890. Jonathan Hold is with the pony and trap.

Hendon Road Shops

Some of the shops I remember in Hendon Road when I was growing up in the 1950s were: Metcalf's newsagents, Sinclair's greengrocers, Lightfoot's chemist, Ballbach pork butcher, Kemp's stores, Atkinson's music shop, Tichy Dixon barber, Bernstein's clothes shop, Pryde's bakery, Grey's drapers (*right*), Bucknell's pork butchers, Moore's grocers, Fitzpatrick's sweet shop, Fella's ice cream, Veities pots and pans, Thompson's Red Stamp store, Pucci's ice cream shop, Valenti's ice cream shop, Crossley's flower shop, Little Ginny's sweet shop, the Co-op, Noble's sweet shop, Ernie Robinson's upholsterers, Patsy Gallagher's sweet shop (formerly a chemists), 'Puffy' Howard's cake shop and Florrie Watson's pie shop.

Left: Joplings & Tuer's store at the bottom of High Street in the 1890s. Sunderland's most famous surviving department store began life in the East End in the 1820s when it was founded by Thomas Jopling and Joseph Tuer. In the 1880s the business was bought out and traded as Hedley, Swan & Co but still used the name Joplings. They remained in this store until after the First World War when they moved into premises further up High Street. They remained here until a disastrous fire in December 1954 forced a move to purpose-built premises in John Street where they remain to this day.

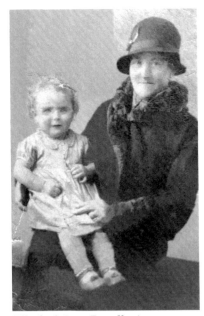

Elizabeth Jane Farrell née Abernethy with daughter Mary about 1920 Surtees Street.

John Abernethy and his wife Jane Ann Todd. John was born 20th September 1868 and died 1904. Jane Ann was born 19th September 1872 and died 1904. They were married on 4th August 1891 St Ignatius Church.

Ellen Bridget Blenkinsopp née Docherty born 30th January 1880 died 16th February 1940 married Robert William Blenkinsopp 21st January 1901.

Laying Them Out

Around most of the streets in Hendon in the event of someone dying there were special women whose purpose was to ensure that those who had passed on were given a respectable send off, regardless of their family's situation. Rich or poor the individual would be looked after. The special women had in their possession a set of sheets that would be used to 'lay out' the deceased. After bathing them, and using some kind of make-up, the person would be looking as well in death as they did throughout their life. What came after one such laying out got me right into trouble. My mam carried out one of these 'laying out' procedures, and afterwards she was preparing to take the sheets to the cleaners so that they would be ready for the next time. After they came back from the cleaners some people would put them in the pawnshop 'for safe keeping'. However, this day my mam had left the dirty sheets on the chair, and I came in and saw them lying there just as the rag and bone man shouted that he had balloons for rags. Out went the sheets for a balloon. As I was coming back into the house to show off my present, my mam was running down the stairs going off her head. She had very quickly realised what had happened to the sheets. She grabbed my balloon and went running after the rag man who put up a fight to keep the sheets. Mam won easily, both times, once against the rag man and the second time when she beat me.

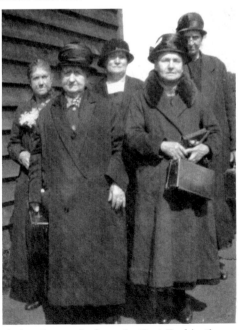

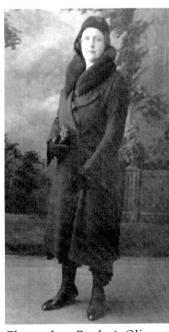

Lizzie Smith on her way to fill her can.

A charabanc trip from the East End in the early 1900s. Lizzie Smith (front left).

Eleanor Jane Reed née Oliver born 4th November 1893.

Samson Besford by Joe Ashton

Joseph Besford lived at the bottom end of Henry Street and was known as Samson because of his outstanding feats of strength. Sometimes he used to perform these demonstrations in his back yard and one particular feat I observed by looking over the back wall. Samson, with a large shovel extending out from each hand, had a woman on each end of the shovels standing on the spade end being lifted up to his waist-height.

He used to perform on Hendon Burn by letting a fire engine drive over his chest. He competed in the British Strong Man Championships held in London and came second to a Mr Edwards of London. Edwards was very good at bending six inch nails but wasn't as good as Samson in the heavy lifting stages but still Edwards was crowned champion.

Joseph 'Samson' Besford, Henry Street.

Samson would have six men on either side of him holding a rope which he would have around his arms, and the men would try to pull his hands apart without success. Rumour has it that he wanted to jump off Sunderland Bridge into the water, but after police advised against it he decided not to.

I have tried to find out, in vain, if Samson attempted the New Year's Eve Race. The race was held along Fawcett Street every year, from the bottom corner of Borough Road to Mackies Corner at the top of High Street. The race began on the sound of the first gong of the Town Hall clock and ended on the twelfth gong, by which time the runners had to be at Mackies Corner. I not sure if Samson took part at any time or if anyone ever won the race.

Joe Ashton, footballer, cricketer, darts and domino player.

Someone once said memories are like roses in winter, and we have many famous roses connected with Sunderland, Kate Adie, Raich Carter and Bobby Gurney, and I also count Joseph 'Samson' Besford among those roses.

A mangle of mangles, Samson Besford's toys.

Breeding Them Strong

Henry Street and Henry Street East in Hendon must have had something special in the water or the residents were being fed extra rations during the war. There was not one strong man, but two. Although living in two different streets they were only three doors apart, Samson Besford living in Henry Street, in the last house, and over the road in Henry Street East, three doors away was Jacky Scott. Little is known about Jacky and his exploits as he never showed what he was capable of in public but to some of the locals he proved to be at least as strong as Samson. Jacky was able to lift and hold waist-height, in each hand at arm's length, eight stone weights, the kind used for weighing bags of coal. He would hold them for as long as five minutes, a very difficult feat. He could not only bend inch thick pokers, but straighten them back out when he was finished. They build them well in Hendon!

Matty Morrison

I was born in Highfield General Hospital in September 1942. My home address was 92 Ward Street, Hendon where I was living with my mother; my father was still away in the war. I was to live most of my young life in Ward Street either with my mother or for the most time with my grandparents Jimmy and Margaret Oliver, who lived a few doors away at number 103. I started Hendon Board School when I was 4 years of age and, but for a brief period of time when I attended Hylton Road and Diamond Hall Schools, I was at Hendon until I left at Christmas 1957. At first I wasn't very good at school, either at sport or academically, but when moving into the seniors and meeting Jack Washington the teacher, my whole outlook changed, I began to take an interest in all the sports including gymnastics, cricket and boxing, but strangely not football. I began to take an interest in music, maths, English and science; so much so that when the time came to leave school I suppose you could say I was reasonably educated. I should have left school in the summer of 1957, but because my 15th birthday fell on the Tuesday 6th of September

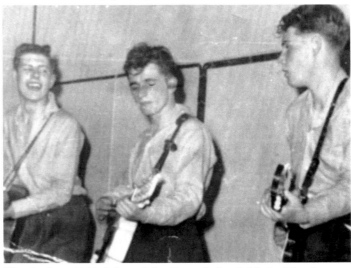

The Avalons 1960, left to right: Barry Ireland, Matty Morrison and Tony Corless.

the day after the school returned from summer holiday I was forced to continue going to school until Christmas. However, because I had passed all my exams in the summer, I had nothing to do, and for long periods I spent my time in an empty classroom studying science. However, for the three months from September to December I spent most of my time away from school and took to working, mostly on a farm, picking potatoes or snedding turnips or feeding the beasts. I also joined the circus for a short time, also looking after the animals, but I did return to school in time to leave!

After I left school I got a job working as an office boy at Batrams Shipyard and when I was sixteen I was offered an apprenticeship as a caulker and burner at Bartrams. When I first started my apprenticeship some of my family were already working there. My grandfather, who had passed away two years earlier, had worked for some years on the rollers in the shed, and his sons, my uncles, were still there, the oldest a plater's helper and the youngest a burner. On my first day one of the older men asked me if I was old Dan's grandson and I replied that I certainly wasn't related to anyone called Dan. The next day someone said that I must be Dan's son and once again I said that I didn't know anyone called Dan. On the afternoon I was having a can of tea with the younger of my uncles when someone asked him who I was. 'He's my nephew,' said my uncle, to which the person retorted that he knew I was some relation to old Dan – his grandson. My uncle just started to laugh, apparently, my grandfather was known as Old Dan, my older uncle was known as Dan and my youngest uncle was known as Young Dan. All the more weird when my grandfather's name was Jim, my oldest uncle was Jim, and my youngest uncle was Allan. I'm pleased I found out as I was sure to have become known as Little Dan. Fortunately for me I was sacked for being off the job and was able to leave with my senses intact.

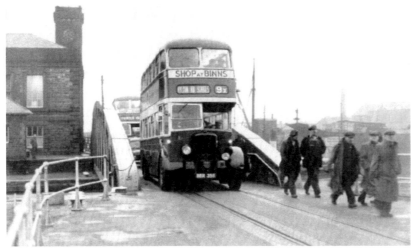

Workers coming from Bartrams Shipyard.

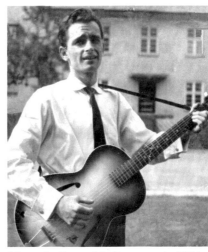

Matty in Detmold, Germany in 1961.

I then went to work for fairground people, in particular Claude Cooper who had a bingo stall and various other show pieces. He bought an arcade up in Spittel near Berwick and, along with Jimmy Wynn I went and decorated it. This was in 1959 and when we finished the arcade it was around wintertime and so I came back with Claude and wintered up with his family in Esh Winning, Durham. In the spring of 1960 the fair came to the Burn in Hendon and in the process of building the machines and stalls I had an argument with Claude and went straight up the town and joined the Army. I enlisted in the Royal Electrical Mechanical Engineers as a mechanic in May 1960. It was while I was doing basic training that I met up with Tony Corless who taught me to play the guitar and eventually formed a group called The Avalons, made up of Barry Ireland, Terry Whitmore and Norman Percival and myself. We were reasonably successful playing in and around Taunton in Somerset. However, it was not to last as Army postings broke us up as they went to Hong Kong and I was posted to Germany. I served in Germany, Cyprus, Thailand and other countries. It was while I was in Germany that I met a lad called Allan Thompson from Grindon and he couldn't believe that coming from Sunderland I wasn't interested in football, so, him being a corporal and me a craftsman he forced me to play, first for the company team, and then for the squadron. I couldn't believe how much I came to enjoy playing, and how reasonably good I was to become at it, eventually playing for the regiment and BAOR.

Squadron Army Air Corps driver RCT, left to right: cook AAC, store man RAOC and Matty Morrison mechanic REME.

I left the Army in May 1966 after six years service and took up employment as a mechanic for Adams and Gibbons in Paley Street, but couldn't settle. After taking on many other jobs as a mechanic, as a long distance driver and as a local driver for a builders' merchant F Keys, I eventually went as a bus driver. Initially for the Sunderland District Omnibus Company and then on to Sunderland Corporation Transport where I remained for a total of 27 years. During this time I became involved in the trade union movement and eventually became chairman of my local branch of the GMB and when the employees bought out the company became one of two employee directors.

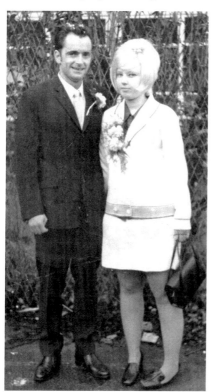

Matty and Gwen Morrison, 25th October 1969, West Park School.

In 1968 I met my future wife Gwen Blenkinsopp, and we married a year later in October 1969. Gwen was from Gray Road in Hendon. She is eight years younger than me, and it wasn't till much later that I found out that I used to baby-sit her when she was about four years old. We have three children – Karen, Kevin and Kim, and six grandchildren – Alisha, Brogan, Cody, Sean and Kirsty. Melissa, my sixth grandchild, passed away in 2002 shortly after birth.

Since 1983 I have been in poor health suffering from a total of four heart attacks, being also diagnosed a tablet diabetic and finishing off with a triple heart by-pass in 2005. Other than that I'm absolutely great. In 2001 I had my first book published *Sunderland – Tramways to Busways.*

Matty GMB Union Chairman Branch 10, 1988.

Joseph Walshaw Sharpe, born 29th January 1856 Hedworth Street, died 28th November 1937, Henry Street. A seaman and dock policeman.

Sarah Elizabeth Armour née McLin, born 23rd September 1878 Clyde Street, died 5th April 1958, Norman Street.

Elsie Curtis formally van Oostendorp née Morrison, born 19th July 1895, North Durham Street, died 24th December 1963.

Isabella Surtees née Oliver born 31st October 1906, died due to a swimming accident 21st August 1934, aged 28 years.

Tichy the Barber

Tichy the barber had a shop in Hendon Road next to Kitty Walker's fish shop. He was very cheap with his hair cuts, especially the children, because most times it was a basin cut. He would really put a basin on the kid's head and just cut round it, but it was the type of hair cut the mothers wanted and the schools approved so he got away with it. What I never understood was, when he would cut the younger kids hair, say the three and four year olds, although the hair cut was still a basin cut, he used to put a box on the barber's chair and sit the kids on the box so the kid's head was above the back of the chair. But because Tichy was so small he then had to get a box for himself to stand on so he could reach the top of the kid's head. He could cut the men's hair when he was standing on the floor. Why couldn't he do the same for the kids? Maybe he should have used the iron ore boat he used to send me for.

Joseph Atkinson, born 1st May 1878, Spring Garden Lane. An ex-seaman.

Barbara Morrison née Downey was born 21st June 1876 and died 11th May 1952.

Robert William Cogdon, born 28th November 1838.

Mason Thompson married Elizabeth Cogdon on 15th May 1891. Mason was born 1868 the son of Robert Ratcliffe Thompson and Elizabeth. Elizabeth Cogdon was born 20th May 1871 daughter of Robert William Cogdon and Anne Hume Hood of Fenwick Terrace.

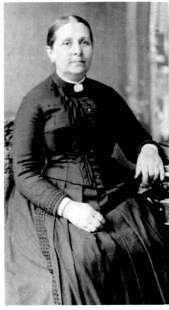

Anne Hume Hood, born 21st August 1841, married Robert William Cogdon on 5th October 1860 at Covent Garden Street.

Working Away

Right: An advert for the Royal Navy from the 1950s. Many men from Hendon and the East End took up the offer to join the Armed Forces as well as the Merchant Navy. Many local men also travelled the world following their trade in civilian life.

Make the ROYAL NAVY your career

THERE'S a special pride in wearing Royal Naval uniform on a great occasion. But wherever the Navy goes, the uniform and the men wearing it are liked and respected.

That's why the Royal Navy is a service you can be proud to join — and why you have to be good to get in.

If you are keen and fit, you may be the right man for the Royal Navy. Think about it — and send for the free book. It's a fine job with good pay and good prospects.

Telephone Nos. : National, 661 ; General Post Office, 16.
Telegraphic Address : " Spardeck, Sunderland.

THOS. PINKNEY,
Shipping Auctioneer and Broker,
For the Sale, Purchase, Construction and Chartering of Ships and Steamers.

GREEK VICE CONSULATE,
BALTIC CHAMBERS, SUNDERLAND,

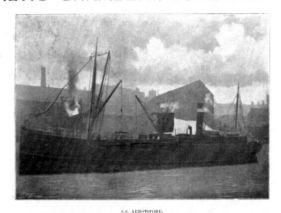

S.S. ABBOTSFORD.

Hull Sunderland Line of Steamers,
For General Cargo between Hull and Sunderland.

AGENTS IN HULL :
Messrs. W. H. H. HUTCHINSON & SON, Pier Street.

AGENTS IN SUNDERLAND :
THOS. PINKNEY, Baltic Chambers.

FREE BOOK: Post this coupon today to D.N.R., (Dept. DW/15), Admiralty, London, S.W.1. (*Applications from U.K. only*).
Name..
Address..
.. Age..........

Above: An advert for a line of Sunderland steamers from 1898. Although these vessels only travelled as far as Hull, men from the area crewed ships that sailed the seven seas.

From Hendon to the Falklands Islands

Up until 1960 I had wandered around fairgrounds where I met Matty Morrison, Lukey Ratcliffe and Jimmy Wynn. We were working for Johnny's Fairs and in particular Johnny's son-in-law Claude Cooper. We were on the Hendon Burn when Matty had a fallout with Claude and joined the Army. It was then that I was able to pick up an apprenticeship with Middleton Pinder of Southwick and I left as a qualified joiner. I moved to Gosforth in Newcastle where I met and married my first wife and we had two children. I still carried on playing sports and in particular football during this time but gave up when my wife and I were divorced. I then moved back to Town End Farm in Sunderland and was lucky enough to gain employment as a foreman joiner for a construction company.

This was a new beginning for me and was able to gain employment as a foreman joiner for many companies in many different countries, including the Falkland Islands, Malta, Algeria, Germany, Guernsey and France. I then came back to Sunderland and took local contracts for construction companies. I am retired now due to ill-health, but my last job was as site foreman for John Laing Construction based in Worcester on the M5 motorway contract. This was when I met my wife Angela.

I'm now settled and living in Bilston, Wolverhampton, West Midlands with my family. I have three step-daughters and ten grandchildren, I am extremely happy and I feel lucky enough to have had the opportunity to travel and live in different countries and achieve my life's goals.

Bill Richardson

Hendon's Military Contribution

Hendon, like all of Sunderland, sent many of its sons and daughters into both First and Second World War campaigns. Many went as volunteers, young and old, with many lying about their ages. Many of those who went never came back. Here are just a few who served.

Gunner Andrew Smith Royal Artillery. Born 1900. Son of Wikkian Smith and Margaret Jackson. Killed in action World War One. Thought to be on the Somme.

Private Richard Armour 43388197 Royal Green Howards. Born 13th May 1915 in Norman Street. Son of James Armour and Sarah Elizabeth McLin. Died 2nd September 1984.

Company Sergeant Major William Armour Royal Army Medical Corps. Born 8th September 1897 in Norman Street. Son of James Armour and Sarah Elizabeth McLin. Died World War Two in a fire.

Private John Freeman Durham Light Infantry. Born 1902 died 4th December 1962.

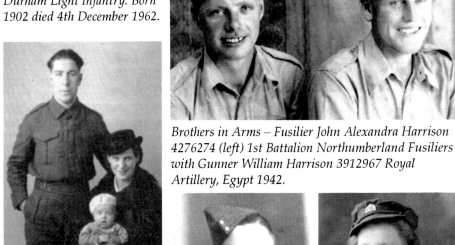

Brothers in Arms – Fusilier John Alexandra Harrison 4276274 (left) 1st Battalion Northumberland Fusiliers with Gunner William Harrison 3912967 Royal Artillery, Egypt 1942.

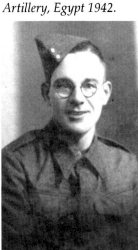

Private William Rowe Pioneer Corps. Born 7th December 1910.

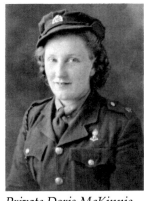

Private Doris McKinnie née Hall W 147156 Women's Royal Army Corps. Served in World War Two. Lived in Woodstock Avenue.

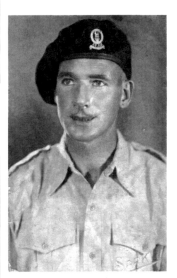

Private Frank Andrew Armour. Born 14th April 1908 in Norman Street. Son of James Armour and Sarah Elizabeth McLin.

John Crighton, Regiment unknown. Here with his wife Lizzie and son John.

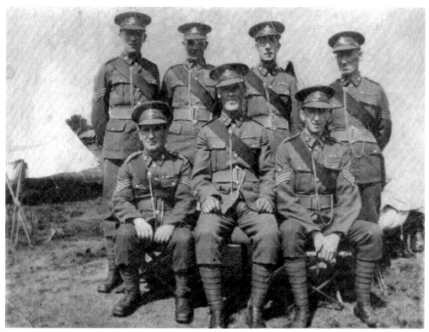

Regimental Sergeant Major Edward Smith Durham Light Infantry (front row centre) with his company NCO's on the field of action World War Two. Born 7th May 1899. Son of William Smith and Margaret Jackson. Died 3rd October 1964.

Gunner Robert William Blenkinsopp Royal Artillery. Born 15th March 1907 West Wear Street. Son of Robert William Blenkinsopp and Bridget Ellen Docherty.

Able Seaman James Oliver C/ JX 658150 Royal Navy. Born 2nd May 1925 in South Durham Street. Son of James Swales Oliver and Margaret Ellen Sharpe.

James Oliver enlisted into the Royal Navy in 1943, aged 18 years, after working in the shipyards. As able seaman he sailed to India on the troop ship *Orotis*. He was in India for about three years and worked on deep sea tugs, also spending eight months on the aircraft carrier *Formidable*. When he returned to England he went to train as a deep sea diver and, after six months and three days he got within six weeks of completion, gave up and took his discharge in 1946.

Private Joseph Blenkinsopp 13748055 Cameron Highlanders. Born 4th March 1924 in West Wear Street. Son of Robert William and Bridget Ellen Blenkinsopp. Died 22nd October 2002.

Joseph Blenkinsopp took part in the Far East Campaign, serving in Burma and Singapore. He was part of the British Forces that had to leave Singapore in a hurry. He did return, however, with the famous Chindits and along with his Regiment freed Singapore. Later he was captured and held Prisoner of War by the Japanese but only for a few months, as luckily the war came to an end and he returned home safely.

Alexander Morrison Royal Navy, River Wear Commissioners 1922. Born 5th April 1873. Died 15th December 1938 in Norman Street.

Matty, my father, was already serving in the TA when the Second World War broke out. He was to enlist in the regulars and joined the King's Own Yorkshire Light Infantry (KOYLI). After basic training, which was very short, he, along with the British Expeditionary Force, was sent to France on the 26th April 1940. This was only for a very short time as the Strategic Withdrawal of France took place at Dunkirk in May of that year. Luckily he was able to return from those terrible beaches. He arrived in England 31st May 1940, having spent a total of 35 days of extreme danger in France. On returning to England dad took two courses of action. He transferred from the Koyli's to the Royal Engineers and in the August he married my mother by special licence. Which of these two events were the most dangerous, he was soon to find out. As a Sapper he was posted to Gibraltar, and remained there for the rest of the war, only coming home for some leave now and then. He was married to my mam for the rest of his life, so the latter option was the most dangerous for him once he got to know my mam. He left the Rock on 11th November 1945 and returned to England on 19th February 1946. He completed his service with the regiment on 31st March 1949 and

Sapper Matthew Wright Downey Morrison 4449448 Royal Engineers. Born 25th May 1914 in Norman Street. Son of Alexander Morrison and Barbara Downey. Died 14th October 1975.

immediately joined the TA again and became 22269747 Sapper Morrison M. (TARER). He remained with the TA at Rock Lodge in Sunderland until he was forced to retire on 31st March 1961. He was absolutely gutted, especially after a total of 29 years service. The Army gave him his Defence Medal and, rather then pinning it on him, they sent it to him through the post.

Sappers Matthew Morrison (left) and Thomas 'Tug' Wilson just after the war on a TA camp.

One of the most feared telegrams anyone could receive during the Second World War was Army Form B104-83, missing presumed dead. Such a telegram was received by my Aunt Annie on 20th July 1940, telling her that her husband, 4444779 Daniel Jukes, had been reported missing since May 1940 during the withdrawal from Dunkirk. However, on 12th August of that year Aunt Annie received the next form, B104-83, reporting

that Danny had been found and that he was a Prisoner of War in Stalag Camp XXb, and that the information had been received by the War Office on the 8th August. Danny was to spend the rest of the war as a prisoner and was one of the first to return at the end of hostilities.

Sergeant Daniel Jukes 4444779 Royal Engineers. Born 1st January 1907 in Lambton Street. Son of Daniel Jukes and Ellen Stevens. Died 20th July 1974.

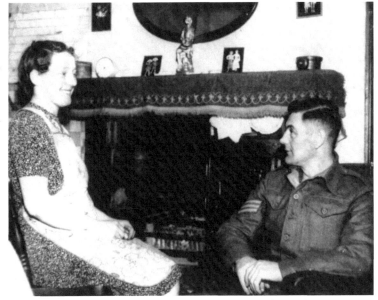

First Prisoner of War to return home. Relaxing at home Sgt. Danny Jukes with his wife Annie née Morrison.

56

Hendon man Tom Fielding had already served some time in the Royal Air Force, when he was sent on a course in Ein Sherner near Palestine (now Israel). The course was to train Tom and others for a Coastal Command unit on Wellington Bombers. The crew would consist of two pilots, captain and co-pilot, an observer who doubled as a navigator and bomb aimer and three wireless operator air gunners. The wireless operator/air gunners all had the same training, radio-radar-gunnery but when Tom's captain, who hand-picked his crew, asked them what they were best at and what they would like to do, Tom chose to be the rear gunner with his four Browning machine guns. Slim Gartland opted for the radio with Eric Rock on the radar and they all remained this way throughout their tour.

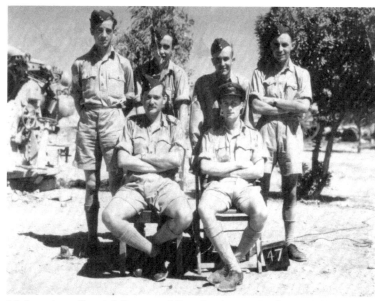

After training the crew, known as 38 Squadron, returned to Benghazi early in 1944. It was back to the old routine, where 50% of flying was on convoy escort, shepherding the ships between Malta and Port Said, and visa versa. The rest of the time they would attack German ships and bomb harbour installations in the Aegean Sea and low level mining of the harbours of Piraeus, Khalkis and Milos. Soon the news came that the Germans were evacuating Greece and it was not long before the squadron were escorting an invasion fleet into Athens. In November 1944 the squadron was moved to Kalamaki near Athens. Soon they were on the move again this time to Grotagle (near Taranto) in Southern Italy to commence training to drop supplies to the partisans in Yugoslavia. However, the unsupercharged Wellingtons had trouble getting over the mountains, so the

38 Squadron Coastal Command Benghazi 1944. Back row, left to right: Sgt. Wireless Operator/Air Gunner Slim Gartland, Sgt. Wireless Operator/Air Gunner Tom Fielding, Flight/Sgt. Wireless Operator/Air Gunner Eric Rock, Flight/Sgt/Observer Pete Taylor. Front: Flying Officer Tug Wilson and Co-Pilot Flying Officer Jack Webster Captain.

operation was abandoned. Instead the Wellingtons were flown down to Algiers and exchanged for brand new Mark-14s. While the exchange was taking place the squadron had been moved to Foggia Main, an airfield that was shared with the Americans and their B17 Fortresses. Then it was back to the old routine, attacking the German shipping lanes, and pickings were plentiful. The patrol started near Venice, all the Adriatic coast, via Trieste and Split, to Dubrovnik.

The last wartime move was to Falconara near Ancona where the war came to an end in the first week of May 1945. After training on Warwicks, a larger version of the Wellington, equipped to carry an airborne lifeboat, which was dropped on three parachutes, 38 Squadron became an Air Sea Rescue Squadron.

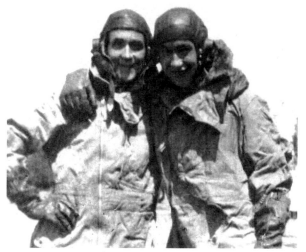

Wireless Operator/Gunner Eric Rock (left) and Wireless Operator/Gunner Tom Fielding, Royal Air Force 38 Squadron Coastal Command Benghazi 1944.

In December 1945, the squadron disbanded and the crew went their different ways but kept in close touch with each other and still do so even today. Tom Fielding, the Sunderland lad, ended up in the Middle East Headquarters on briefing duties. When his demob came up he left the RAF but rejoined after a few months as an Instrument trainer and spent some time in Southern Rhodesia and finally retired in the 1950s as a corporal.

Tom Fielding in 2006.

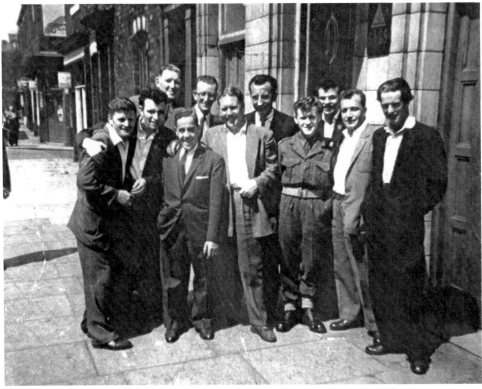

Pte Ernest Smith 23746918 Royal Army Ordinance Corps 1961-64 with friends outside of the Tatham Arms including R. Baxter, E. Smith Snr, Ritchie Coxon, Ronnie Taylor and Stan Francis.

Gunner Alexander Sloanes 23150571 H Troop C Battery 15th Regiment Royal Horse Artillery Gun Layer. National Service 1955-57.

Hell on Paradise Island

I arrived for basic training at 6th Training Battalion, Houndstone Camp, Yeovil in Somerset. The training included basic military training and driver training with the Royal Army Service Corps on completion and passing out. I was posted to 47 Company Air Detachment to train in logistics and supplies by Air Transport Command. This was a job I relished. Within a few weeks I served in North Africa and Malta and on my return I was posted to Cyprus as a permanent posting. There my adventure started. I was doing rather well, serving with a great bunch of blokes, playing football and basketball against other units on the island. Once a month we would go pot holing in the Kyrena mountains. It was tiring but the social side was great. Unfortunately for me my service was cut short by a suspicious fire setting ablaze to the office I was in. I was unable to escape through the door and for security reasons the windows were all barred. I was somehow rescued by a lone guard but by then I was seriously burned and was flown by helicopter to Dhekelia Military Hospital on the island. A week later I was flown to Withinshaw Hospital Manchester burns unit where I was treated on and off for three years. After umpteen operations I decided I had had enough and I wanted to get on with my life, having been married in 1963, I wanted to be with my wife and children, born in 1963 and 1964.

I started to look for work and found employment with Bartrams Shipyard in 1966 as a timekeeper, and eventually became head timekeeper in 1977. After 11 years in 1988 I retired. Those years at Bartrams were great because after my accident I thought my life was over but my family and friends pulled me through and in reality I consider myself to be very lucky.

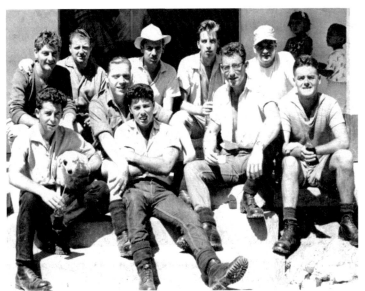

George Mole and his Army mates in Kyrenia, Cyprus. George is second from the left in the middle row.

George Mole

The Army to Escape Boredom

I attended Hendon Board until I was thirteen years old. I then moved on to Commercial Road School, when my parents moved home. I left school at fifteen and went to work as an office boy for Shorts Shipyard and when I was sixteen started an apprenticeship as a shipwright, but after two years got a bit bored with it, so left and joined the Army. I served with the Royal Signal Regiment and came out as a corporal. I was posted to Berlin and I was there when the wall went up. With me being me, I often wondered whether the Russians heard I was coming and put up the wall to stop me getting in. I also served in southern Germany, and then later in Cyprus, and then returned to Germany where I was discharged after completing a total of six years.

I then went to work for an oil company called Regent. After almost two years Regent were bought out by Texaco. That really was the beginning of my career as I remained with the company for twenty-eight years, doing various jobs. After a time I was offered a Terminal supervisor's job, and later a Terminal manager's job in Manchester, and I remained in the job until 1994, when I was diagnosed with having diabetes and had to retire due to ill-health. I have been married twice but sadly both my wives died. I've got one daughter Mandy, and one step-daughter Elaine and two grandchildren – one boy and one girl. I've had a charmed life, a smashing life, I cannot really complain. Although I never kept up with my sporting side of life I'm now getting involved with my grandchildren's sport. I still see a few of my schoolmates, although they are from Commercial Road School, rather than from Hendon Board.

Kenny Vipond

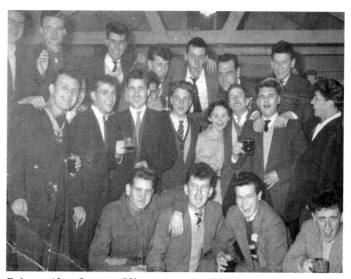

Private Alan Surtees Oliver 23366107 (third from the left middle row) Royal Army Ordnance Corps. Born 14th November 1935. Son of James Swales Oliver and Margaret Ellen Sharpe. National Service 1957-1959, Hillsea Barracks Portsmouth, Blackdown and Cyprus.

Private Stephen Humble Army Catering Corps and Pioneer Corps. Born 28th October 1961 in Ward Street. Son of Harold Humble and Phyllis Oliver. Died 26th August 1981 Northern Ireland. Accidental death.

L/Gunner J.W. Hodgson 22655163 Royal Artillery.

Private Albert Freeman 22501499 (left) Royal Army Ordnance Corps. Born 6th May 1933 in Gray Road. Son of John Freeman and Margaret Ann Davies. National Service 1951-1953, Egypt.

Sea, Scrap, Copper & Coal

"Nip up to Lightfoots the chemists and get two ha'penny sticks of Spanish," me ma said. So I knew where we were going – only one of two places, Backhouse Park or Hendon Beach. The ha'penny sticks of Spanish were to make three or four bottles of Spanish water to drink wherever we were going. The old puroh milk bottles had a snap top and were ideal for shaking and making the Spanish water. When she said ask Billy Carter next door about the tide, I knew it was the beach. It was weird, but Billy and most of the old men could tell you anytime you asked, about the tide. They would just stick their finger in their mouths and

Low tide at 11 o'clock with a light south westerly breeze.

Lads and lasses on Hendon Beach.

A washed-up porpoise on the beach with the Podd children.

wet it, then stick it in the air and tell you that the tide was low at 11 o'clock and that there was a south westerly breeze with it, good for plodging. Funnily enough they would be right. While I was away getting the Spanish me ma would make some sandwiches for us all (seven of us). They would either be sugar and bread or bread and dripping. The topping we would get when we began eating them down the beach. It would be sand that had blown on to them by the south westerly breeze. She would give us our cosies to carry, wrapped up in our towels made of old sheets she had cut up to give to the rag man, but we didn't care we were going out for the day. The only thing I hated was when I wore my home-made cosie, made from my dad's old pullover. When I went in the water the crotch would hang down to my ankles with the weight of the water dragging it down. Why I worried I don't know because most of the other lads had the same problem. It's funny but when I think back to those days the summers were always warm and sunny and being down the beach seemed the best place to be. All your mates were there and you could

play for hours, football, cricket and anything you wanted. You could just jump in the water and have a swim, making sure you avoided the small brown logs created by humans, that would float around, back and forward with the waves. Hendon Beach really was a good place for kids in the 1950s, plenty of sand, and some rocks with rock pools, for the kids to catch small fish and crabs. You really could stay all day and come home with your feet so wrinkled from being in the water for so long that it hurt to walk on them; but who cared.

The beach wasn't just for pleasure so the days weren't entirely wasted. When we had time we kids would look about for firewood, pile it all up and when it was time for home we would find some string or wire and make bundles to carry home with us. Because it would be low tide some of the men and the young lads would dig for rag worm for fishing with later. Maybe they would come back that night with their hand lines, just ordinary cord line, with a couple of fish hooks on and cast out from the beach, checking for the fish biting with the cord draped over their forefinger. Sometimes if they caught any fish that were too small they would go crabbing with their home-made crab pot, made of an old bike wheel, cut in half, and held together by criss-crossing cord over the wheel. They would tie the fish to the middle of the wheel and lower it down at high tide over the drum head off Hendon Pier. They lifted the pot from time to time while they carried on fishing.

Alfred 'Pedro' Hill a fisherman from Gray Road.

George and David Hill from Gray Road.

Back of The Piles looking south towards Hendon Beach.

When they were building the groyne behind the Hendon Pier, they used the opportunity to use it as a land-fill, to build up the groyne as a breakwater and they placed bulk heads of steel, placing the rubbish behind and covering it with concrete. What they didn't realise was that they were building a new industry. Some of the land-fill rubbish was coming from the shipyards close by, and the lorries were bringing all kinds of scrap metal, old melted scrap from the furnaces, now to become known as *scarry*, old iron pops from the rivet hole in the ships' steel plates, iron lugs used when the cranes lifted the steel plates, old rollers and all kinds of iron. There was also old copper and brass washers, brass hinges, copper piping, welders' old copper cables and all kinds of copper and brass which was to become known as *jewellery*. All this stuff was collectable and the men working on the groyne would do their bit for recycling and collect it. They also told their mates who didn't work there, and of course being environmentally conscious and concerned, they too began to collect it. Because of the piles of rubbish being tipped there the place became known as The Piles. And so if anyone was going there they were going back of The Piles. When it was low tide you could walk round the Hendon

Pier to the back of The Piles and collect whatever you were looking for – scrap, copper and brass, or mixed (which was material which had a bit of both which you couldn't part). Some men would rake the sand near The Piles and find all kinds, sometimes coins of the realm, shillings, two bob bits, tanners and the coin that interested me – the farthing. The men who found these used to give them to me so I could buy my halfpenny iron ore boat (two farthings made a halfpenny).

When the men had collected their scrap and copper they would take it to the scrapyards and sell it, but it was a struggle to get the scrap from the beach to the yard. The scrappers had their own style of bicycle which they had converted themselves. A twenty-eight inch frame bike that had its front forks strengthened by cutting the handles from an old pram and fitting them on to the forks the opposite way to which the forks bent. They would then take an old thick rubber hose pipe and cut it to replace the back and front tyres – no more punctures. Then they would fit a wooden seat over the back wheel to sit on while they pushed and rode the bike to the scrapyard. With this method they could carry two 2 hundredweight bags through the frame of the bike and one bag over the cross bar, carrying a total of twenty-four stones, quite a weight, but still awkward to push. Then along came Dapple with his barrow, he would wait on

Les Podd picking coal on Hendon Beach.

Lily and Albert 'Dapple' Thompson celebrating their Golden Wedding Anniversary.

Hendon Beach side of the pier and buy the scrap off the men for a cut price, and then would take it to the scrapyard and get the right price. Wisely Dapple kept the profits, bought a wagon and carried on until he opened his own scrapyard. Dapple is none other than Albert Thompson, Builders Merchant of Hendon. Don't be misled by the way Dapple started his business. He may have had help from quite a few men and boys in the beginning but pushing him from behind and guiding him in the right way was a strong woman, his wife Lily. And though they may have made one or two enemies on the way, they made just as many friends and admirers. Albert and Lily Thompson have built up a substantial business over the years and are to be congratulated for the number of Hendon people they have kept in work over the years. With their help there are many families that have been able to make it through the 1950s and '60s to the present day.

Hendon Beach was our major source of fuel with wood and coal being washed up, either from tipping, or direct from the slag that the local pits threw up. There was one incident in particular which I recall which happened in about 1956-57. The usual crowd I went around with had been to the Regent Cinema in Grangetown, and after the pictures we decided to go down the beach for a laugh, maybe have a plodge or throw a couple of the girls that were with us in for a swim. We went down Grangetown

Above: Phyllis Humble née Oliver, wife and mother extraordinary to husband Harold and eight children shown below right.

Right: Alfie Podd ready to strengthen the front forks. The bike itself was bought from Palmer's Arcade on the never-never in 1973. Alfie still has the payment book to prove to everybody that it was paid off in full. He still uses his bike to this day.

way and were walking along the beach, toward Hendon, when the sound of my feet on the stones seemed to change to a dull kind of sound, and I sank a little further. When I struck a match, as it was dark, about 9.30pm, I realised that I was walking on coal. In fact I was knee-deep in coal. I left the crowd and went home and got a rivet bag, told mother, that when dad came in from the pub he was to come down the beach and help me. I got back to the beach about 10 o'clock and began scooping the coal into the bag and taking it up on to the pathway leading to the beach, I carried on doing this until my dad came down about midnight. By then I must have picked about half a ton of coal, the news had got out and everybody from Hendon was there picking coal. Actually there was so much coal they were shovelling it in hundredweight bags.

Above: Scrapper Harry Humble and family. Back row, left to right: Ashey Humble, Christine Humble, Joyce Humble, Phyllis Humble. Middle row: Janet Humble, Harry Humble, Edna Humble. Front: Margaret Ellen Humble.

Left: Scrapper Teddy Critchlow with friend Lizzie Crighton in the Queen's Hotel now The Charltons.

People were running away with prams full of coal, bags on bikes and barrows and coming back for more. Early in the morning Dapple came with his lorry and filled it, went away and came back for more. At one time it didn't look as though the coal was ever going to run out. My family and the other families who lived with us in the same building just dumped all the coal that we collected in the back yard. There must have been five or six tons of it and we never needed coal for quite sometime after. There was a few after events when the coal finally ran out from the beach and that was people still picked what was left, without checking first if it was good coal or some slate. Those poor people who were using this coal had to make sure that the bleezer that they would use on a morning to start the fire had to remain up so they could avoid the shooting stones coming at them. Believe me when the stones went off it was worse than World War Two. Where did all that coal come from? I think a seam near the surface was exposed by the actions of the waves.

Washing in the coal.

A young girl waiting for her father to finish collecting coal.

Oil tanks at Hendon Beach.

Scrapper Jimmy Crawley.

Hendon Beach by Lindsey Davison

It's a place of thought. A place to go when you feel you need to escape. A place of peacefulness and loneliness. Sounds beautiful, yes? Well then I have misled you. The place is a beach – Hendon Beach. The air is filled with grey coloured smog. The water is polluted with sewage from the nearby factories but still there remains something special about it.

I often like to go down there, and sit on the grassy heaths, watching the crests of the waves crashing against the walls of the promenade. The only disturbance is the coal train rattling along the line behind the grassy banks. As I sit, I sometimes watch a boat or ship out on the ocean or maybe a fisherman or two casting out their lines. I watched one come and go one day. He left without catching one single fish and today he is here again.

'He is down here for the same reason I am', I said to myself.

'Not to fish, but purely to think. I wonder what he's thinking about.' Then again, he is probably thinking the same as me as he walks past and greets me with a friendly smile.

Lindsey Davison.

As I look round the now deserted beach, I feel like I know it so well.

I stood up and dusted the grass off my jeans and made my way across the top of the bank steps that lead down to the promenade. I place my hand on the cold and rusty handrail. Some of the sky-blue paint cracks off into my hands. The steps are overgrown with grass and wild flowers. As I reach the bottom, directly in front of me is another set of steps that lead down onto the mustard coloured sands of the beach. These can be treacherous as the stone is being gradually worn away. They are covered in a green slimy moss which makes the steps even more frightening. But then I reach the sands and everything is worthwhile. The tide is right out. All over there are small craters where the fishermen have been digging for worms.

As I stand and look out to sea, the cold, salty breeze ruffles my hair and my eyes begin to water.

This beach had always been here for me, in good times and in bad, I had grown up with it and I knew it so well. In fact, it was almost like a best friend and probably always will be.

Hendon Beach calming down.

Catching crabs at the back of The Piles at Hendon Beach.

Hendon Board School
Opening Day 6th January 1879

The new Board Schools at Hendon, being the sixth school built by the School Board of Sunderland, was opened this afternoon. The school is situate on the north edge of Hendon Valley, being at the east end of Robinson Street and directly facing Hendon Road, and it will accommodate fully 1,300 children. It is built of red brick, and as the whole of the school faces Cumberland Terrace, it presents an elegant appearance. The boys' school is at the west and the girls' school is at the east end of the block, the infants' department being in the centre. The boys and girls' schools each comprise two flats, the senior scholars being placed in the upper stories; while the infants' department is wholly on the ground floor, being surmounted by a neat clock tower, which also acts as a ventilation shaft. The accommodation is divided as follows:– Boys' school 452; girls' school 452, and infants' school 400; and each department is structurally distinct. About half of the ground purchased by the Board from Mr Marshall Fowler, 7,995 square yards has been left for playgrounds. The schools are well lighted, comfortably heated and excellently ventilated and being roomy, substantially furnished and liberally provided with educational apparatus. Government Inspectors and chief teachers, alike with unpractical laymen, may justly describe them as splendid schools. The architect is Mr W.H. Blessby of Middlesbrough and the building has been erected within the year by Mr Jas. Lord contractor, of the same place. The site cost £1,875 and the total cost of the schools is estimated at £9,500; which sum, of course, has been obtained on loan from the Public Works Loan Commissioners. Below is furnished the particulars as to each school:–

BOYS' DEPARTMENT:– Principal certificated master, Mr J. Ramsay; first certificated assistant master, Mr W.C. Chappel. Subjects taught – reading, writing, arithmetic, English grammar and composition, geography, history, algebra, Euclid, vocal music, drawing and drill.

GIRLS' DEPARTMENT:– Principal certificated mistress, Miss S. Campbell; first certificated assistant mistress, Miss M. Peel. Subjects taught – as above; also needlework and cutting-out.

INFANTS' DEPARTMENT:– Principal certificated mistress, Miss E.J. Todd; first certificated assistant mistress, Mrs M.

Hendon Board Infants.

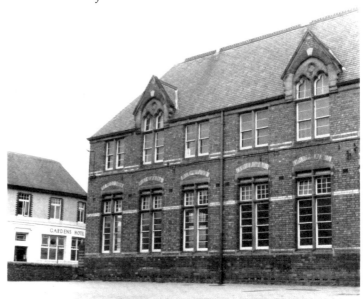

Hendon Board Senior Boys School.

Hendon Road view from Hendon Board School.

Graham. Subjects taught – reading, writing, arithmetic, object lessons and singing. Female infants taught to use the needle. All departments have an efficient staff of pupil teachers.

Fees:– Boys' department 4d per week; girls' department 3d per week; infants' department 2d per week. Four of a family attending this school, the eldest child will be educated free; and where three attend, the youngest is taught free. Hours of attendance – morning 9 to 12, afternoon 1.30 to 4.

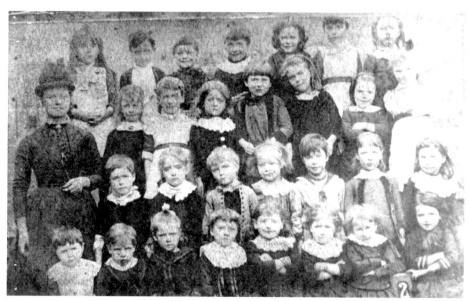

Hendon Board School Class 2 1886 the only two pupils known are in the front row 3rd and 4th from the right, 3rd is Sarah Ward and 4th is Elizabeth Taylor.

In the Boys' School there are now 282 children on the roll, 70 having been placed on it this morning, in addition to those boys who attended the temporary school in Mainsforth Terrace. In the Girls' School 300, 32 having entered this forenoon; and in the Infants' School 318, 60 having been admitted today. The children assembled this morning were clean and neat in appearance and intelligent in demeanour, and possessing able and agreeable teachers like Mr Ramsay, Miss Campbell and Miss Todd, they may fairly be expected to give a good account of themselves at the next examination.

It was expected that there would have been a formal opening of the schools but not a single member of the School Board put in an appearance. Of course a large proportion of the accommodation provided has yet to be filled, but as the schools are schools to which no parent in the town need be ashamed to send his children, and as each department is well officered, the zealous schools officers for the district, Messrs Low and Beaney, may soon hope to have little vacant space in the Hendon Board School.

Sunderland Daily Echo 6th January 1879.

Hendon Board School Class 6 1896. Teacher believed to be Miss Ramsay first Head of the Girls School.

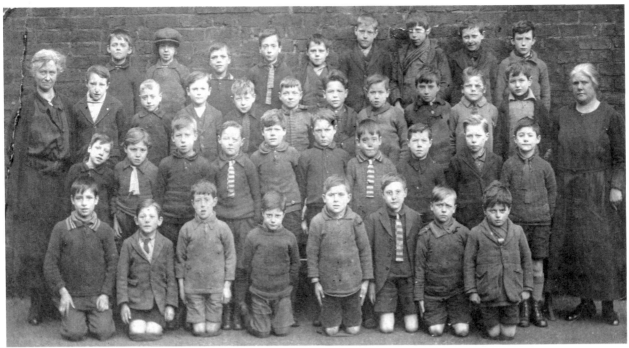

Hendon Board School Senior Boys 1922-23 The only two pupils known are Stanley Hall on the right of the back row and Leslie Kelly next to him.

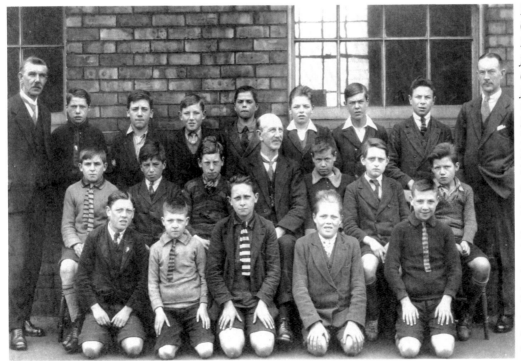

Hendon Board Cricket Team 1926-27 skippered by the future Sunderland and England footballer Raich Carter. Back row, left to right: Mr Todd, French, Elliott, Garrett, Lobban, H.S. Carter capt, Ditchburn, Eaton, Mr Whitehouse. Middle row: Thompson, Wake, Corner, Mr Park, Ross, Scott, John Miles. Front row: Price, Tate, Stanley Hall, Matthew Erskine and Tate.

Most Famous Old Boy

Over its long history Hendon Board's most famous pupil has to have been Horatio Stratton Carter. Raich, as he soon became known, attended the school in the years immediately after the First World War. He started his school football career as a 10 year old playing for the Under 13s at left half. His outstanding ability led to him being selected for Sunderland Boys, Durham County Boys and England Boys. In his autobiography *Footballer's Progress* Raich recalled the day he left Hendon Board School. For the rest of his life he remembered that day when he was presented with a gold medal inscribed:

'H.S. Carter. From the Pupils and Teachers of Hendon Boys School, Sunderland. 1927. Cricket, 111 runs in 25 minutes (in Final). 1928. Football (Captain of English team), July 1928.'

Hendon Board Senior Boys 1947. Back row, left to right: Peter McDonnell, Benny Curle, John Ridley, Tommy Dunlop, George Herbert, John Foster, Billy Johnson, Joe Ashton, John Edmonds. Middle row: Toby Hodgson, Fred Tyler, Gordon Gardiner, Dicky Pritchard, Bobby Davison, John Watson, John Roberts, Dicky King, Hughie Lawson, Arthur Hedley, Ronnie Brown, John Hope. Front row: Charlie Leithead, John Hutchinson, Alex McBeth, John Priest, Jackie Arnett, John Armour, Lenny Lamb, Fred Nesbitt, Raymond Bell and Peter Donkin.

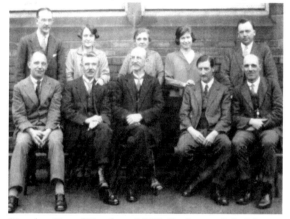

Hendon Board Teachers 1935. Back row, left, Mr Whitehouse. Front row, second left, Mr Todd, third left Mr Park.

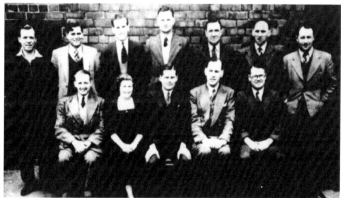

Hendon Board Teachers 1950. Back row, left to right: Jack Washington, Fred Whiting, Frank Randolph, Bob Stores, Mr Dockray, Walter Hooker, Mr Ron Bell. Front row: Jim Cowens, Miss Wright, Arnold Rutter, Mr Johnstone and Bill Taylor.

Hendon Board Juniors 1949-50. Back row, left to right: No one identified in back row. Middle row: unknown, Alan Dodds, George Jackson, unknown, unknown, Alf Lindsey, Billy Green, Tommy Southern, Bobby Carney, unknown, Jimmy Davison. No one in front row identified.

Hendon Board Junior Girls 1952-53. Back row, left to right: Margaret Fraser, Carol Wiseman, unknown, Sheila Dolman, Maureen Blanchard, unknown, Hilda Robinson, Irene Hodgson, Vivian Carter. Middle row: Miss Rich, Dorothy Liddle, Dorothy Coulthard, Miriam Grieveson, Kathleen Latimer, Ann Collins, Gladys Davison, Margaret Allan, Hilda Skillins, Mary Davison, Joan Reed, Margaret Martin, Student Teacher. Front row: Emily Pescod, Mary Marshall, Ann Miller, Nancy Dennis, Celia Johnson, Violet Woods, Jean Parker, Megan Hall, Maureen Cooperwaite, Margaret Anderson, Irene McCready, unknown and Prescott.

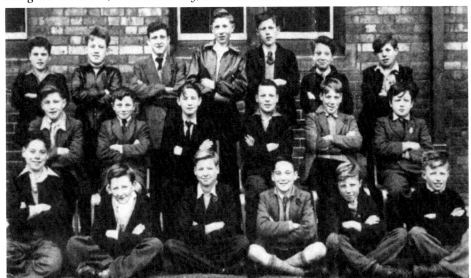

Left: Hendon Board Senior Boys 1956. Back row, left to right: Henry Smith, Douglas McCalister, Fred Fair, John Hodgson, Jacky Bradford, Ray Seafield, Tommy Wilson. Middle row: Brian Bainbridge, Billy Blyth, Malcolm Bainbridge, Stan Wright, Keith Brown, Norman Stokell. Front row: Tom Smith, Andrew Nash, Jimmy Hall, Stan Cruddas, John Malt and John Mills.

Hendon Board Junior Library Class 1954-55. Back row, left to right: D. Jones, R. Stokoe, Brian McArdle, H. Hart, B. Pallas, K. Rowe, D. Staite, E. McCarthy, A. Cook, M. Keep. Middle row: N. Barker, unknown, M. Dennis, G. Goodhall, unknown, unknown, W. Dagg, N. Potts, E. Forrest, E. Cuthbertson. Front row: unknown, Brenda McArdle, E. Donkin, A. Turner, E. Wilson, J. Hamilton, E. Mills and unknown.

Hendon Board Juniors 1952. Back row, left to right: unknown, unknown, Micheal Percy, Jean Parker, unknown, John Avery, unknown. Middle row: Brian Kemp, Maureen Blanchard, unknown, Anne Wilson, Kathy Butler, Joan Reed, Billy Robson, unknown, unknown, John Iley. Front row: Sheila Gettins, Vera Savage, Derek Wilson, unknown, Julia Burlinson, John Potts, unknown, Davy Wake, Ann Wilson, Bobby Byers, Betty Todd, Gladys Davison and Syd Mordey.

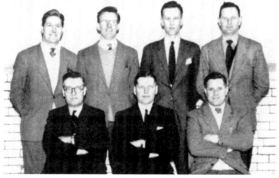

Hendon Board Teachers 1960. Back row, left to right: Mr Bassett, Mr Pullin, Mr Harrison, Mr Stores. Front row: Mr Taylor, Mr Rutter (Head) and Mr Whiting.

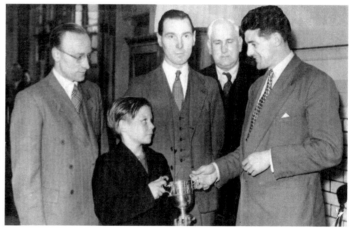

Presentation to Norman Turner by Trevor Ford Sunderland AFC.

Hendon Board Senior Boys 1955. Back row, left to right: Brown, Mitchinson, Miller, Hope, Emmerson, Robinson. Middle row: Mr Rutter, Wellburn, White, Carter, Routledge, Cowe, A. Rutter, Mr J. Cowen. Front row: Miller, Duncan, Doneathy, R. Dunn, Mole, Martin and W. Todd.

Overcoming Setbacks

Davy Wake was born on Wednesday 7th April 1943 in Mowbray Road. The family then moved to Arnott Street where they lived happily for about four years. Then unfortunately Davy developed ricketts so when he started Hendon Board School in 1948 he was taken to school in a wheelchair. He struggled for two and a half years in that way in Miss Saggers and then Miss Eaker's class, although at times he had a bit of fun, when he had to be escorted to the outside toilets by some of the young girls several times a day. As he grew stronger and was able to dispense with the wheelchair he began to play football, although he couldn't run he was able to move about enough to be able to play in goal. His football pitch was Bull's back lane just off Hendon Road. He reckons he made fabulous and spectacular saves to stop the ball going out on to the main road. After another two years his legs, once like sparrow's ankles, grew stronger, and he learnt to walk and eventually to run and as he grew older he used to race people up and down the Parade, Kenny Vipond being one of his opponents. The contests would take place either from Sally Riser's shop, or from the Parade public house to Surtees Street, which was the longer of the races. This contest went on and on for every day for about two years and Kenny always won, but one day Davy was successful. From that day Davy never looked back and began to take part in sporting activities for real, football and cricket and his main interest, running. He was now about thirteen and his interests were beginning to wander away from school, and he was dreaming of the Merchant Navy. As most of his family history was steeped in the sea it was easy for him to take to the sea and, at the age of fifteen, upon leaving school he joined the Merchant Navy. He travelled to the sea training school in Gloucester for boys between the ages of fifteen and eighteen. Davy completed his training successfully and joined his first ship, the *Reavely*, and sailed most of the world's oceans over the next twelve months. He returned to England by sailing into his first English port, London. He served in the Merchant Navy until he was about twenty-one years old and then began to look for a shore job. By this time his parents had moved from 4 Arnott Street and went to live in Tudor Grove without telling Davy, so when he arrived in Sunderland, and not knowing where Tudor Grove was, he had to hire a taxi to take him home. The first thing he noticed was the inside toilet and a proper bath. He found a job with Ericssons factory but he didn't settle so he left. In the mean time, having met his future wife, they married in 1967 and set off to produce their family, a girl Sally born 1971 and a son Danny, born 1977. After taking on various jobs and making a move to Washington they finally settled in the house where they live now. Davy's interest in sports was still abundant but the sport had changed from football and cricket to swimming, where over the years he qualified in many of the divisions and eventually became a teacher in swimming. When the swimming ended Davy took up cycling like a duck to water and, along with his wife who also became interested, they cycled all over the North East. In conclusion, like most people there have been troubled times for Davy and his family, but in general he considers himself very lucky and that he has spent life to the full and enjoyed every minute.

Hendon Board First Year Seniors 1950-51. Back row, left to right: Cowen, Forthergill, Platt, Gibson, Bethwaite, Metcalf, Sinclair, unknown, Lamb, Moore. Middle row: Bowens, Wilson, Wardle, unknown, unknown, Dempsey, unknown, Bulmer, unknown, Downey, Telford. Front row: Hutchinson, Brewerton, Moody, Green, Davey, Innes, Kelly, Croft, unknown. Front row: Swanson, Hopper, Banks, Lyon and Usher.

Right: Hendon Board Seniors football team 1947-48. Back row, left to right: Mr Whiting, Bill Johnson, John Hope, Richard Pritchard, Ronnie Brown, Robert Pryor, Peter McDonell, Mr Mountford. Front row: Alex McBeth, Stanley Baxter, Joe Ashton capt, Jack Arnett and Jimmy Breen.

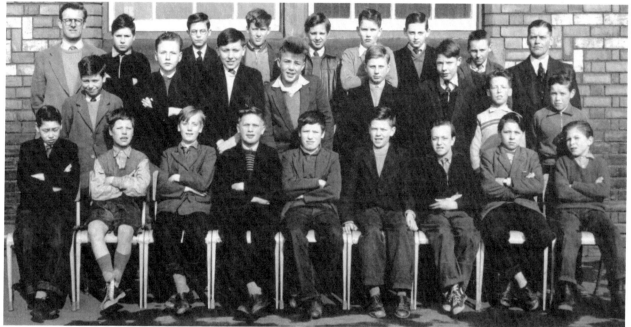

Above: Hendon Board Senior Boys 1958-59. Back row, left to right: Mr Pullin, unknown, Peter Dick, Joe Smith, unknown, Joe Sutherland, Eddie Hall, Eddie Cuthbertson, Mr Rutter (Head). Middle row: unknown, Michael Downey, Peter Shevlin, Robert Wilson, unknown, Ernie Rutter, Robert Hanson, John Hamilton. Front row: William Davy, Alfie Podd, Edward Marsh, John Fletcher, unknown, Micky Hammond, Arthur Addison, unknown and Freddy Cleghorn.

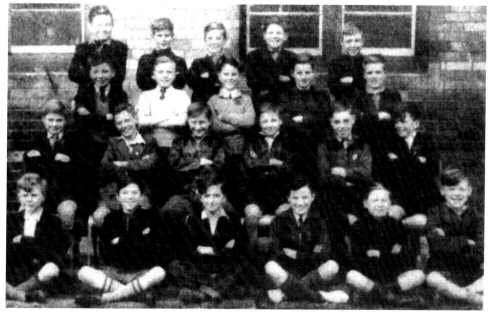

Left: Hendon Board School Senior Boys 1957. Back row, left to right: Billy Green, Alf Lindsey, unknown, Billy Hargrave unknown. Second row: unknown, Archie Perry, George West, Edward Potts, Tommy Mordey. Third row: Alan Dodds, George Loughton, Ivan Lincoln, Kenny Arthur, George Jackson, Derek Johnson. Front row: Eddie Mustard, Bobby Carney, Matty Morrison, Norman Bracy, Ernie Smith and George Roberts.

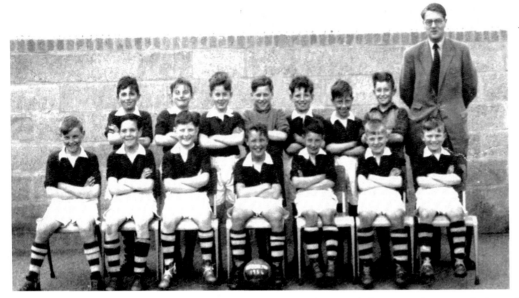

Left: Hendon Board football team 1954. Back row, left to right: Gordon Walker, Billy Richardson, Syd Mordey, Tommy Southern, Billy Robson, John Byrne, A. Howard, Mr Liddle. Front row: Davy Wake, Kenny Vipond, David Carter, Jimmy Davison capt, Jimmy Goodfellow, Alfie Hargrave and Dennis Hargrave.

Right: Hendon Board Junior football team 1962-63. Back row, left to right: Keith Miller, George Udale, Gary Sparks, Bobby Carlisle, Colin Blakeway. Third row: Peter Cowie, Tommy Drew, Keith Webb, Albert Barraclough, Alan Simpson. Second row: Mr Liddle, Brian O'Leary, John Hawkins capt, David Fletcher, Alan Davison, Kevin McKeever. Front row: Keith Farrow, Paul Pybus, Dennis Ellis and Billy Blanchard.

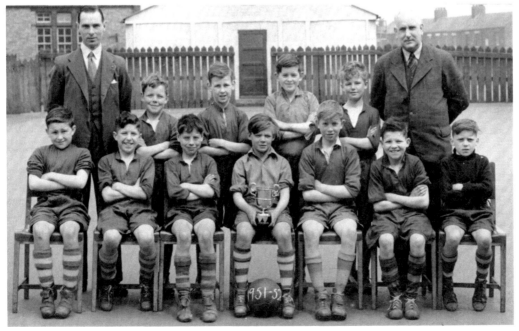

Left: Hendon Board football team Cup winners 1951-52. Back row: Mr Hopkirk, Bruce, Fothergill, unknown, Jimmy Pallas, Mr Mountford (Head). Front row: Malcolm Bainbridge, Tommy Lamb, Billy Robson, Norman Turner capt, Hodgson, Billy Hargrave and Tommy Southern.

Gordon Liddle

Mr Liddle was a unique teacher in many ways. He had the same attitude as Jack Washington towards us kids and most of us got on really well with him, especially if you were interested in any kind of sport. He trained the football and cricket teams, even at night sometimes, and he knew all of his athletes by name. He was successful in all of the school competitions, and when the photographs of the successful teams were taken Mr Liddle would buy one for himself. He proved that he had done that when he attended the School reunions and produced a load of sports and class photographs with all the names. He taught first year seniors and was the first teacher I met who used subject associated teaching. He would tell stories about anything that involved the specific subject, and when revision or tests came around you would remember the lesson by remembering the story. Funnily his stories were mainly about Winnie the Pooh or Toy Town, and I still remember the stories and the subjects. I know he later became headmaster of Springwell Junior School as he used to travel on my bus sometimes in the 1980s. Although he was breaking the rules by standing at the front of the bus, I enjoyed our little chats together. He wasn't at the last reunion 2005, and I won't be at the next one 2006, but I wish him well and hope to see him at future reunions.

Hendon Board Juniors 1956-57. Back row, left to right: Pat Angus, Linda Lough, Valerie Cleghorn, Sarah Hewitt, Linda Fletcher, Maureen Garrett, Eva Mole, Ivy Morrison, Brian Bailey. Third row: Brian Butler, William Lisle, Ann Donkin, Carol Chapman, Alan Surtees, unknown, Robert Moody, Linda Haslett. Second row: unknown, Charlie Crow, Anthony Aitcheson, Edwards, Bob Davison, Mr Liddle, Tommy Fletcher, unknown, Gladys McGinty, Margaret Kitson, unknown. Front row: Carole Triggs, Catherine Burlinson, Norma Barraclough, Kathleen Johnson, Linda Thompson and Doreen White.

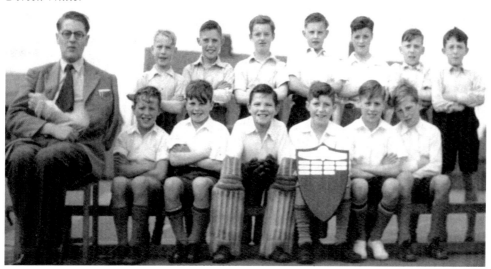

Left: Even injuries would not stop Mr Liddle's involvement in school sports. Hendon Board cricket team 1953-54. Back row, left to right: John Innes, unknown, Ned Potts, Alf Lindsey, unknown, Tommy Southern, Bobby Carney, unknown. Front row: Mr Liddle, Jimmy Davison, Derek Johnson, Billy Hargrave, Tommy Lamb, unknown, Barry Ellison and Peter Old.

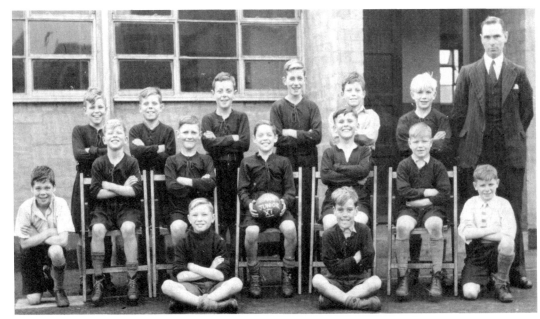

Left: Hendon Board Juniors football team 1949. Back row, left to right: unknown, A. Mole, T. Bowens, J. Reekie, unknown, J. Davison. Middle row: R. Sumner, W. Todd, J. Moody, A. Robinson, G. Tyson, A. Edmonds, I. Pearson. Front: T. Miller and R. Pritchard.

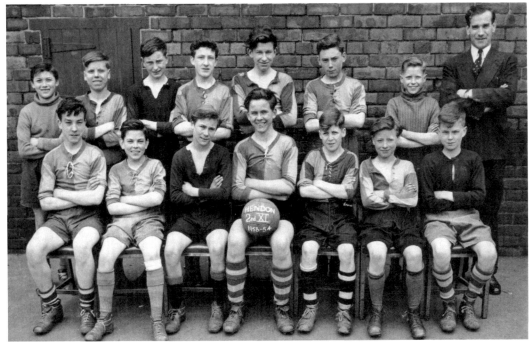

Right: Hendon Board football team 2nd XI 1953-54. Back row, left to right: unknown, A. Mole, unknown, F. Fair, J. Kish, N. Hackett. Front row: A. Hope, unknown, unknown, G. Tyson, unknown, C. Doneathy and unknown.

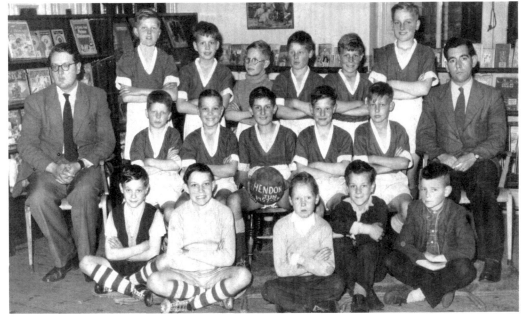

Left: Hendon Board Juniors football team 1957-58. Back row, left to right: Bentley, Ellison, Lawson, Fletcher, Woods, Loughton. Middle row: Mr Liddle, Anderson, Edmunds, Berridge, Reed, Ridley, Mr Watson. Front row: Metcalf, Anderson, Dunlop, Walker and Park.

Jack Washington

Jack Washington was not a Hendon boy by birth – I originally thought he was from Bishop Auckland, because of his long sporting connections with the town – but he was born in Kitsgrove in Staffordshire. He moved to Sunderland at the age of 3 years when his father came to build the concrete ships, which of course was an unsuccessful venture. Jack's father then went to work at Castletown Colliery and so Jack was brought up and educated in Southwick and, because it wasn't a grammar school, Jack began evening classes five times a week but he was still interested in sports and so after evening classes, he would jump on his bike and peddle to the church hall so he could play table tennis – killing two birds with one stone, enriching his knowledge and getting fit at the same time.

When Jack was old enough to take a job he went to work for a building society in Fawcett Street but he didn't much care for it, so in a way he was pleased when war broke out and he was called up. In the Army he worked as a storeman and attained the rank of Quarter Master Sergeant, but he was always taking time out to take part in any kind of sporting activity, and so his interest was growing all the time. It seemed natural to him not to return to the building society when the war ended but during a chance conversation, while playing in Saltburn, someone advised Jack that he would make a good teacher, then the spark lit the fire and Jack knew where he was going – he would become a teacher.

He started by attending a learning facility in Chester Road and then went on to Coventry College. Luckily for Jack that while working for the building society he had earned a charted secretary degree so he only needed to attend the College for a year. The building society's loss was Hendon Board School's gain, for in 1947 that was to be his first teaching post and he loved his time there. One of the main reasons that Jack could enjoy his time at the school was that he had the support of his wife, who, like all the other partners of the teachers could attend special days at the school, sports days, and Christmas and Easter, when they could bring their own children to join in the activities. The partners could meet each other and some became close friends, so it was much like a social club than a school.

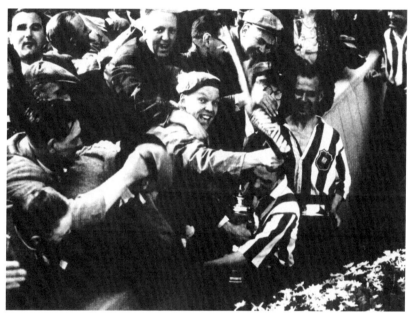

The 1937 FA Cup Final at Wembley Stadium. Jack Washington, future Hendon Board teacher, patting Raich Carter former Hendon Board pupil on the head. Jack was to return to Wembley as a player thirteen years later. He kept goal for Bishop Auckland in the FA Amateur Cup Final but local rivals Willington spoilt his big day.

Festive Boxing

Every Christmas a boxing tournament took place in Hendon Board Seniors and the same pupils were matched with each other every time. For the four years while I was in the seniors I was matched with Ernie Smith and for the first three years he beat me on points. In the last year things would be different. On the morning of the fight, the bout was due to take place in the afternoon, there was danger in the schoolyard. A mouse was loose and scaring everyone in the yard, including me, but I overcame my fear and pursued the animal. Low and behold I was unlucky and caught it and picked it up, and it promptly bit my finger but I held on to it until Jack Washington came along and got it off. Jack then stuck a plaster on my wound and said what a brave boy I was for saving all the rest of the children and that God would be good and I would be rewarded for my pain. The fight was to start at two, and I was ready and up for it. At the announcement of the contest Jack Washington related to the crowd what had taken place in the schoolyard that morning and that as a reward he would award me an extra point before the fight took place and the teachers, who were the judges, were to take note. The fight was over three rounds, and although I was at my best I felt that the fight was going the same way as usual and, in the end, Ernie would win as usual but I rallied and the judges announced the fight was a draw but due to me being awarded the extra point I was announced the winner. Although God was good, I don't think Ernie ever forgave me, even though we were good mates then and still are today.

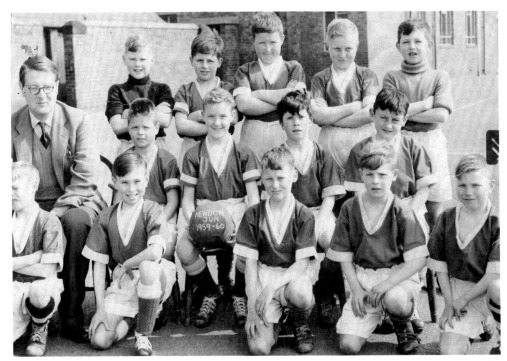

Left: Hendon Board Juniors 1959-60. Back row, left to right: Hall, T. Fletcher, Bailey, O'Brian, Surtees. Middle row: Mr Liddle, Anderson, R. Davison, D. Mullin, Lewis. Front row: Woods, Aitcheson, J. Moon, R. Fletcher and Edmunds.

Right: Hendon Board cricket team 1960. Back row, left to right: Anderson, A. Allan, D. Anderson, D. Mullin, S. Lister. Middle row: Mr Liddle, J. Dunlop, R. Davison, A. Surtees, Ellison, G. Trusty. Front row: Metcalf, Lamb and H. Walker.

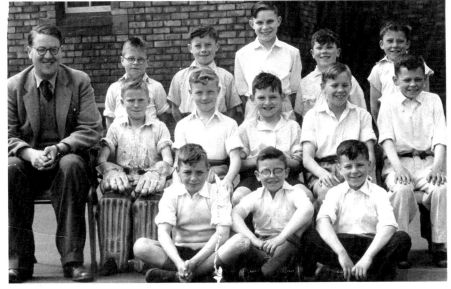

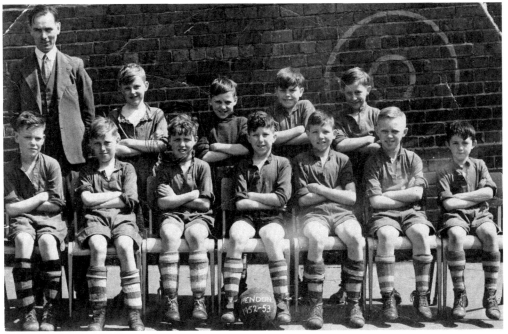

Left: Hendon Board Juniors football team 1952-53. Back row, left to right: Mr Hopkirk, Davy Wake, Tommy Southern, Derek Johnson, Ivan Lincoln. Front row: John Iley, Peter Old, Jimmy Davison, Tommy Lamb, Billy Hargrave, Brian Norton and Bobby Carney.

Jimmy Davison

Jimmy was born in Tower Street, Hendon in 1942 and his house faced the Burn, the football ground that was to play an important part in his early life. It wasn't difficult for the teachers of Hendon Board, where Jimmy attended, to see that he was destined to be a sportsman although that wasn't his parents view of the future for Jimmy. While Jimmy developed and excelled in football and cricket mam and dad encouraged him to develop academically as well and Jimmy, being the kind of person he was, wanted to please them, and eventually he passed his 11 plus and went to the Bede Grammar School, where, although his sporting career carried on, he also developed very well in his education. That was in 1953 and the last time I would see Jimmy until years later.

Jimmy did well in football terms and there were many scouts from professional teams all over the country looking for his signature, which pleased Jimmy, but his parents were not happy, they had plans for their son to become an accountant which he could have easily become considering the qualifications he was now amassing. Eventually he was given trials by Sunderland AFC, the manager being Alan Brown at the time, and he was signed on as an apprentice in 1958. The teachers at Hendon Board were keeping tabs on Jimmy and they were still very proud to have been involved in his early development, especially Mr Liddle and Mr Randolf the sports teachers. On 21st November 1959, after only three games for Sunderland

Reserves, Jimmy was to make his debut. The teachers were so proud that they wanted to mark the occasion, believing it to be an honour for the School, so the day before Mr Liddle and Mr Randolf invited Jimmy's dad and his young brother Bobby to join them on the journey to the Old Showground, Scunthorpe United's ground. As there weren't many cars around, and transport was short, they all went in Mr Randolf's car. Although the match ended in a 3-1 defeat for Sunderland, Jimmy played well, and brought home with him an interesting memory. Jimmy was up against a full back called Jack Brownsword, who introduced himself to Jimmy, by saying 'Have a good game, but you do know I'm going

*Completing a trio of Hendon footballing brothers –
Alan (left) and Bobby Davison.*

to kick you off the park,' and he did. Jack Brownsword stayed with Scunthorpe as a trainer, and when a certain young apprentice joined Scunthorpe Jack took him under his wing and taught him all that he knew, so much so, the apprentice attributed his professional career to what he was taught by Jack. That apprentice was none other than Kevin Keegan.

Jimmy remained with Sunderland from 1959 until 1962-63 season, when he was transferred to Bill Ridding's First Division team, Bolton Wanderers, for about £15,000, which was quite a few bob in those days. Having played a couple of seasons for Bolton, and after picking up one or two injuries, Jimmy moved on and eventually ended up in Dumfries playing for Queen of the South, which was where I saw him again after all this time. It was about 1967, about 14-15 years since I last saw him, yet he still recognised me. He became a goal scoring legend for the Queen's and the fans of course loved him and they still talk about him today. Age was now creeping up on Jimmy and he moved on to play for South Shields at Simonside and then moved on to play for Darlington where his football career ended.

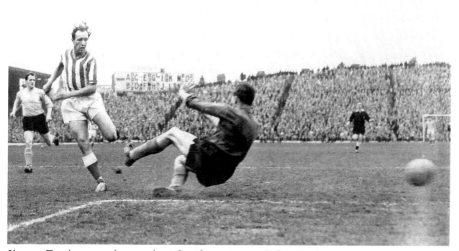

Jimmy Davison scoring against Southampton at Roker Park.

He then took up employment with Sunderland Council as a time and motion man and also had a spell at Brian Mills doing the same job before returning to the Council. On 2nd February 1987, in the early hours of that morning at the tender age of 45 years, Jimmy suffered a sudden heart attack and passed away. He is and will be remembered for always by his family and his friends and teachers from Hendon Board School who were proud to call him friend.

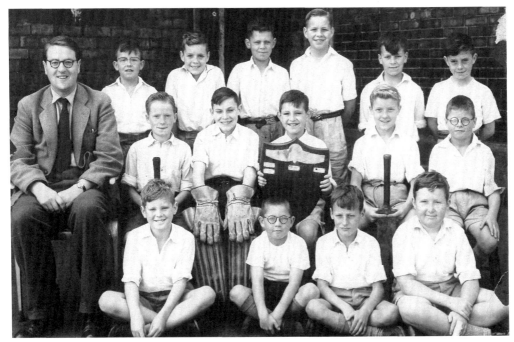

Left: Hendon Board cricket team 1959-60. Back row, left to right: Lamb, Metcalf, Trusty, Ellison, Walker, Allan. Middle row: Mr Liddle, Dunlop, A. Surtees, Anderson, Davison, Anderson. Front row: Hall, Anderson, Moon and Bailey.

Right: Hendon Board Seniors football team 1957-58. Back row, left to right: Alfie Hargrave, Mr Whiting, John Turner, Ronnie Carter, John McNally, Stan Willis, Ray Lowes, Mr Rutter, George Mole. Front row: Joe Haslam, Billy Richardson, Billy Robson, Alfie Moon, Bobby Sly and Billy Surtees.

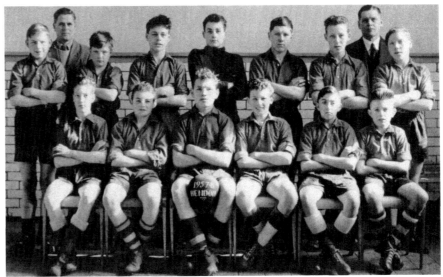

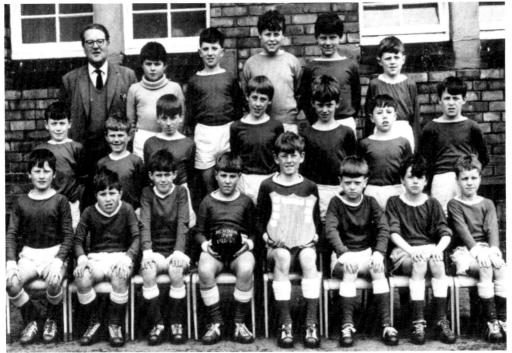

Left: Hendon Board Juniors football team 1966. Back row, left to right: Mr Liddle, Richard Marshall, Robert Foster, Billy Brian, Michael Venner, unknown. Middle row: Keith Robertson, Robert Heaton, Jimmy Fergerson, Jimmy Buckle, unknown, Sayers, Robert Arlington. Front row: Tommy Dunlop, Jimmy Mullin, Alan Steinberg, Peter Farrar, Tony Tinnon, Johnson, Brown and White.

Work Before Play

I was born on the 30th March 1943 at 4 Christopher Street, Hendon and grew up in and around the streets of Hendon where, in those days, poverty reigned. My mother was unable to work; she never had the time, having to bring up me, my brother and two sisters. My dad worked for North Eastern Marine as a crane driver but I think most of his earnings were donated to the Prince of Wales and other Hendon pubs, so we just had to fend for ourselves. When I was old enough I went to Hendon Board School, where I recall my first teacher was Miss Eaker. When I went into the seniors I had grown somewhat and was tall and skinny, and our sports master, Jack Washington, must have thought I had some potential as a fast bowler in the cricket team in which he included me. He then sent me to Alec Bedser's School of Coaching in Silksworth, but by now I was fourteen years old and I was offered a job at the London and Newcastle Tea stores in Hendon Road as an errand boy delivering groceries and, the way things were at home, with mum needing help, the cricket got the boot. Not that I regretted it as I was earning about thirteen shillings a week plus tips, so it was a big help. My next job after leaving school was on the railway on the South Docks, starting as a messenger, and then working up to become a shunter, but then along came Mr Beecham who made me redundant so I got a job at Plessey's for about six months and hated it. I started driving again for A.A. Joblings, a wholesale grocery firm in Woodbine Street, where I worked for about a year, moving then to sell bread for Mothers Pride. After that I went to drive for VG Food stores at Durham and then on to Clark's Haulage for a week, then on to Walls Ice Cream, delivering wholesale to shops. After that it was back to the railway for a short spell then on to National Carriers delivering parcels, then on to Vaux Breweries as a drayman where I remained for nine years, before I became a steward for the Railway Club in Holmeside where I remained for twenty-two years.

In the meantime I had met a young girl from St Leonard Street called Margaret Walker, whom I married in 1968. We went on to have three children, two boys and one girl, and we now have three lovely grandchildren who we see on a regular basis. I'm now retired, and we are enjoying the kind of lifestyle we could only dream of when we were kids. I now play a lot of golf, and we have two West Highland Whites which we walk every day to keep us fit and healthy. This is the life now and it's CUSTY.

Freddy Warren

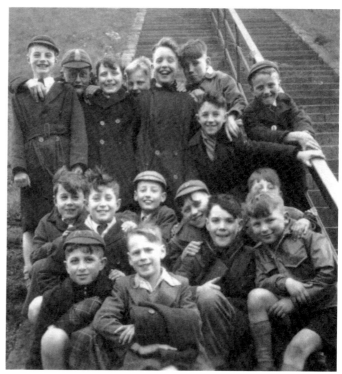

Hendon Board football team on a visit to Tang Hall in York to play a friendly match in 1954. The game was arranged by Hendon teacher Mr Gordon Liddle and his brother who was a teacher at Tang Hall. They were beaten 2-1 with Davy Wake scoring the Hendon goal. Back row, left right: Billy Richardson, Davy Wake, David Carter, Alfie Hargrave, Jimmy Davison, Billy Robson, Keith Cubby, Bobby Carney. Front row: Syd Mordey, Alan Howard, Jimmy Goodfellow, Tommy Southern, John Byrne, Kenny Vipond, Dennis Hargrave, Gordon Walker and John Innes.

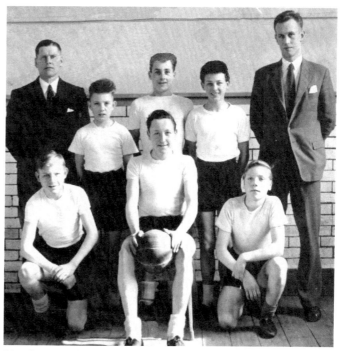

Hendon Boys basketball team 1957. Back row, left to right: Mr Rutter, W. Surtees, McNally, A. Moon. Mr Harrison. Front row: A. Hargrave, Richards and G. Mole.

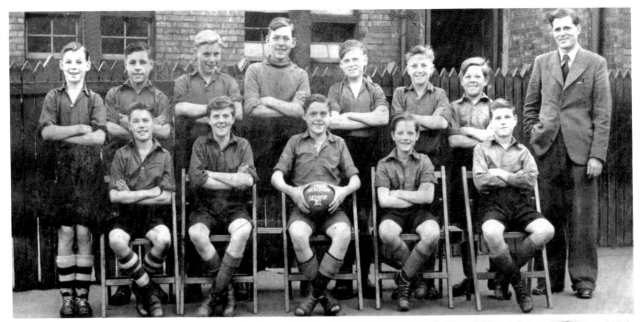

Above: Hendon Board Seniors football team 1951-52. Back row, left to right: R. Sumner, Marshall, Moore, Alex Bryan, Mordey, Gardener, Hunter. Front row: unknown, Swales, Chapman capt, unknown, Hill and Mr Whiting.

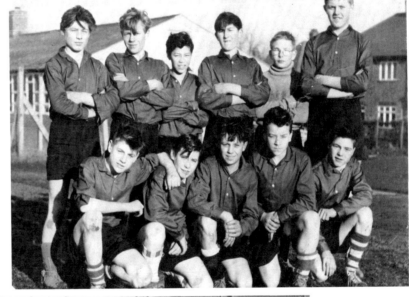

Right: Hendon Board Seniors 1962. Back row, left to right: John Fletcher, Ernie Woods, Harry Macca, John Berridge, A. Lawson, Bentley. Front row: John Knox, Micky Whitehead, Tommy Sayers, Harry Walker and Eddie Gallon.

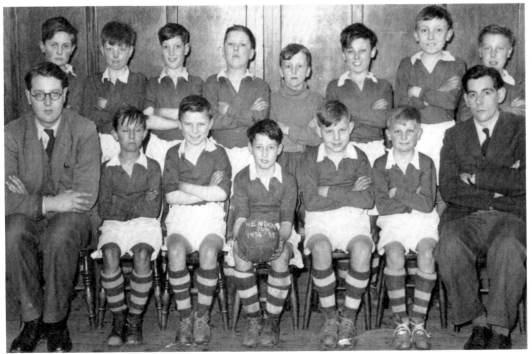

Left: Hendon Board Juniors football team 1954-55. Back row, left to right: Freddy Bailey, John Turner, unknown, Stan Willis, Cubby, Alfie Moon, Peter Shevlin, unknown. Front row: Mr Liddle, unknown, Dennis Hargrave, Jimmy Goodfellow, Alfie Hargrave, Roland Hedgley and Mr Pullin.

Jimmy Goodfellow

Jimmy Goodfellow was born 16th September 1943, in Hendon, near Hendon Board School. From a very early age his father used to tell Jimmy stories of Hendon Board's most famous pupil, Horatio Stratton Carter. Raich Carter was born only a few streets away and of course played for England and was captain of the FA Cup-winning Sunderland team of 1937, so it was little wonder that Jimmy would grow up with football on his mind.

Jimmy Goodfellow, Cardiff City and Hendon Board.

Jimmy was to attend Hendon Board from September 1948 and not only would he become outstanding at football but he was to become very good in cricket and gymnastics. He was so interested in these sports he would practise during dinner times and after school almost every day, with of course much encouragement from two of the best sports teachers ever, Mr Liddle and Mr Jack Washington. Being such a sportsman himself, Jimmy would watch the professionals at Roker Park and his favourite Sunderland players at the time were the likes of Len Shackleton and the Welsh wizard, Trevor Ford, who Jimmy would meet many times during his own career, and another Welsh defender, Ray Daniel. Jimmy seemed as though he was destined to be connected to the Welsh. After passing his 11 plus exam, Jimmy moved to Villiers Street Technical School and then on to Southmoor Technical School. He began playing for Sunderland Schools in the same team as Sunderland legend Jimmy Montgomery and he also played for one of the most famous Youth Clubs in Sunderland – Lambton Street Boys. Sadly then Jimmy committed one of the North East's deadly sins when he went to play for Newcastle United Juniors with the likes of Bobby Moncur and David Craig. He met Jimmy Scoular, who was then United's captain, but who was to become manager of Cardiff City. At first Jimmy didn't break into the professional ranks but toured the amateur circuit playing for Crook Town where he was to become a Wembley winner in April 1964, when Crook beat Enfield 2-1 with Jimmy scoring the first goal to lift the FA Amateur Cup. On that day Sunderland clinched promotion and the *Football Echo's* front page was full of the story while the back page showed Jimmy scoring his goal at Wembley.

Jimmy stayed with Crook for a couple of years before moving to Bishop Auckland where Lawrie McMenemy was manager. While he was there he got an offer from Port Vale to turn professional. Jimmy was still amateur at the time and his proper job was as a draughtsman at Vickers Shipbuilding but the offer of becoming a full-time footballer was always his dream. His dream came true by being signed-on by one of England's most famous footballers, Stanley Matthews, later to become Sir Stanley. After Port Vale Jimmy moved to Workington but could have moved to Hartlepool when Len Ashurst was manager in the 1970s, but Hartlepool couldn't afford the asking price so Ashurst recommended Jimmy to Rotherham United where he moved in 1973. He remained with the Yorkshire club until 1978 when he moved to Stockport County. Sadly Jimmy's playing career ended while playing for Stockport. He had taken up a position as unofficial player-coach under Mike Summerbee who was player/manager and, after playing a handful of games, he sustained a knee ligament injury while playing against Halifax on 22nd August 1978 and he more or less decided to retire. He tried to play one more game when Stockport were drawn against Manchester United and his name was on the teamsheet but he was unable to get on the pitch, but as it was his last game, both teams signed a programme for him which he treasure's to this day. Living in Sheffield at the time Jimmy was thinking of going into training youths in the Rotherham area when in January 1979 the call came from Len Ashurst who was manager of Newport County, and so Jimmy and his family moved to Rogerstone in Gwent where they still live today. He spent two years there before he was sacked because of economy measures, so they were told, so when Len was appointed manager of Cardiff City he took Jimmy with him as trainer/physio. He was there until Len left and was manager himself for a short while in 1984. He then had spells at Plymouth and Sunderland when Len Ashurst was manager. It was while he was at Sunderland that he met Frank Burrows, and when Frank was appointed manager of Cardiff City he asked Jimmy to go with him as physio and, as Jimmy and his family were still in Wales, he asked Len Ashurst to release him. He is still at Cardiff City today ready for retirement and looking forward to spending more quality time with Sylvia, his wife, and Claire and Mark, his son and daughter, Geraint and Nicola their partners and of course the light of his life grandson Jim, Mark's son and Scott and Lili, children of Claire.

Unlucky Goalkeeper

Tommy Southern started Hendon Board in 1947 and from a very early age showed an interest as a goalkeeper in football and as a wicketkeeper in cricket, excelling in both positions. Like most kids of the time he was encouraged in his sporting activities by his dad, kicking a tennis ball about, throwing it about and catching to develop his ability in goal and wicketkeeping. It was in school where Tommy was brought on by Jack Washington a sports teacher who developed what Tommy's dad had already sown. Tommy had the obvious heroes outside of school, Johnny Bollands the then Sunderland goalkeeper and, although he was at the end of his career, Johnny Mapson. As he progressed and developed he was offered a trial with Sunderland AFC but unfortunately the other goalkeeper that day was accepted and was to become one of the most successful goalkeepers of all time – Jimmy Montgomery. In 1954 Tommy left Hendon Board for West Park to further his academic career and continued with his sporting activities but never developed enough for a professional career in sport. In my opinion the sporting world lost out.

When Tommy went for a job as a draughtsman at JL Thompson's in 1958 the personnel officer, Jack Wilson, asked him if he was interested in sport and when the reply was that he was, Tommy was told you can start tomorrow. He went on to play for the JL Thompson's apprentices and the senior teams, but when he finished his apprenticeship, although he had games for other teams, he lost touch and although he would have liked to continue other things came along and he just drifted away from the sport. Tommy did comment that because of injuries received by playing in goal he lost a lot of time off work and that was one of the main reasons why he left the sporting world. Sadly he also admits to being a very bad spectator and continues to kick every ball from the sideline.

When Tommy left Hendon Board for West Park his family continued to live in Hendon and Tommy was proud so much so that he was angry that a native of Hendon once commented that having left Hendon he was glad to do so and wouldn't return for all the tea in China. Tommy replied that he was proud to say he came from Hendon and that even today he drives around Hendon where he was born, just to be close to his roots and his memories. Having married a Sunderland girl who was living in Hendon at the time, Tommy and his wife have one son and now have a granddaughter aged 16 months and, having been married for 37 years, he and his family are looking forward to a long and happy retirement. As a footnote, on the day I went to visit him, Tommy having had a quadruple heart-by pass in 1998, having dropped me off in the town, went home and had a heart attack and had to go through to the Freeman Hospital to have two 'stents' put in his arteries. May I wish him a full recovery and long life and the very best to his family.

Hendon Girls netball team 1960-61. Back row, left to right: Mrs Wyman, Edna Humble, Carol Miller, Margaret Woods, Denise Potts, Mrs Loffman. Front row: Sandra Taylor, Ann Prossen and Veronica Johnson.

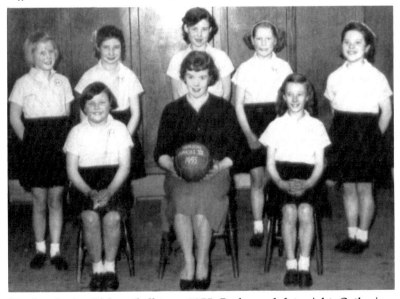

Hendon Senior Girls netball team 1955. Back row, left to right: Catherine Latimer, Mary Davison, Gladys Davison, Miriam Grieveson, Margaret Anderson. Front row: Sheila Dolman, Miss Rich and Jean Parker.

Right: Moor Board football team 1950: Back row, left to right: Billy Miller, Freddy Kramer, Mr Royston, Ron Swinburn, Jean Tisard, Tommy Siddell, Les Mitchinson. Front row: Billy Middlemas, Tommy Ross, Eddie Crawford, Alex Sloanes, Charlie Richardson, Tommy Rackstraw and Alan Mitchell. Foreground George Dagg and Alan Wake.

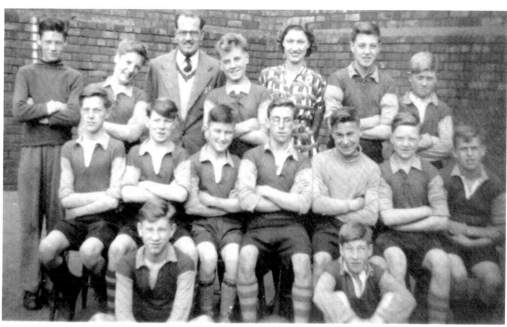

Left: Moor Board football team in civies 1948. Back row, left to right: Amos Robinson, George Manners, John Reay, Jimmy Middlemas, unknown, Billy Sawyer. Front row: Davy Dunn, George Gray, Tommy Owens and Bobby Downs.

In the 1880s Moor Board School, along with Hendon Board and James William Street, provided dinners for children in the East End and Hendon. This was at a time of depression in trade and the Relief Committee asked the School Board for help. Cooking equipment was installed in a total of five schools in town and they served almost 90,000 meals for children who might otherwise have gone without.

Moor Board Secondary Modern School Form 3 1950. Back row, left to right: J. Ward, D. Weldon, M. Urch, R. McKinney, T. Siddell, B. Wilson, F. Eggleston, A. Sloanes, R. Ashton, B. Fox. Third row: W. Middlemas, G. Dagg, A. Smith, M. Johnstone, A. Manners, A. Wilkinson, S. Dobbs, M. Dowd, D. Dunn, T. Rackstraw, T. Ross. Second row: V. Clayton, Durston, E. Purnell, Kent, B. Robinson, Mr Bowens, B. Gillespie, A. Smith, Harrison, Sumner, I. MacLean. Front row: J. Owens, D. Foster, T. Taylor, C. Richardson, T. Davison, D. Underwood, R. Thompson, B. Murtha and L. Mitchinson.

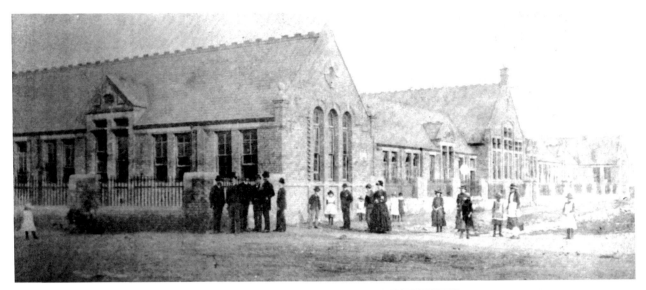

Above: Opening Day November 1884 Hendon Valley Road Schools.

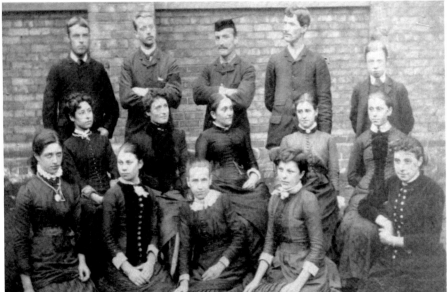

Left: Hendon Valley Road Staff 1885. Back row, left to right: F.A. Scholefield, unknown, G.T. Ferguson, J. Leitch, R.P. Watson. Middle row: J.R. McLean, M. Livingstone, B. Bowes, unknown, H. Summers. Front row: unknown, E. MacKay, Jolly, A. Brown and E. Mason.

Right: Hendon Valley Road Staff 1887. Back row, left to right: A. Brown, H. Summers, unknown, R.P. Watson, E. Chrishop, J. Carter. Fourth row: unknown, E. MacKay, W. Phorson, Jolly, F.A. Scholefield, unknown. Third row: F. Woodward, R. Barnes, unknown, J. Leitch, unknown. Second row: unknown, E.M. Burlinson, B. Bowes, G.T. Ferguson, M. Livingstone, J.R. McLean, A. Gaine. Front row: Cooper, A.J. Robson, E. Mason and S. Tindle.

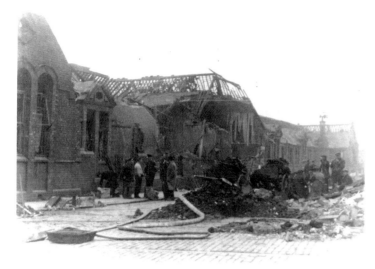

Left: The aftermath of the bombing of Valley Road School 10th November 1942.

Below: Hendon Valley Road Senior Girls School around 1950. Back row, left to right: Shirley Daley, Dorothy McDonald, Maria Burn, Ann Aitcheson, Margaret Cutting, Joyce Shotton, Audrey Gerrard, Betty Harvey, Muriel Waters, Rhoda Passmore. Middle row: Mary Davison, Christine Longridge, Brenda Abrahams, Edith Hinds, Irene Southern, Isabel Mullaney, Charlotte Fullard, Betty Clark, Audrey Svenson, Margaret Wright, Brenda Scott, Joan Parker, Ellen Wayman. Front row: Phyllis Skinner, Dorothy Walker, Judith Crompton, Cathy Robson, Margaret Ditchburn, Lillian Nesbitt, Olga Warwick, Peggy Smith, Avril South, Pamela Robinson and Pat Reid.

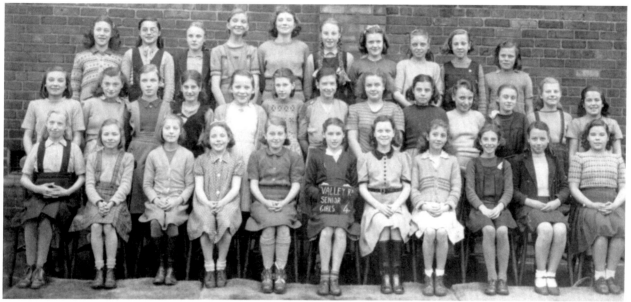

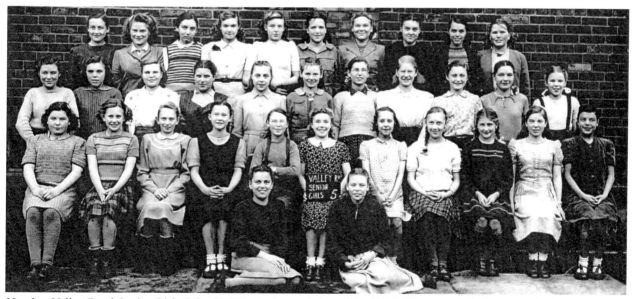

Hendon Valley Road Senior Girls School 1951. Back row, left to right: Edith Wingate, Sally Young, Winifred Jones, Rita Richardson, Hazel Turnbull, Mabel Bailey, Norma Stewart, Freda Roberson, Kathleen Wilkinson, Audrey Taggart. Middle row: Thelma Shotton, Pat Greenlay, Audrey Potter, Florence Coates, Sheila Munro, Sylvia Savage, Sheila Forman, unknown, Pat Dixon, Brenda Robinson, Sheila Reay. Front row: Catherine Nicholson, Joan Hall, Jean Coombes, Jean Birkett, Audrey Pallas, Sylvia Robson, Muriel Rogers, Joyce Morrell, Ena Johnson, Francis Crossley, Elsie Bargwell. Front on ground: Sheila Adams and Dorothy Gibson.

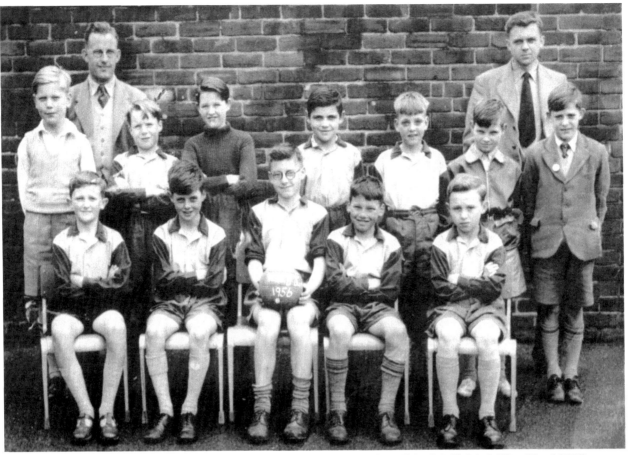

Hendon Valley Road Juniors football team 1955-56. Back row, left to right: Michael Still, Mr Miller, Harold Wilson, Roy Ladbrooke, John Brown, Billy Paterson, unknown, Mr K.C. Wallace, unknown. Front row: Stanley Hall, John Smiles, Trevor Steel, Brian Carter and unknown.

Left: Hendon Valley Road Teachers April 1959. Back row, left to right: M. Bennett, E. Ward, M.T. Allard, F.M. Brodrick. Front row: T. Richardson, D.J. Whale, E.M. Scholefield (Head), H. Leith and Mr Wallace.

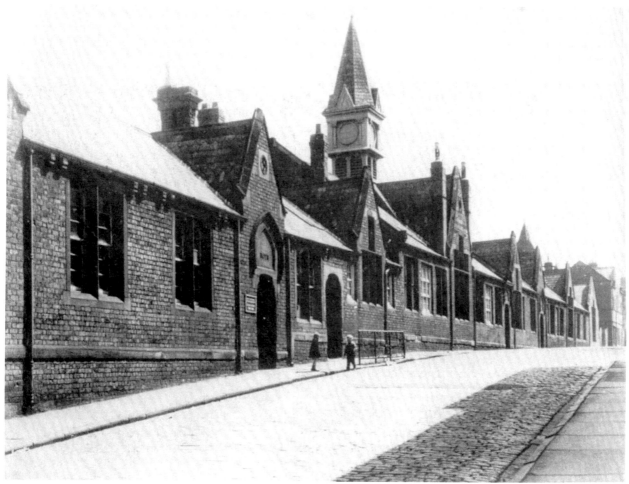

James William Street School affectionately known by everyone in the area as Jimmy Willies. Jimmy Willies was one of the first Board Schools in Sunderland opening in 1871. Pupils of note in later years – John 'Pasty' Brown and the Rich brothers Arthur and Henry were just two of many good footballers to come out of the school. The most eagerly awaited game for the football team was the clash with local rivals St Pat's. The winners of this fixture in the post-war period could call themselves the East End's Top Dogs – until the next local derby.

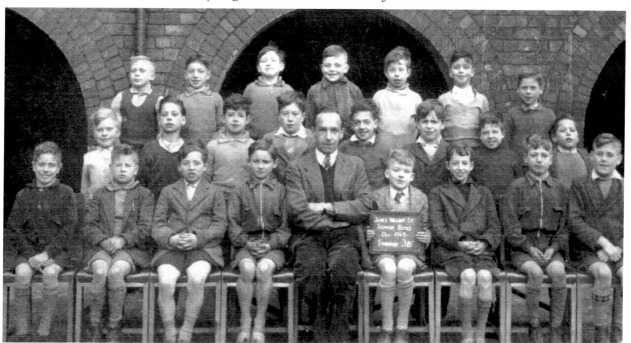

James William Street Senior Boys Standard 3B October 1949. Back row, left to right: Ron Black, Billy Robson, John Dunn, unknown, Emmerson, Eric Craig, John Ward, John Smith. Middle row: Maurice Laws, George Waiters, Alan Gray, Charlie Coatsworth, Billy Stokoe, Jim Cobhan, John Fletcher, George Smith. Front row: Tom Leithe, Alf Banks, Charlie McKenna, Robert Bewick, Mr Bailey, John Brown, Jim Lawson, John Smith and Steve Coates.

Arthur Rich

Arthur Rich was born in Flag Lane in the East End of Sunderland in 1935. Arthur is the oldest son of Henry and Rebecca Rich. Their second son Henry was born three years later, and was the last of Henry and Rebecca's children. When Flag Lane was demolished the family then moved to Covent Garden Street. Both Arthur and Henry were to become professional footballers, and began to show their talents when attending James William Street School. Both played for the school teams but at different times of course. When Arthur passed his 11 plus he went on to West Park School, a school for Further Education, and continued his football by playing for the school teams. Although Arthur's father Henry was to encourage him in his footballing interests, the feel for the game was inbred and natural to him from a very early age. Arthur and Henry's uncle on their mother's side, while encouraging both boys, fired Henry on with a task which turned out lucrative for Henry. It was to be most expensive for the uncle. He offered Henry a shilling for every goal he scored and Henry was a prolific goalscoring centre forward. In the first week after the offer he scored five goals and in the second week he scored seven. I don't think the offer stood for a third week. Speaking to George Tyson,

Henry aged 3 and Arthur Rich aged 6, Covent Garden Street.

who went to Hendon Board School and played against Henry Rich when Henry played for Jimmy Willies, Hendon were beaten by 9 goals to nil and Henry scored them all, so George remembers Henry all right!

Arthur left West Park School at fifteen and started work for JL Thompson's Shipyard, and played football for Thompson's B team on a Saturday mornings and for the YMCA on the afternoons. While he was playing for the YMCA, Bishopwearmouth came and asked him to sign for them, which he did, helping them to a trophy hoard for a couple of seasons. He then went on to play for Durham County Boys. While playing for these two teams, Arthur was approached by Leeds United's scout for the area, ex-policeman Matty Taylor. Arthur accepted the invite and was

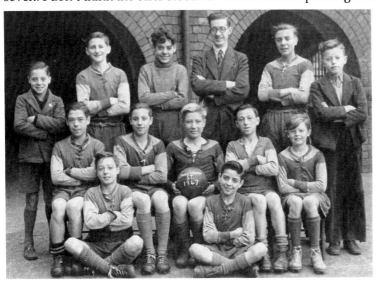

James William Street School 1947-48. Back row, left to right: Bobby Pescod, Sep King, Tommy Hall, Joe Barr, Jimmy Simpson, Freddy Lay. Middle: Billy Gooch, Billy Watson, Tommy Smith, Harry Dury, Arthur Rich. Front: Jimmy Binyon and Bobby Tate.

introduced to a Hendon Board lad who was manager at the time for Leeds – Raich Carter. After a brief trial, Arthur signed and began playing for the intermediate team, winning their league in his first season.

Not long after joining Leeds A team, Arthur was called up for his National Service. He served two years with the Royal Artillery, with 29 Field Regiment based in Germany. He was there for two years almost and of course he played for the BAOR football team. On

Leeds United under 18's. Back row, left to right: Ernie Taylor, Delwyn Jones, Leon Herford, Arthur Rich, Kenny Noble, Peter Flynn, Malcolm Newton, John Reynolds. Front: Joe Conroy, Ernie Edmonds, Peter McConnell, Michael Evans, Davy Jones and Davy Powell.

his discharge he returned to Leeds United and began playing in the reserves. He played one game in the first team, a West Riding Cup Final, against Halifax. He was at Leeds for four years where he was understudy for the great John Charles and big Jackie Charlton, and we all know how far they went.

Arthur was transferred to Bradford Park Avenue but because of home sickness after a year he left Bradford and returned to the North East. He met up with his brother Henry and they both signed for Spennymoor United who were in the Midland League at the time, playing two seasons and winning the Durham Challenge Cup in the process. The Midland League then folded and Spennymoor went into the Northern League which was

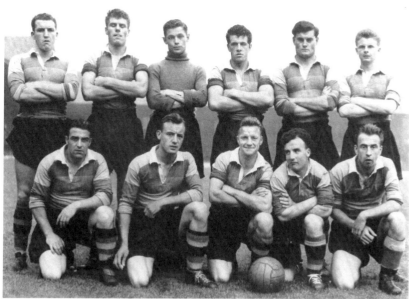

Bradford Park Avenue. Back row, left to right: Frank Bates, Gerry Baker, Peter French, Alan Jones, Bryan Redfern, Arthur Rich. Front: Ernie Winter, unknown, unknown, Peter Ward and unknown.

open only to amateur footballers, so Arthur, being a professional, had to leave and he signed for Easington in the Wearside League. He played for three or four seasons but then left. The next time he played he had to get a permit which cost him ten shillings and he signed for the Pallion Club which was where he finished his football career. He was now thirty-seven years old.

While he was playing amateur football Arthur had took up working in the shipyards as a welder, and he worked for most of the yards on the river, Thompsons, Bartrams and Austin and Pickersgills, naming just a few. He never played for any of the works' teams after he retired, but like all footballers who finish playing, he said it's like having your legs cut off. When he goes to watch a game he kicks every ball and heads every ball in defence. Arthur was a centre half, so he directs the defence. In other words he still plays the game but this time in his head.

Arthur met and married his lovely wife Audrey Smith, an East End girl, from the Barracks. They were married in 1958 and had three children, all boys, Arthur, Robert and Stuart, none of whom played football. Most sadly after 48 years together, Audrey passed away earlier this year (2006), leaving Arthur and the boys, and many, many, friends devastated over her passing. I know that all of Arthur's family and friends will rally round, but Audrey will be a big miss to all who knew her.

Arthur Rich, July 2006.

Spennymoor United. Back row, left to right: Norman Fields (trainer), Peter Stansfield, Jimmy Fulwell, unknown, unknown, unknown, Arthur Rich, Billy Blenkinron, unknown (trainer). Front: Harry Dobbie, Dick Young, Harry Hall, Tommy McQuilligan, unknown and Dick Young.

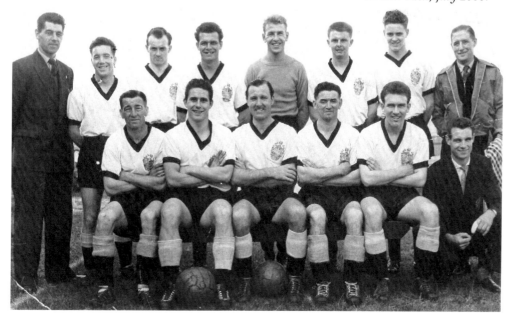

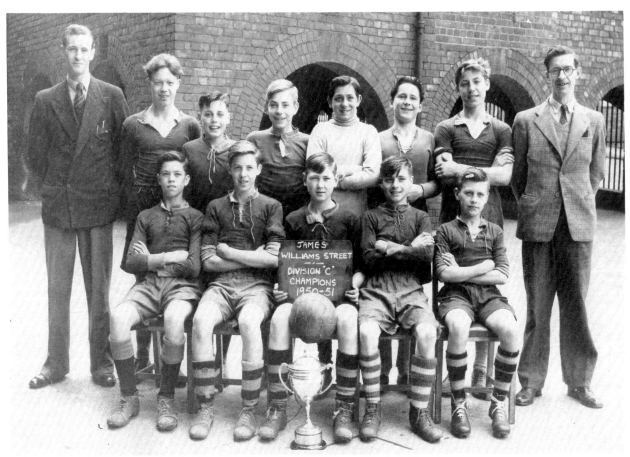

James William Street football team Division C Winners 1950-51. Back row, left to right: Mr Hunter, Fred Binyon, Alan Martin, Hopper, Alan Dunn, Les Bewick, Giles, Joe Barr. Front row: Tommy Appleby, Henry Rich (brother of Leeds United's Arthur), Norman Young, Purvis and Turnbull.

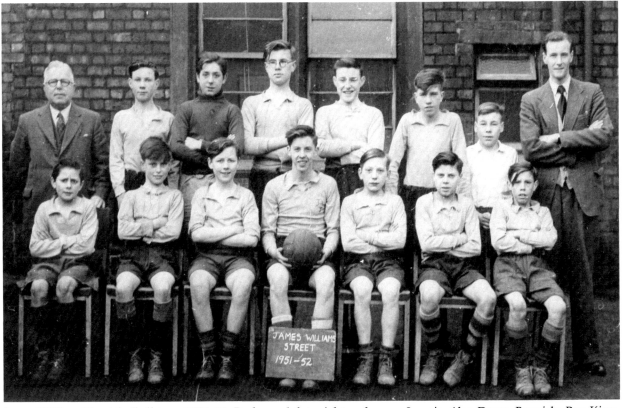

James William Street football team 1951-52. Back row, left to right: unknown, Lonnie, Alan Dunn, Burnicle, Ray King, Eddie Ashton, Tommy Thompson, Hunter. Front row: Ronnie Tate, Derek Scott, George Binyon, Henry Rich, Billy Taylor, Norman Pescod and Lonnie.

Right: St Patrick's School football team League Champions 1923. Back row, left to right: Tom McGregor, Joe Geraldi, Bert Brown, Dennis Lone, Tony Mincella, Matty Kelly. Middle row: J. Watters, J. Lynch, Father Anthony, J. Wilkie. P. Walsh. Front row: Micky Wilkinson, Jimmy Kelly, Billy Miller, Miles Martin and J. Stanley.

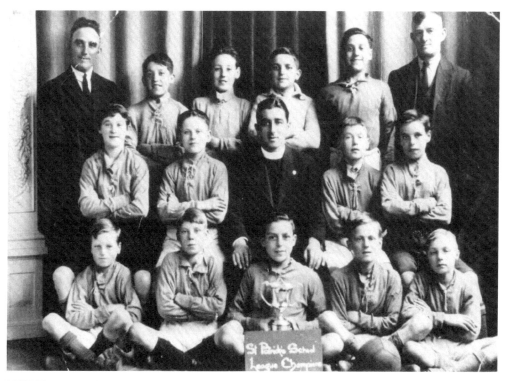

An advert for Liverpool House from 1951. The cost of these items of schoolwear were beyond the pockets of most families in Hendon and the East End. Many got their children's uniforms from Ginny Moore's – all clothes and shoes were about 3d or 6d each.

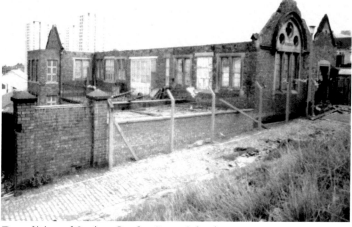

Demolition of Spring Garden Lane School.

William Roberts, Hudson Road School, 1943.

An illustration of Gray School in the East End. This school closed in 1938.

93

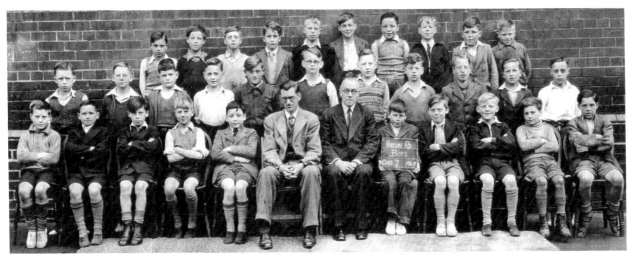

Hudson Road Senior Boys Class 7 1949. Back row, left to right: Richard Maxwell, Charlie Mavin, George Bell, unknown, Lowes, unknown, Scott, Michael McCarthy, John Hodgson, Jack Hurdman, Vincent Mulvanny, Tommy Simpson. Middle row: George Hair, Henry Wilkinson, unknown, Hunter, Alan Freeman, R. Howard, Alan Miller, Harry Bell, Ronald Wallace, Arthur Atkinson, George Mavin, Robert Downey. Front row: Matthew Trotter, John Bewick, John Fergerson, Jim Goodings, Tommy Peacock, Mr Easton, Mr Kirby, Derek Ward, George Kaye, Raymond Burnett, Harry Woodhams and Albert Roberts.

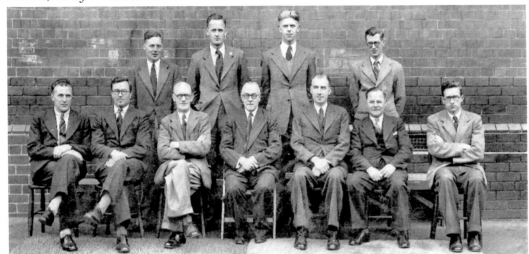

Left: Hudson Road Teachers 1947. Back row, left to right: A. Ross, A. Fairless, J. Phillips, W.D. Easton. Front row: W. Boocock, R. Scott, J. Bainbridge, L. Kirby, A. Lodge, W. Walker and S. McMahon.

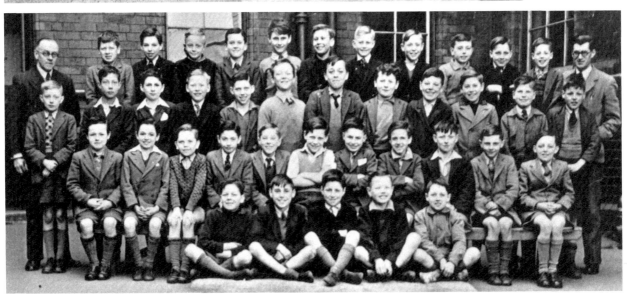

Hudson Road Schools Senior Boys 1949. Back row: Mr Kirby, J. Rathbone, unknown, J. Allan, A. Smith, unknown, Brian Deighton, A. Burnett, unknown, R. Fisher, C. Walker, P. Henderson, Mr Easton. Third row: Anderson, N. Harper, J. Gregory, W. Craggs, A. Blake, E. Shields, T. Lobbin, Morton, Storey, unknown, K. Robertson, J. Dunville. Second row: A. Glendenning, M. McCarthy, unknown, W. Woodhouse, R. Lister, unknown, A. Corner, P. Robertson, R. Casey, T. Cheeseborough, G. Walker. Front row: J. Phillips, C. Carr, T. Reynolds, Craggs and J. Hill.

Commercial Road Senior Girls School 1951. Back row, left to right: Joyce Morton, Audrey Miller, Miss M. Stewart, Margaret Curle, Marjorie Johnson. Middle row: Moira Burn, Sheila Munroe, Sheila Adams, Muriel Kinnier, Hazel Turnbull, Margaret Kinnier, Freda Robinson, Kathleen Wilkinson. Front row: Audrey Pallas, Joan Hall, Betty Telfer, Mary Horn, Dorothy Marshall, Shirley Lemon, Ivy Laing and Ella Fisher.

Left: Commercial Road School around 1990. By this time the Senior Departments had already been demolished. A new school stands on the site and is now called Grangetown Primary.

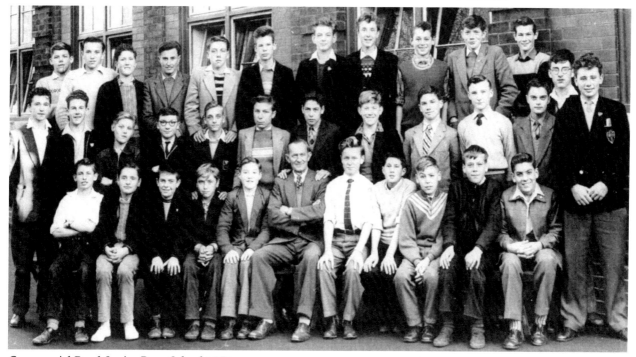

Commercial Road Senior Boys School 1959.

Bobby Carlisle

I was born in hospital in 1952 and my family were living in 14 Ward Street, Hendon at the time, and then we moved to Salem Street when I was about 5 years old. We lived there until I was about 13 and then we moved to the East End skyscraper South Durham Court.

As far as schooldays went I was a great lover of sport and I played football and cricket for Hendon Board. It became a toss up between football and the guitar and I chose the guitar. One of the lads I can remember who I played football with was Davy Edmundson who played for Sunderland Boys. I also played for Sunderland Boys a couple of times. There was a lad called Tommy Routledge who played in goal and Peter Lowrey. I remember when the bull escaped from the slaughterhouse in Bull's Back Lane and got into the schoolyard. My teachers were Miss Stothard, headmistress. There was Fred Whiting, Tony Adamson, Mr Pulling, although he never taught me, and Mr Liddle. I remember one Saturday morning I was playing football and the ground was covered in ice, and I fell and split my knee wide open. Mr Liddle picked me up and carried me for ages. We finally reached a church, what church it was I'm not sure but we were playing up at Spark's Farm, I was only about 9 years old, anyway the vicar of the church strapped me up. To me Mr Liddle was the best teacher ever.

Bobby Carlisle aged 12 years.

From being a kid I was always fascinated with the guitar, I just couldn't pass a shop. There weren't any guitar shops as such, but there was the likes of Bergs Music Shop, Atkinsons, and lots of second-hand shops that had these guitars in the windows, and of course Brechners in Hendon Road. I eventually got a guitar when I was 10 years old, and me ma sent me for lessons. I was influenced by the likes of Hank Marvin and Bert Weedon, but I mostly admired Les Paul. There were a couple of lads who used to live in Salem Street

Bobby aged 16 upstairs in the Tatham Arms.

who were older than me and used to play guitar, Matty McCarty, used to have a milk round and Norman Emmerson, and although I tried to learn off them it seemed as though I was getting nowhere, so me ma sent me to a fella in Percy Terrace. He was a Salvation Army Band leader, John Hall was his name. He was also a welder at Austin and Pickersgills, although he had never played a guitar in his life he taught me to play. In 1962 I started to play 'for real', I began lessons in the March, in the December, me da and me Uncle Jack went to the Silksworth Buffs on a Sunday morning Jolly Boys, and they got me a spot on a Sunday morning. The first Sunday I did a spot with Karl Denver's *Wimoweh*, I only did about 20 minutes, and I didn't have an electric guitar just an acoustic. I just played some instrumentals and I went back the following Sunday and Val Doonican was on! At the time I was teaching my cousin, our Col, who was 4 years older than me, and together with a couple of other lads we got a bit of a group together. I was going to one of my last lessons, and I was standing outside of Fred Crooks paper shop, and this fella came up and saw my guitar, and he said in pit jargon "Ow youngin can thou play that thing," he was wearing a tuxedo, and I said "Why aye a can play," and he said that when I learnt to play properly I had to go and see him and he gave me his card, Patsy Gallagher, he lived in Peel Street and he was the local impresario. It was advertised

in the Echo a few weeks later, that an act was wanted for the Patsy Gallagher Road Show. Well I had just got a new electric guitar for Christmas, the rehearsals were at Red House Comprehensive School Community Centre, and I went up with my group. Well I had been in contact with Patsy and he said to jump on a bus and come up so we turned up with all our bits of gear. There were loads of acts there, including a woman called Pearl Macavanny. They were running the show, she said, "Oh we just want you we don't want the group," which was a bit of a stinker for the lads, but it was something that I always wanted to do, so I got into the show and the other groups used to back me. I ended being the star of the show and the other groups hated me because I was only a 12 year old kid, and they were 18, 19 and 20 year olds and they had all the best gear, so they had to back me and they really hated it. I stopped with the show for well over a year. We then did a charity show for a young boy called Peter Lamb who had his legs cut off in a train accident, and we raised money for prosthetics. So we did this show through at Washington, but when Patsy done a charity show he would get another booking for pay. I was paid 12/6d, 10s and 2/6d for petrol. If the pay was 15s you would get 17/6d, Patsy always paid expenses. In the end I was getting a guinea a song, 12 years old, I was making more money than my dad. I would do about 20 minutes, sing about six songs and get six guineas, and I worked five nights a week. Thirty guineas a week aged 12 years. That was about 1964 so it was a lot of money. I continued to play until I left school and got a 'proper job'.

I went to Cowies as a mechanic and hated every minute, I served my time and the day I was 21 I went to the office and said I'm off and left. Then I went to the Public Works and operated the windy hammer. After that I had bits of jobs, but decided to work for myself as a plasterer. So I've been self-employed for about 30 years. If the opportunity came along for me to go back to music I would jump at the chance, I was professional for about 22 years, it got to about 1982 and the clubs were dying a death, so I more or less packed the club scene in and just did a few pubs just to keep my hand in so to speak.

Rockin Two By Two, from top: Dave Panton bass, Kevin Tierney drums, Peter Smith rhythm guitar and Bobby Carlisle solo and vocals.

When I was still professional I used to do a regular spot at the Fiesta in Stockton and I used to do a duo with a Irish lad called Colin John. What we used to do was probably do a spot in say the River Wear Club in Sunderland, finish at about 10.30pm and then shoot off down to Stockton, where we were used to warm up for the main act coming on. We would be paid about £25. Some of the main acts would be Tony Christie, Roy Orbison, The Platters, The Searchers, and we became a good quality double act, as well as performing, I used to just sit and watch these professionals and pick up some good pointers. I once worked with Dave Allan the Irish comedian and at the end of his act he would say, "Drive safely and may *YOUR GOD* go with you." Your god and not anyone else's, which I thought was magic. Now I always say the same thing.

After a time without regular club work and getting bored with the pubs Bobby Knoxall used to come and watch me and he always used to say come on the road with me. Anyway in the end it was a good thing what happened. I went on the road show with him and after about two years raising cash we were coming to the end and we wanted somewhere big to do the final show. At the time we were doing a show at Sunderland Golf Club, when Patrick Lavelle asked where we could do the final show, because it would have to be somewhere big, and Bobby Knoxall turned to me and asked where I would want it to be. I answered the Empire in Sunderland and so he said well that's where it will be. It was always my ambition to play at the Empire, all my life it was always my goal, and that was my reward for all my hard work in music. We got the £20,000, and the road show itself was real good with class acts including Steve Lavelle, Dolly Mix, guest artists like comedian Chris Magray from Middlesbrough. We had the Motown Brothers on for a while, and of course Bobby was the star of the show, although he was very poorly at the time he was still as great as ever. Anyway Bobby and the show brought back my enthusiasm. As for raising monies for charities, I helped with the £20,000, and in the early days hundreds of pounds for other causes, and of course I will still continue to do so.

Bobby Knoxall

Without doubt the most notable entertainer in and around the North East came from and was dragged up in the East End of Sunderland, Bobby McKenna, much better known as Bobby Knoxall. What is there left to say about Bobby that hasn't already be said, good or bad he is still as popular today as he has ever been, giving much of his time now, although he hasn't been in the best of health, to charity events, raising many

thousands of pounds for the underprivileged, or the infirm. The underprivileged he knows much about having come from an area and a time when life was hard. Bobby has written his own story – *Stand Up!* – and it is certainly worth a read, so I won't spoil any part of the book for any potential reader. I can, however, relate to certain memories of my own about Bobby.

The first time I saw Bobby he was standing on a table telling a few jokes and playing a saxophone in the Bells Hotel at the corner of Bridge Street, in about 1957. He still tells the

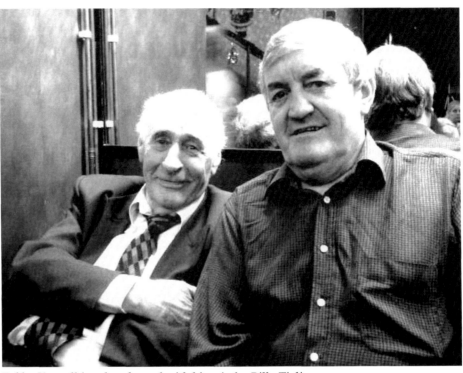

Bobby Knoxall in relaxed mood with his minder Billy Tipling.

same jokes today and I like an idiot, still laugh at them. He was wearing a black jacket with silver speckles, which he still wears today, the funny thing is it still fits him. But I'm glad he gave up singing in favour of becoming a comedian, he's much better at that, as his record he made in 1973 for the Sunderland Cup run proves. There's not much more I can say about Bobby, except take care of yourself, your health and your family, as the whole community needs to know you are there ready to keep us laughing.

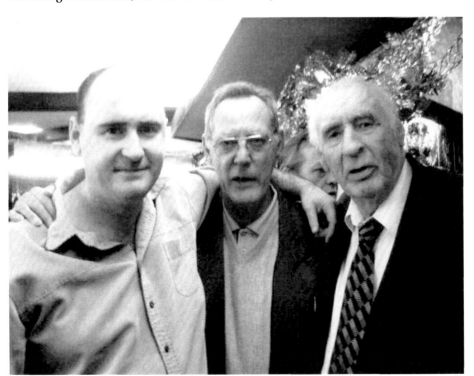

Left to right: Robert McKenna, Pat Conlin and Bobby Knoxall at the River Wear Club.

Stand Up!
The amazing life story of one of Britain's funniest comics and his hilarious encounters with world famous stars

Bobby Knoxall
As told to Patrick Lavelle

Bobby's book covers a lot of his early life in the East End, at Jimmy Willies and working as a barrow boy.

The Villiers Remembered

When Arthur Rich was at Leeds United Raich Carter was his manager, but did Raich make contact with Arthur's family years before? After training, the team would take a bath, and one day, Raich asked Arthur, knowing he was from Sunderland, if he ever went to the Electric. Arthur didn't understand what Raich was on about so he asked him, "Electric what's Electric?" Raich replied "You must know what the Electric is, everybody goes to the Electric." When Raich told him where it was Arthur realised he meant the Villiers. The Villiers Electric Theatre being the first electric cinema in the town.

If Raich went as often as he said he would have met a member of Arthur's family there. He must have bought an apple or some nuts off the little old lady sitting on the step outside the Villiers. She was known as 'Meggie the Apple', or to give her her real name Margaret Magglin, born in the East End, probably in Flag Lane. The connection with Arthur Rich? Meggie was his aunt.

Above: Arthur Rich with Leeds United team-mate and future World Cup winner Jackie Charlton. Although both were from the North East Arthur's allegiances were with Sunderland while Jack's heart was with the Magpies.

Left: Leeds United manager Raich Carter holding court from his bath tub with the great John Charles. When the Hendon-born manager recalled an old Sunderland picture house with Arthur Rich it took a while before they were on the same wavelength.

The Villiers Electric Theatre – popular with East End and Hendon film fans.

Edward Freeman, born 10th May 1927, was the Villiers projectionist.

From Hendon to Wembley

After joining his hometown club in 1931 Raich Carter went on to become one of Sunderland's greatest players of all-time. In the 1935-36 season his 31 goals helped the club to its sixth League championship success. The following season he skippered the team to the first FA Cup win in the club's history. He was one of the goalscorers in the 3-1 victory over Preston North End at Wembley Stadium. A fortnight before the Cup triumph Raich played before a world record crowd of 149,597 at Hampden Park. He was making his sixth appearance for England but ended up on the losing side against Scotland that day. His playing career was interrupted by the war but he eventually won 13 full caps. After the war he joined Derby County and had an immediate impact helping to lift the FA Cup in 1946. He was later manager of Hull City, Leeds United, Mansfield Town and Middlesbrough.

Above: Hendon Cycle Club at the North Moor rest area. Left to right: John Wilson, unknown, Tommy Sayers, Rob Lowe, Robbie Wilson and Ray Donkin.

Left: An advert from Palmers store for bicycles 'for the open road'.

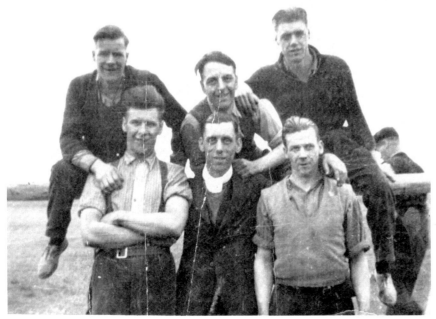

A friendly game of football at Spark's Farm in 1936, John A. Harrison, back right. In the early years when Hendon Burn was waterlogged Hendon Board Schools would play their fixtures on Spark's Farm at Hill View. We would change in an old tramcar having walked to Hill View from Hendon. The pitches went when Wearside College was built on the site in the early 1970s. Now the college has gone and houses stand on the old Spark's Farm. Where have all the football pitches gone?

Raich Carter, Hendon Board, Sunderland and England.

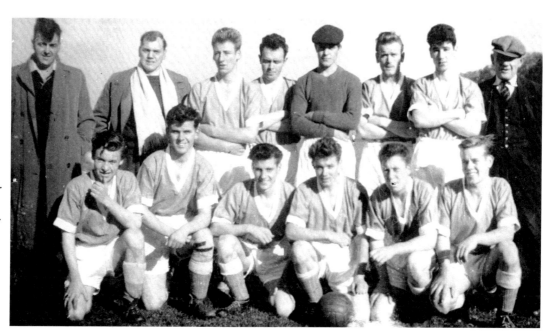

Bartrams Apprentices. Back row, left to right: N. Collins, C. Brown, J. Routledge, T. Bowens, S. Rowntree, E. White, K. Ethridge, G. Jenner. Front row: A. Jenner, G. Tyson, L. Charles, N. Robinson, R. Old and H. Richardson.

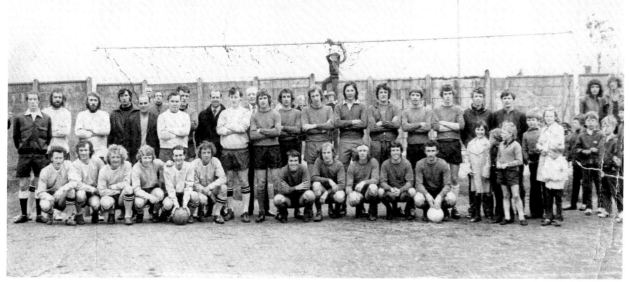

Bank Holiday friendly between the Ivy Leaf Club (dark shirts) and Commercial Road Club (light shirts) in 1975.

Young Hendon star Jimmy Davison (left of front row) in the Sunderland Juniors team of 1959.

Oddfellows Homing Pigeon Society by Gordon Cowe

I am a founder member of the Oddfellows Homing Pigeon Society. The Oddfellows was a public house at the bottom of Robinson Terrace in Hendon, where we used to have our meetings, but a lot of people used to call it the Monkey House, I don't why. We used to have our meetings there because in those days we had our pigeon crees in the back yards, because it was illegal to keep pigeons, some had their pigeons in the coal house and some had proper crees, and so we just formed a membership. There was Mr Lynch, we used to call him Patrick; there was Geordie Lunn, Taylor, Todd and Ronalds. There are lots I can't remember. As I was only a kid about 17 years old, my dad had pigeons before the war but he didn't have a permit and we didn't go in for a permit. Like many others we used to feed the pigeons on bread and dried peas. We just kept them as a hobby during the war but at the end of the war we started up a club. I was a bit older then and I started to take a real interest. As founder member I think I'm the only one left but I'm not sure I think that one of the Tyes is still around, but as I say I'm not sure they are not still flying anyway. The place where we are now was known as the Corporation Road Ground, but in 1959 when we first came on it was known as the Catholic Ground because of the connection with St Cecilia's Church that owned the

Gordon Cowe – over sixty years experience in keeping pigeons.

ground. We only had a small portion of the ground originally, enough for about 15 plots, just big enough for one cree or loft. We rented the ground at first from Father O'Connor, who was a nice man, and every year we were told by some people you'll have to get off, because the residents over the road were complaining about the noise, but every time we saw Father O'Connor he said they were only rumours and for us not to worry.

The Oddfellows at the time were only young men, and wanted a place of their own, although the older members were still flying from their back yards, they eventually came up here and so around about 1959 we were established on this ground. The Committee noticed that the number of lofts was slowly increasing and so in anticipation decided to try and purchase the land from the Church. As luck would have it the Church was already to move from their location at the time to a new location in Grangetown opposite the

The Oddfellows Arms which stood at the bottom of Robinson Terrace.

Sunderland Cemetery, where it remains today. At the end of the Corporation Ground Strattons, the coach operator, had a garage for repairing their coaches as well as a parking area. Because Fred Stratton was purchasing this land he also helped out the Oddfellows Homing Society by paying for their portion of the land.

I explained to Gordon that I was interested as to how the Oddfellows Homing Society fitted in with the community now as opposed to when they were flying from the back yards with them being so close to the community. Gordon replied

Billy Tipling with hat and Kenny Rowe 'our birds first in'.

that when they first moved, they still thrived as a close-knit group but as in all walks of life new blood was joining the flight and many were young strangers, and although they fitted in quite well, the tightness of the original group seems to have gone. Although everybody still help each other all the time it just seems different. I have to say this mind you that when I was ill, and it was necessary to look after my pigeons every day, George Rowe came in for me and he tidied my cree out for me. He had to reduce the number of pigeons so that the rest could survive, as I had far too many because for as long as I have kept pigeons, I just haven't had the heart to do what is needed and put them to sleep. I have been flying pigeons for over 60 years and I have one or two major

An advert for pigeon feed from a local firm.

races, I have won Borgers over in France, I came 2nd in Albany in France which is 700 miles. A chap called Tommy Thompson was first, but we were disqualified because of some discrepancy. We had what you call a two hour bat on our clock. We were at work and the rings off both birds were in the same clock so my pigeon's ring wasn't in my clock. We forgot about the rules. But I did win the Borgers which is about 565 miles away. The same pigeon won Borgers three times. I won Luxemburg and Brussels. Those baskets went by train and plane, but in earlier days we used to take the baskets up to the railway station in Sunderland and they were sent by train to different places. At the other end was a liberator, a person who was there for the purpose of letting the birds out, and when he had done so he would send a telegram to let us know what time he let them out.

Now George Rowe has a brother Kenny who has a flight with Billy Welsh, and if any of the pigeons, anybody's pigeons, cut or injure themselves while flying, possibly hitting overhead cables, well Billy will sew them up and save their lives, so even though we find it necessary to put pigeons to sleep we do care for them a great deal. In fact many of our wives will say that we care more for our pigeons than we do about them.

Billy Welsh checking one of his birds.

The Fight Game

Growing up in Hendon in the 1950s as far as looking after yourself physically was a task in itself. You either did or you went under. You would have to stand up for yourself or you would be bullied and picked on for the rest of your life, and that, unfortunately, meant girls as well as the boys. Of course normally you wouldn't go out and cause problems for yourself deliberately, but if others did then you had to be able to defend yourself, either that or avoid contact with the people who were well known around the area where you lived. There were many people of that type in the area, but I have no intention of naming them now, but I'm sure that they know who I'm talking about, and that my friends can remember them. Stories abound about people in the Teddy Boy era, going around with coshes, and knuckle-dusters, razor blades stuck in their caps, known as cheesies, even carrying bicycle chains with them to swing around their heads at opponents. But in all the fights that I was involved in I never saw any such weapons or saw them used. The kind of fights that I saw, or took part in, happened on the spot and ended on the spot with fists and only fists. The same went for the grown ups with their fights outside the pubs on Saturday nights, they were forgotten about on a Sunday morning. There were also men who would arrange fights against each other that would take place either on the Town Moor in the East End or on The Burn in Hendon. These arranged fights would take the form of the Marquis of Queensberry rules, or something close to the rules, and there would be the occasional side bet on whichever your favourite was. These fights were known as bareknuckle fights, simply because boxing gloves were not used, it was considered soft to use the gloves for these kinds of fights. There were of course the normal people who boxed properly, under the proper rules and the proper equipment, and although the majority were amateur, there was still a few bob around for them in a purse, and thank God that these people carried on after retiring from the ring themselves.

People like Jack Wilson, who fought under the name of Jack Todd. Why Todd? Well when Jack was starting out in 1937, Sweeney Todd the murderous barber was all over the National newspapers, so Jack just took the name from there. The name stuck and Jack was to go on and fight 189 bouts winning 161. He was introduced to boxing at the tender age of eight when he went to the East End Carnival and saw the Johnstone Brothers Boxing Booth. One of the Johnstone brothers had a unique way of opening the booth. He would ask for someone from the crowd to come up into the ring, place a apple on their head, and with a six foot sword, split the apple in two. Jack having no money took the bait and went into the ring for the first time, when asked later about his experience, he just said 'Av got a splittin headache.' Jack was a plater in Bartrams Shipyard and was a semi-professional boxer, at first earning about four shillings (20p) a fight, but once fought a boxer called Ernie Walters from Norwich, a Commonwealth title contender, and was surprised when both boxers earned a purse of fourteen shillings each. That was more

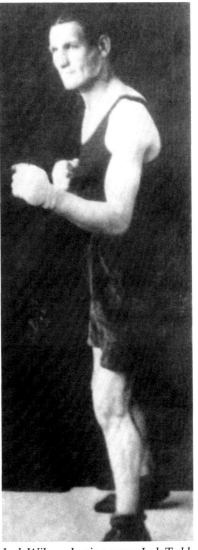

Jack Wilson, boxing name Jack Todd.

Retired boxing friends Billy Kerr and Jack Wilson.

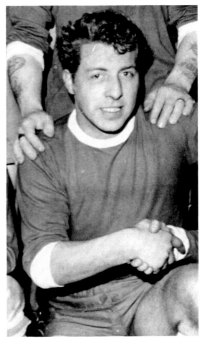

Sporting son of Jack Wilson, Allan Wilson, who emigrated to Australia.

than six weeks wages in the yards. Jack never really retired from boxing he just came out of the ring and took up training young up-and-coming boxers, the thing he loved and was most respected for. He was as successful as a coach as he was a boxer, bringing many local talents to National representative levels. There are many young boys who became men under Jack Wilson. There are also many boxing clubs that would have ceased to exist, especially Lambton Street Boys, through Jack's dedication, by entering every pub in Sunderland begging for cash, was able to carry on operating. Although Jack Wilson dedicated a total 41 years to training young hopefuls and keeping them off the streets he was also a dedicated family man. Jack passed away losing his last fight in October 1997. His favourite saying was, 'You'll do for me son', and though I was lucky enough to meet him, it was only a couple of times, but from what I have heard and read since, 'Jack, you'll do for me.'

When mentioning young people to keep clear of when we were at school, a set of twins, called Malcolm and Brian Bainbridge were a pair to avoid. Not because they were villains as such, but they could take care of themselves, and not because they fought as a pair, as normal twins do, because they were good as individuals. Now I know why. Their father was Tommy Bainbridge, or as he was known as in his boxing days, Tommy Best. Tommy was born in Sans Street in 1911 and in his early days fought as Tommy Coates before changing his name to Best. Tommy began his boxing career in 1927, with his first fight being in the old St James' Hall in Newcastle and, although he never reached the very top, he was a

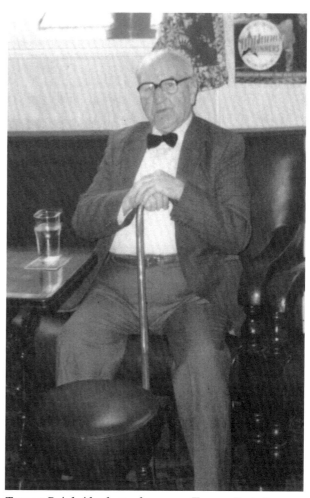

Tommy Bainbridge better known as Tommy Best. Born 1911 in Sans Street, died 12th December 2001.

crowd pleaser, a fighter that would always give of his best, a one hundred and ten percenter. He fought in all of the local halls including The Royal in Bedford Street, Ryhope, Silksworth, Hetton and Seaham Miners' Halls, taking on and beating such fighters as Young Walsh, Tommy Dixon, Rob Trilby, Ginger McGrath, Jim Baker, Jim Britton, Bob Turnbull and Drummer Britt. On 1st April 1936 at The Royal he battled out a draw with Harry Strongbow, once again pleasing the crowd with his never-say-die tactics. His greatest disappointment was fighting Charlie Donnelly six times and losing to him each time. Tommy rated his best fight, although losing the contest, was during the war as he reached the veteran stage of his career. He was matched with Alf Brailsford, the younger fighter from Derby, in the Grove Stadium, Glasgow. Brailsford was a knock-out specialist in his day but Tommy resisted all of Alf's efforts to floor him and after ten rounds, Tommy was still there.

In May 1992 Tommy Bainbridge celebrated his 81st birthday by being honoured by his peers in boxing, including old and new in the boxing world. These included Nick Crake, Willie Neil, John Brown, Gordon Jackson and Bert Ingram, President of the Sunderland Ex-Boxers Association.

Tommy had a bigger battle to take care of in 1940, he had to survive the strategic withdrawal of Dunkirk, but once again he gave his usual one hundred and ten percent and came home. He carried on with his military connection by becoming a provost sergeant in the TA. His real job was as a drayman for Vaux Breweries where he was employed for twenty-seven years, Tommy also worked for a number of years in Park Lane bus depot until he retired in 1976. On 12th December 2001 at the age of 90 years Tommy lost his last fight and passed away, but this time peacefully. Rest in peace Tommy you really were the BEST.

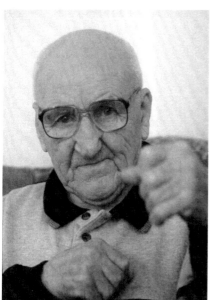

Tommy Best fighter.

Sunderland Ex-Boxers Association

Tribute has to be given to the Sunderland Ex-Boxers Association in light of their continued support of all the former fighters and their encouragement towards the present and future generations coming into the noble art of boxing. It's hard to single out any special individuals for their devotion to the Ex-Boxers but one or two must come into the reckoning, people like Bert Ingram, who after giving of his best inside the ring in the 1940s and '50s, served the Association both as Chairman and President for over 20 years. Bert fought as a middleweight and was close to becoming Area Champion, being narrowly beaten by George Casson of North Shields. The fight ended with controversy after Bert had Casson on the floor six times. The first time the count went on longer than in the infamous Dempsey-Tunney fight. Bert's experience in the ring certainly became a benefit to the Ex-Boxers outside the ring, he enjoyed every minute he spent with his friends and colleagues. Sadly, aged 75 years Bert passed away suddenly, leaving his wife Joyce and his two sons. He will be missed by all his friends in and outside of the Association.

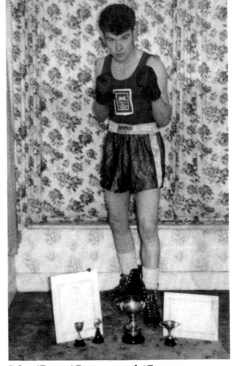

John 'Pasty' Brown aged 17 years.

There has to be an inclusion in this piece, in recognition of their services to the sport, to the coaches. Jim Richardson for his hands-on development of Tony Jeffries; Tommy Conroy who has helped many young boxers, not only in coaching but in promoting many of their bouts and his sponsorship of many venues. There are others of course, and the story wouldn't be complete with out a special mention of my friend John Brown. John has been involved in boxing since he was about nine or ten years old, both as a fighter, and a successful one at that, and of course as he is today a very competent coach. John has coached the Sunderland Amateur Club for almost thirty years, coaching in different areas of the East End and Hendon including Hendon Board School. His venue now is Barnes Junior School but lots of youths from the Hendon area still attend. In this year (2006), John was nominated as coach of the year, which he took with his usual humility and won hands down. Congratulations to John and may he coach the youth of Sunderland for many years to come.

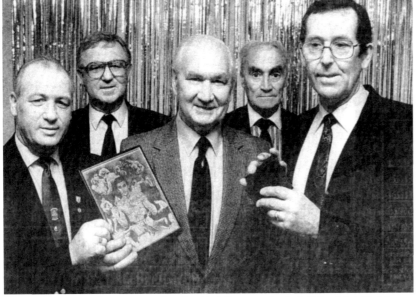

John Brown and boxing commentator Reg Gutteridge.

Sunderland Sports Fund

Awards Dinner

Ivy Suite

Sunderland Health & Racquet Club

Friday, 29th September, 2006

Twenty years service presentation for Bert Ingram, back, left to right: Ted Lynn chairman Ex-Boxers and Joe Riley. Front: Malcolm Dinning, Bert Ingram and Les Simm secretary Ex-Boxers.

John Brown received the Sir Tom Cowie Coach of the Year Award at the Awards Dinner on 29th September 2006.

Presentation to Danny Moyer from his coach Tommy Conroy, left to right: Danny Moyer, Billy Hardy, Tommy Conroy and Glen McCrory, River Wear Club, 23rd July 2006.

Sunderland Ex-Boxers Association Secretary Les Simm May 2006.

Well on his way to the Championship – Glen Foot.

Matty Parkin and John Brown, River Wear Club 23rd July 2006.

Tommy Cumiskey.

Present Chairman Ted Lynn, May 2006.

Billy Jones owner River Wear Club, Matty Parkin ex-boxer and Les Simm, River Wear Club, 23rd July 2006.

Youth at its best – John Askew with Billy Hardy.

Bobby Bute

You don't have to be at the top of the physical side of boxing to pass on the finer points of the sport, coach someone else and help them to reach the top. One such coach was a person who would take not one but many youngsters to the top. Bobby Bute was such a coach well respected by boxers and other coaches alike.

Alongside his life long friend, John 'Pasty' Brown, Bobby trained the young crop of lads, while John took on the senior fighters.

Bobby was born in Fulwell, but was brought up in the East End, and with his friend John, spent sometime as youngsters in the Merchant Navy, finally settling in Hitchin, London and boxing together for the Hitchin Boys Club. While there Bobby became more interested in the coaching side of the game and began learning his new trade as a boxing coach. He married Liz, a girl from London, before returning to his native North East, early in the 1970s. He took up working in one or two, of the many shipyards before settling at Cammell Laird's in Hebburn. John Brown was also back in the area and was coaching for the Sunderland Amateur Boxing Association and he persuaded

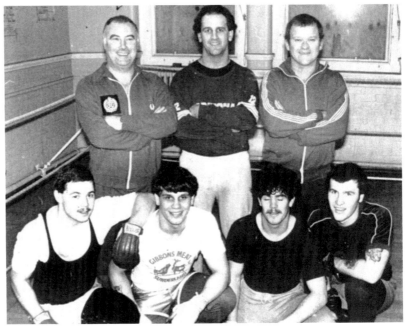

Coaches, back row: left to right: Bobby Bute, Jim Richardson, John Brown. Front: Glen Bosher, Willie Neil, Geoff Rushworth and Gordon 'Pedro' Phillips.

Bobby to join him, which he did, and from the start the youngsters loved him even though he was very strict he was very good and fair and so the kids kept coming back for more.

Although boxing was only his second love, his first was of course his family, being totally dedicated to them. He loved life in general and liked nothing more than being with his friends in boxing. Alas in about the year 2000 he was diagnosed as having cancer. So began his biggest fight, which he fought in his usual way, always looking and being positive about his illness and bringing all his coaching skills together, showing the kids that you can still be positive and hopeful under extreme pressure and against great odds, the kind of skills you need to enter a boxing ring and win.

High Hopes for the future, left to right: Kirk Goodings 4 times North East Champion and 3 times Regional Champion, Anthony Tunney twice North East Champion and once Regional Champion with senior coach John Brown, Sunderland Amateur Boxing Association, River Wear Club, 23rd July 2006.

Joe Purvis Jnr. 41 fights 29 wins. Junior ABA National Champion, NACYP National Finalist 2005, River Wear Club, 23rd July 2006.

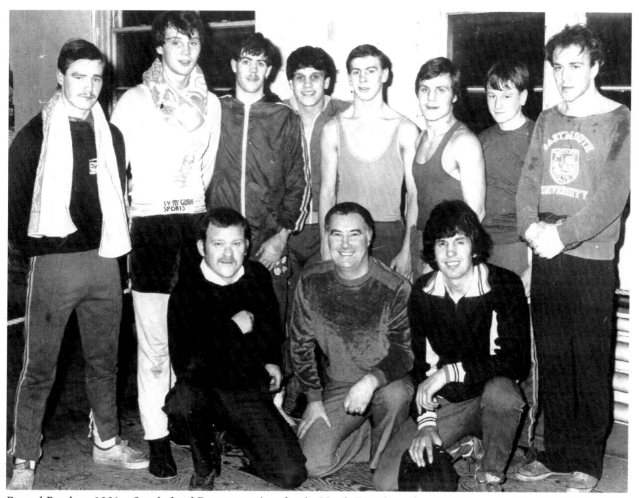

Record Breakers 1981 – Sunderland Representatives for the North East Counties ABA Championships in Peterlee. Back row, left to right: Steve Laws (Lightweight), Joe Purvis (Middleweight), Geoff Rushworth (Bantamweight), Willie Neil (Welterweight), Kevin Howard (Featherweight), David Mills (Lightweight), Michael O'Neil (Flyweight) and Ernie Bewick (Light-Middleweight). Front, the coaches, left to right: John Brown, Bobby Bute and Tommy Conroy.

Bobby was successful with this fight for five years, but succumbed on 12th August 2005, aged sixty-five. Truly a star was lost that day, a terrible loss to Liz his wife, to his four children, Michelle, Robert, Michael and Jennifer, and of course his lifelong friend John Brown and all the rest of his friends in boxing.

Jim Richardson coach, Tony Jeffries ABA Light-Heavyweight Champion and Joe Purvis Snr.

Here are just a few of Bobby's successes. Tony Jeffries, England representative in the Commonwealth Games in Australia and European Junior Champion. Gordon 'Pedro' Phillips in 1985 became the first fighter from Sunderland to qualify for the ABA Championships. He also captained the England Amateur squad, winning 101 bouts out of 120. Billy Tyrell, British Schools Champion in the 1990s and winning the Crowtree Award in 1993 for his achievements in boxing. The list goes on and on, Willie Neil, Tony Wilkinson, Karl Duke, Joe Purvis and his son Joe, Geoff Rushworth and Preston Quinn, all Bobby's Babes. They all miss you but give their thanks and will never forget you, Bobby Bute.

Left: Hendon Sports Club cricket team. Back row, left to right: Andrew Nash secretary, George Curle, Bill Thornton, John Wellburn, George Nash, John Bailey, Harold Gardener, Richard Ashton. Front row: Bobby Forrest, Joe Ashton, Jim Ashton, Jim Heron and Dennis Cheal.

Right: Mowbray cricket team (Hendon-based) 1949. Back row, left to right: T. Graham, W. Cheal, H. Gardener, R. Ashton, D. Cheal, J. Carter, J. Gardener, J. Lang. Front row: B. Curle, G. Curle, C. Davison, J. Patterson and J. Ashton.

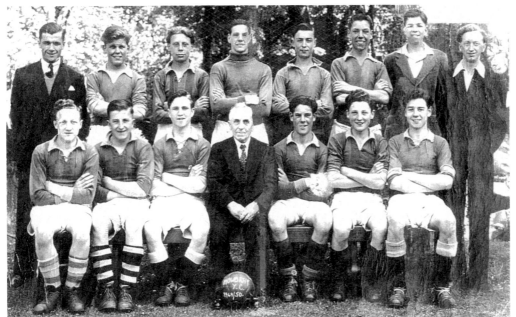

Left: Mowbray Youth football team 1949-50. Back row, left to right: Harry Barton committee, Stan Rackstraw, Jacky Arnett, Bill Johnson, Ben Curle, John Edmunds, Jimmy Graham, Tom Davison secretary. Front row: unknown, J. Hughes, Stan Barton, Cuthbert Davison, Joe Ashton, Ronnie Kirby and Robbie Booth.

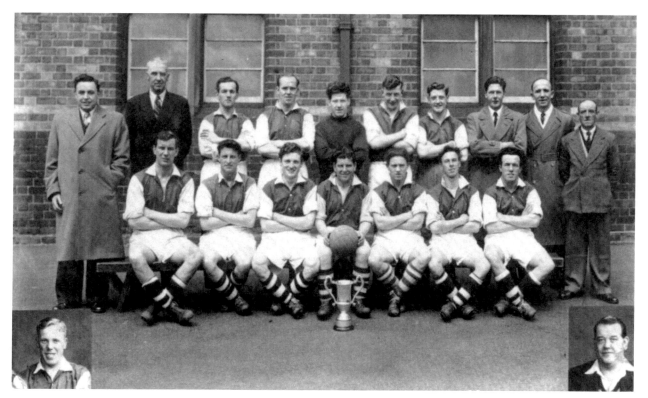

Hendon Sports Club 1954-55. Winners of the Sunderland and District Knock-out Cup and the Blind Institute Cup. Completed the Double – League Championship and Knock-out Cup 1955-56. Back row, left to right: Mr Lightfoot, Andrew Nash, Billy Laws, Dempsey Leonard, Joe Hope, Ronnie Brewis, Arthur McLaren, A. Brown, Bobby Forrest, John Byrne. Front row: John Welburn, Davie Graham, Ronnie Kelly, Jimmy Heron, Ritchie Carter, Martin Taylor and Arthur Carter. Inset: Bobby Lorriane (left) and George Neal (right).

Maple Amateurs AFC 1934-35. Winners of the Sunderland and District Division One, the Aged Miners Cup, the Oddfellows Cup and runners-up in the Children's Hospital Cup and the Eye Infirmary Cup. Back row, left to right: S. Cowe capt, T. Patchett, A. Blackett. Middle row: T. Cutis. G. Cranmer, L. Reah, D. Lemon. Front row: C. Cranmer trainer, R. Hutchinson, A. Nash, P. Coundon, W. Rattray, D. Johnson, J. Moon and C.E. Flack secretary.

Darts and Dominoes

What is now a multi-million pound business, earning thousands of pounds per match for the likes of Phil Taylor, John Part, Roland Sholton, and all the world renowned professionals, darts began humbly in the pubs of Britain as a pastime, albeit the game itself is thousands of years old and probably began in China. The people that I watched and then later was able to compete with were Jimmy Moore, Billy Beeby, Harry Humble, my dad Matty Morrison, and as I grew older Davy Mason, Big Allan Bryan, Denny Rolfe, Ed Jacob and Alfie Hutchinson, and many, many more. Their names don't escape me, they are just too numerous to mention. A few are Alex Smith, Keith Bevans, the three Kirkwoods – Jimmy, Bobby and Davy, Kenny Spraggon, George, Billy, Norman, Kenny and Brian Rowe, John, Robbie and Ronnie Potts, the Kragers – Geordie and Davy. There were the ladies too, Katy Farrar, Maureen Woodruff, Mary Bevans, Susan Spoors and her mum Ivy Morrison. I'll have to stop naming names or there will be no story.

Down to Doms – Jimmy Morrison, River Wear Club.

The kind of darts that most of these people used were big brass barrelled, with home-made wooden stems, and home-made paper flights. Today they play with specially made tungsten darts with their own specially printed machine-made flights. The standard dartboard specifications have not altered very much over the years, so the space between the wires on the double and trebles are the same, and although it is still difficult to hit the 180s and doubles, when needed, with the new darts, imagine trying to hit 180s, with the old brass darts. But it was achieved by many of the old darts players, and Jimmy Moore was reputed to be able to hit 180 with a full pint of beer on his head. Billy Beeby used to do the same thing wearing his heavy top coat and played his game wearing it. Alfie Hutchinson still had brass darts, with all-in-one plastic stems and flights, but they were very light and he used to

George Rowe 27th July 2006 Bush Inn.

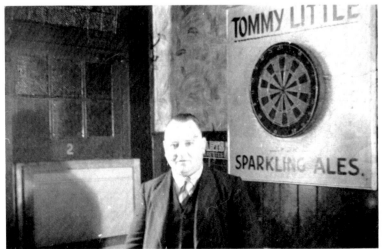

Above: Tommy Little setting up the board, The Divan, Hendon Road.

Right: Tommy Little's Place, The Divan, Hendon Road.

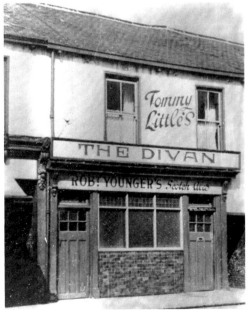

throw his darts as though floating them, but his aim was true. No matter how unusual his throwing action was, naturally he became known as The Floater.

There is a saying that's been around for years, and that is that domino players are only retired darts players who still want to get out on a Monday night. Let me tell you that is rubbish. There are some darts players who are great domino players and not retired. There are domino players, young players who are great players, so good that if the game was to go professional, they would make a good living from it. There are some players, both young and old, who can read the dominoes blindfold and still tell you what you have in your hand. There is one big problem about dominoes and that is the violence that goes with the game. There is more trouble in the game of dominoes than many sports, including boxing. False knocking, playing a wrong domino on purpose, palming a domino, hiding it when there is a count, I don't play the game myself so I can't be sure, but just watching is enough to put me off, and I'm a retired darts player.

Les Cowens with brother John waiting for the match to start at the Lord Roberts.

Edwin Jacob, The Royal Oak.

Ladies Darts Individuals Presentation at Vaux Club, back, left to right: Mary Morrison and Linda Barrett. Front: Ivy Morrison (centre).

Alfie Hutchinson, The Rink.

Left: Darts Marathon at the Whitehouse, Hendon Road in 1988, at back beside dartboard: David Kirkwood. Middle row, left to right: Keith Bevans, Tommy Cranner, Bobby Kirkwood, Jimmy Kirkwood. Front: Doug Owens and his wife Cathy, Mary Bevans, Matty Morrison, Pat Conley and Councillor Eric Holt.

Keith Bevans, White House /
Hendon Gardens/Hearts of
Oak.

Lizzie Jones née Humble, The Boar's Head.

Allan Bryan, The White House (and
many others).

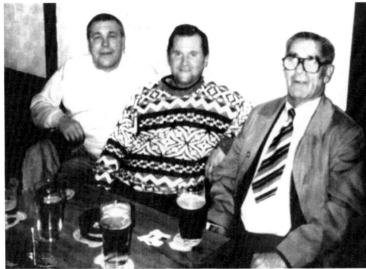

Jimmy Moore,
Hendon Gardens.

Left to right: Geordie Smith Ernie Smith and Billy Talbot, Tatham
Arms.

Sammy Liddle, River
Wear Club.

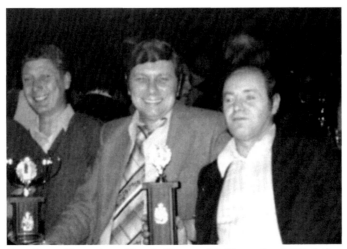

Alex Sloanes, River Wear
Club.

Dominoes Champions, Regale Tavern, 4th December 1978, left
to right: Frankie Gibson, George Alder and Charlie Davis.

Ronnie Potts, White
House/Hendon Gardens.

Right: Hendon and East End Ladies Dart and Domino League Presentation to the Sunderland Hospitals at Ivy Leaf Club in 1988. Back row, left to right: Chris Farnsworth, Margie Taggett, Alison Bowman, Jenny Innes. Front row: Mary Bevans, Ann Clark and a Hospital representative (kneeling).

Darts Champions, Regale Tavern, 4th December 1978, left to right: Harry Kemp, Charlie Davis, Frankie Gibson, Joe Arnett and J. Richardson.

Billy Rowe, River Wear Club.

Dominoes Individuals Presentation River Wear Club, left to right: Peter Donkin, Tommy Hethrington and Frankie Gibson.

Kenny and Brian Rowe, River Wear Club.

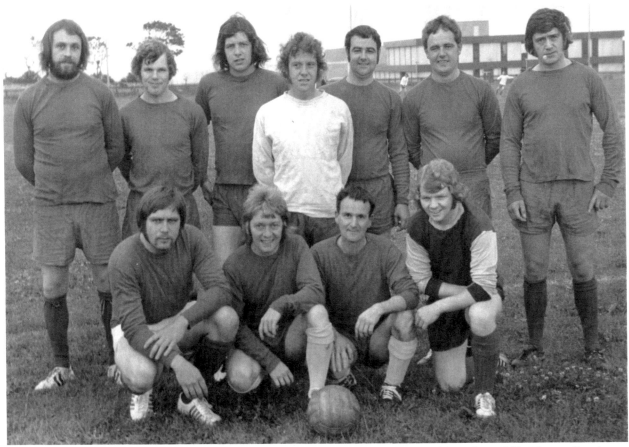

Ivy Leaf Club football team around 1978. Back row, left to right: Tommy Sayers, Keith Waiters, Billy Thoms, Bernie Cummings, Alan Pallas, Jimmy Pallas, Billy Surtees. Front row: unknown, Barry Grant, John Hutchinson and Geordie Anderson.

Henry Milley, River Wear trainer.

John Harkess, River Wear player.

Jimmy Liddle River Wear trainer and fund-raiser.

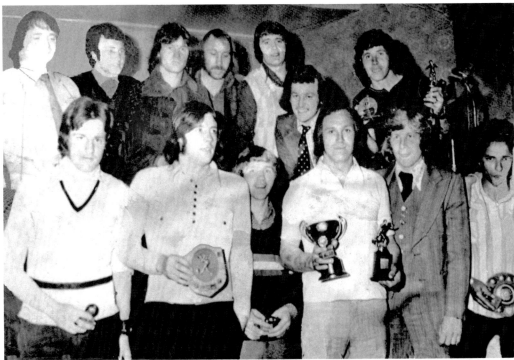

River Wear Club football team July 1973. Back row, left to right: Matty Morrison, Terry Grieveson, David 'Pop' Woods, Matty Sayers, Billy Surtees, Davy Mullin. Front row: Brian Grieveson, Billy Thoms, Terry Warren, Les Cain (captain), Tommy Sayers, Jimmy Montgomery goalkeeper Sunderland AFC and Peter Lawson.

Right: Arthur Harkess, River Wear half back 1973.

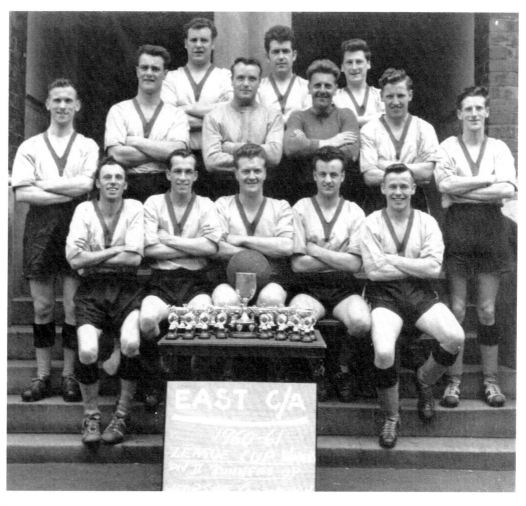

Right: Sunderland East End Community Association Wearside Combination League Cup winners and Division One runners-up 1960-61. Photographed at the East End Orphanage. Back row, left to right: Kit Henry, Tommy Cruickshanks, Gerry Watson. Middle row: John Trueman, Tommy Blanchard, Charlie Moore, Larry McQue, unknown, Graham, Ernie Davison. Front row: Billy Snowball, Alan Ward, Sid Swales capt, Terry Waugh and Alan Smith.

Kit Henry was born in 1934 in Rays Landsale coal depot near the Docks' entrance beside the Regale Tavern. He attended St John's School in 1939 then after a brief time went to Moor Board School. He picked up his interest in football almost immediately and was soon playing for the school team. In later years while playing for amateur teams Kit was invited by Blackburn Rovers for trials but things didn't work out so he returned home. He later had trials with Southend United but once again it didn't work out. Kit was a very good amateur and went on to have a successful career in local football. As well as turning out for East End CA he played for Reyrolles who were one of the most successful teams of the time. Kit is now 74 and still enjoys watching the modern game.

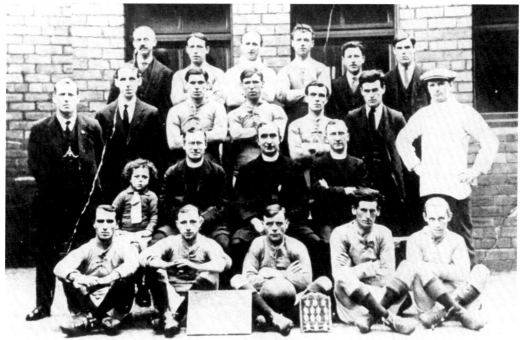

Left: St Patrick's Club football team 1921-22. Back row, left to right: T. Tugman, Micky Lang, G. Naisby, R. Hill, Major Burke, Jim Bowens. Third row: E. Huston, B. Brown, R. Stonley, Lawson, J. Miller, J. Ferry, P. Smith. Second row: Jnr Miller, Father McAney, Father Welling, Father Kelly. Front row: L. Rossi, P. Quinnan, John McGuinnes, John Ferry and R. Carolan.

Above: Charabanc trip to the races from the Maple and the Swan public houses. Peter Someo is sitting in the arm chair.

Left: Hendon-born George Tyson with former Sunderland stars Eric Gates and Martin Scott and boxing champion Billy Hardy at a golf event. Left to right: Eric Gates, George Tyson, Martin Scott and Billy Hardy.

Below: A trip from the Boar's Head to Newcastle Quayside. Included are: Ned Anderson, Tom Sloanes, Tommy Magaritty, Billy Kelly, Les Macnally, Jimmy Richardson, David Sloanes, Tom Howie, Pat Conlin, Jackie Ellis, Gordon Ellis, Eddie Kerr, Alex Sloanes and Charlie Gray.

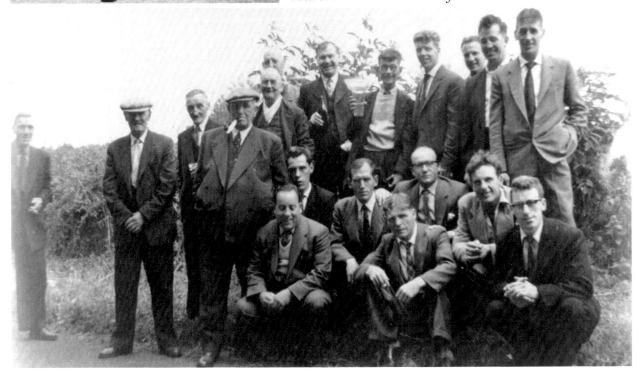

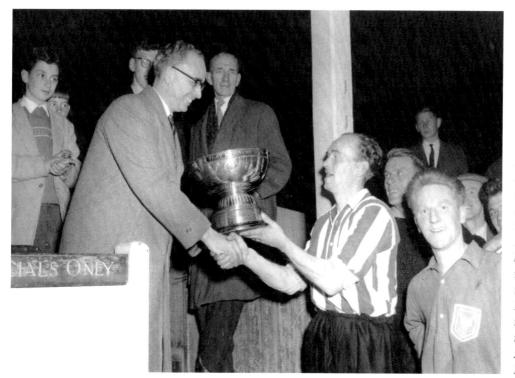

Left: Hood Street Methodists' skipper Dempsey Leonard receiving the All-Britain Methodist Cup in 1960. Although the team was from the north side of the river Dempsey was a Hendon lad. They had been trying to win this important national competition throughout the 1950s. In 1953-54 they were beaten finalists and reached the semi-final the following season. In 1959-60 season they finally lifted the trophy when they beat Abbey Wood from Kent in the Final.

High Tackle

Alan Dunn, footballer and former James William Street School pupil, had the most blatant foul committed on him, that I have ever seen, and seen by the referee, and was never given the award of a free kick. For many years amateur football was played on the six pitches near what is now Nissan Car Plant, but what was Sunderland Airport. In the early 1970s a game was taking place which included prolific goalscorer Alan Dunn, who was well known in amateur circles. During the game Alan picked up the ball and was heading toward the opposition's goal, getting close and ready to shoot, when literally out of the blue he was fouled by an outstanding drop kick to his head. All the spectators with one voice shouted, 'Foul, send him off ref!' but the referee couldn't send him off, he wasn't even playing, not for either team, he wasn't even a spectator. The offender was a parachutist! The way Alan went after him I think the parachutist was hoping the plane would come back and pick him up off the ground and forget about the early bath.

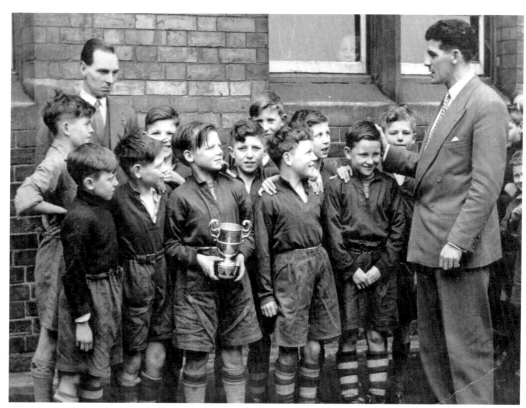

Presentation to Hendon Board football team, Cup Winners 1950-51 by Trevor Ford centre forward for Sunderland AFC. Left to right: unknown, Mr Hopkirk, Tommy Southern, Billy Robson, Billy Hargrave, Norman Turner capt, Tommy Lamb, John Hodgson, unknown, Bruce, Malcolm Bainbridge, Jimmy Pallas and Trevor Ford.

Pubs & Clubs

The Bush Inn, Ward Street. Now called the Rovers Return.

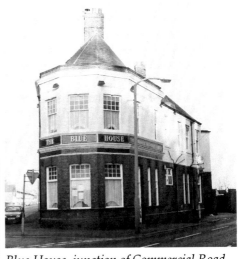

Blue House, junction of Commercial Road and Corporation Road.

Party time at the River Wear Club, left to right: Mary Arnett, Peter Donkin and George Adler.

Hendon Gardens, Noble's Bank Road. Left to right: Henry Foster (milkman), pub manager and Richard Armour (with cat).

The Burlington in Hendon Road.

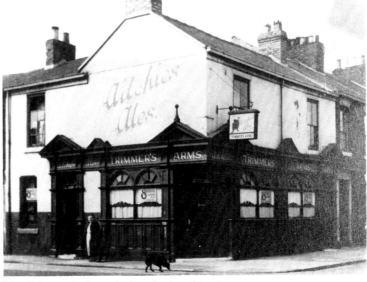

The Trimmer's Arms in Pemberton Street.

No Favouritism

In early 1960 Bobby Byers' parents took charge of the Linden Arms in Hendon but it was no advantage to Bobby. At age 17 he was too young to drink and his dad Jack refused to serve him, so Bobby and his good friend Jimmy Dobson had to go to the Salem for a pint. Jack and Mary Byers had the Linden Arms until about 1967, and Bobby and brother Jimmy and a few of the other pub regulars used to nip up to Backhouse Park on most evenings, Saturday mornings and Sunday mornings for a strenuous game of cricket, work up a sweat, and then back to the pub for a small drink. Bobby had the same circle of friends as me. There was Joe Doran, Bobby McClean, Jimmy Lindsey, Jimmy Wynn, George Roberts and Jimmy Dobson. There were the girls of course, Betty Usher, Eileen Leigh, Sheila Cooper, Brenda Wilson, Norma Lucas, Hilda Johnson and the girl Bobby was to marry in St Ignatius Church in 1962, Wendy Jones. After they were married Bobby and Wendy moved to live in Downhill and then Plains Farm and on to Humbledon Bank where he lives to this day. Bobby is still working as a joiner for himself but hopes to retire next year (2007). He has four children, all grown up now of course, and with his first grandchild expected sometime this year it is probably as well he intends to retire. Good luck in you and Wendy's future and may your health hold out so you can enjoy your grandchild.

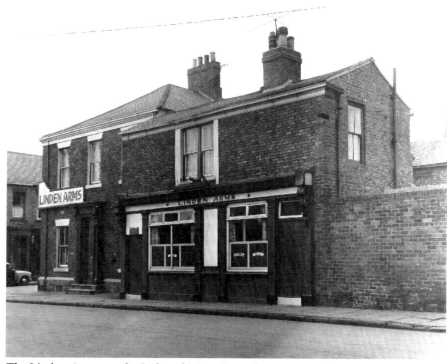

The Linden Arms run by Jack and Mary Byers from 1960 until 1967.

Left to right: Bob Harker, John 'Bull' Rennie and Tommy 'Spider' Killala .

Jean Lashley née Arnott and sister Eileen Horn née Arnett in the River Wear Club.

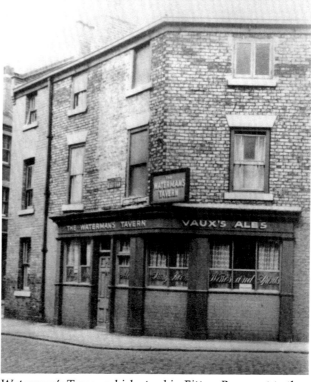

Waterman's Tavern which stood in Fitters Row next to the Wellington Foundry.

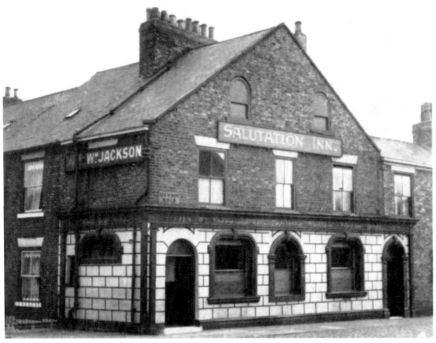

The Salutation Inn, Hendon Road.

David and Alex Sloanes, Salisbury Street 1950 – ready for a pint.

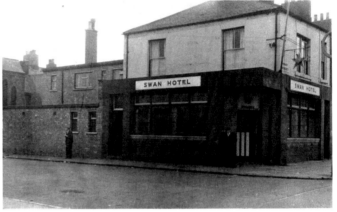

The Tap & Spile before it returned to its original name – The Salem.

Swan Hotel, bottom of Henry Street.

Left: The Station Hotel in Hendon Street. I visited the home of classmate Newrick Stores a few times and it was exciting because he lived in a real railway station, Hendon Station.

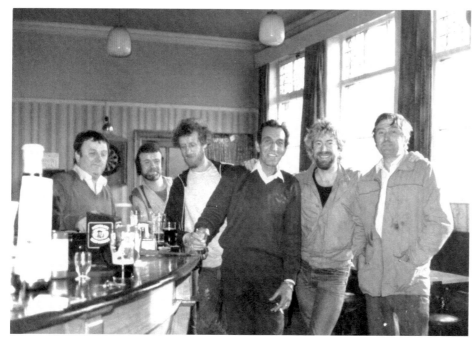

A Foot Away From Disaster

During the Teddy Boy days, 1955-1960, I thought I was the bee's knees in my mode of dressing with a long red drape coat that came down to my knees, tight powder blue drain pipe jeans, blue suede beetle crusher shoes, which were about a size too big for me to give the right effect setting off the tightness of the jeans. A nice yellow shirt with a shoe lace tie that I got off Lukey Ratcliffe. It was fastened by a skull and cross bones. The shoulder pads on the jacket were as wide as I was tall, so they stuck out quite a bit. At the time I had plenty of black hair, that was slicked back into a DA. The front was sporting an elephant's trunk and the side burns came down to my shoulders, all held together by my mother's best lard. Wow did I look great or so I thought until I met my dad coming home from work. I was in a bit of a rush, hurrying to meet a girl on my first date with her and I was a bit late, so I was running up Bramwell Street, preening myself, making last minute adjustments, when down the street came my dad. Saying a quick hello to him, I carried on running, when all my dreams and visions of myself, and all that I hoped was going to happen that night, were completely dashed by one comment my dad was to make in jest, 'You shouldn't run like that' he said, 'if you catch your foot in your pocket you'll gan ar– over tip.'

Above: In the bar of the Hendon Grange, left to right: Billy Jones, Malcolm Innes, Peter Bannon, Les De Cruz, Bo Daniels and unknown.

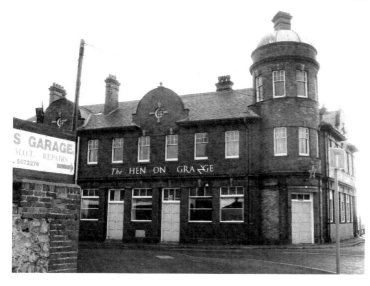

Right: The Hendon Grange in Ocean Road.

Tommy Little (*right*) was a well-known Hendon character owning The Divan public house in Hendon Road as well as off licences (*below*). Tommy was a keen supporter of Sunderland Football Club and he used to run coach trips to away matches from The Divan.

Phone : 2107.

THOS. D. LITTLE,
ALE, WINE & SPIRIT MERCHANT,
11 HENDON VALLEY ROAD,
SUNDERLAND.

Also at The Divan, Hendon Road, Sunderland.
and 97 Princess Road, Seaham.

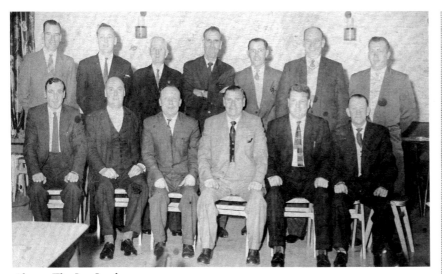

Above: The Ivy Leaf Club Committee around 1960. Back row, left to right: R. Olson, W. Todd, W. Jeffery, F. Moore, J. Carney, E. Cowe, F. Folly. Front: C. Olson, R. Teasdale, J. Folly, J. Daley, W. Johnson and J. Donkin.

Right: The Ivy Leaf in Tatham Street

Younger's Ale was drank all around Sunderland in the 1940s and '50s and was distributed by Fenwick & Co. Fenwick's main depot was 176 High Street West but they also had shops at 74 High Street West, Coronation Street and North Durham Street.

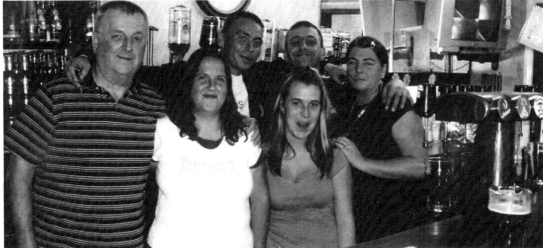

Left: Behind the bar of the River Wear Club, October 2006. Left to right: Billy Jones (owner), Maxine, Sam, Carmen, Lindsey (steward) and John (concert chairman).

Leslie and Alfie Podd in the Queen's Hotel (Charltons) in Hendon Road.

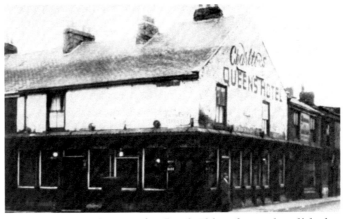

The Queen's Hotel in Hendon Road. This pub was demolished and rebuilt as Charltons.

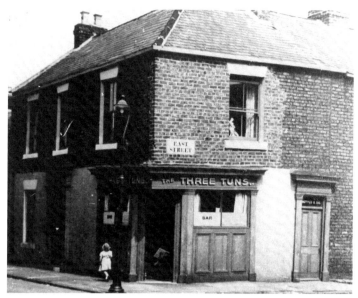

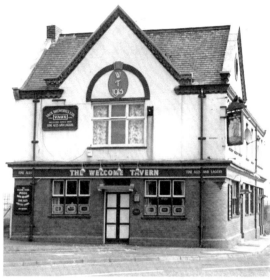

Three Tuns, East Street.

Welcome Tavern, Barrack Street.

Norfolk Hotel, 31st August 1965, left to right: Brian Hall, Frankie Fergerson, Richie Miller, two girls unknown, Tommy Lindsey and Donald Hall. All Ward Street characters.

Enjoying a pint in the River Wear Commissioners Club, left to right: Alfie 'Pedro' Hill, George Hill and Tony Nash.

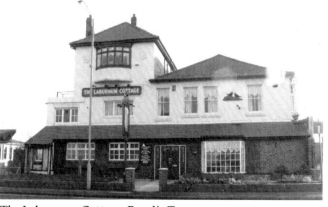

Tommy McHenry and Micky Downey in the River Wear Club 2006 .

The Laburnum Cottage, Rosalie Terrace.

Kath and Pat Conlin.

Sylvia McSwan née Staples.

Malcolm Chappell and Davy Jones.

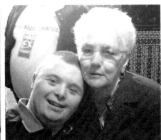

Tony Hilton and Rosie Hutchinson.

Jean Thompson and Gina Jones.

Tommy Maughan.

Phil and Ruby McClennan.

Barbara Douglas née Peverley.

William Rowe and wife Georgina née Hall.

Present River Wear Social Club formally River Wear Commissioners Club with some of its regulars.

Harry and Bella Smith.

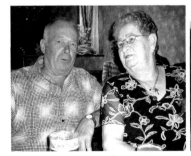

Steve Potts and wife Beatrice née Carroll.

Les and Mandy Hutchinson.

Eleanor Nelly Fergerson.

Iris and John Fletcher.

Mary Peverley and Paddy MaCarthy.

Debbie Maughan and mam Eva Maughan née Mole .

Joyce Hill and husband George.

Alfred 'Maxi' Miller.

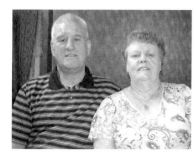
Fred and Florence Harkness née Liddle.

Norma Cowans and Brian Ganley.

Sylvia Cooper née Hair.

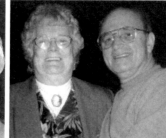
Isabella Miller and Matty Morrison.

Margie Drew née Curtis.

Lindsey and Natalie Cooper.

Margy Gilby and daughter-in-law Monica Gilby.

Ivy Laing.

Margaret Rowe née Tyrell.

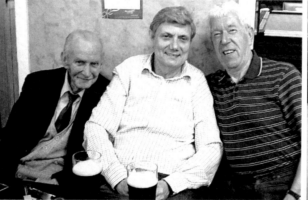
The Three Musketeers – Stan Rock, George Adler and Joe Arnett Snr.

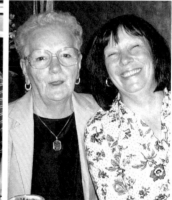
Rose and Rita Hutchinson.

John Morrison and Geoff Richmond. Cathy Peverley.

Joe and Joan Spence.

Brenda and Joe Smith.

Norman Bracy.

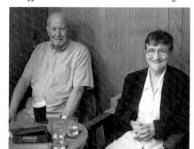
Davy and May Forbes.

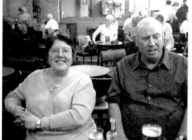
Carol Cummings and Billy Welsh.

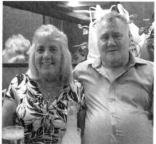
Pauline and Bobby Steabler.

Brian Blyth.

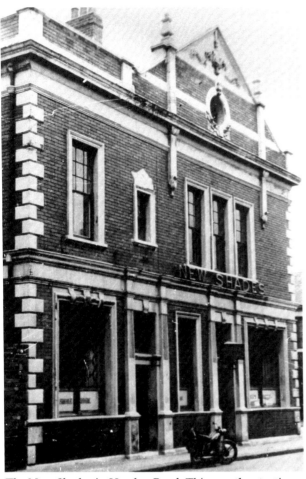

Matt and Ivy Morrison enjoying a night out at the River Wear Commissioners' Club with Audrey Tyrell.

The New Shades in Hendon Road. This was the starting point of Al Jolson AKA Norman Stubbs, singer from Bramwell Street. The motor bike is said to be Lukey Ratcliffe's!

Happy days with family – Jimmy Davison Sunderland AFC winger with dad on his right and brother Bob on his left. Behind them is John Foreman Jnr MBE.

Hendon and East End lads celebrating a wedding at the Argo Frigate in 1958. Left to right: Charlie Brown, Billy Whellens, John Brown (ex-proprietor of Hendon Gardens), Maurice Laws, Hughie Quinn (ex-proprietor of White Lion), Bobby Bute and K. Richie.